The Art of
Canadian Nature
Photography

Photographs by
Mary E. Abbott
Paul von Baich
Don Beers
Hans Blohm
Egon Bork
Fred Bruemmer
Vince Claerhout
Lorne Coulson
Brent Evans
Mary Ferguson
Menno Fieguth
Rick Filler
Tim Fitzharris
Hälle Flygare
David Gray
Betty Greenacre
Paul Guyot
Chic Harris

Douglas Heard
Bob Herger
Len Holmes
Dennis Horwood
Stephen J. Krasemann
Albert Kuhnigk
Wayne Lankinen
Norman Lightfoot
Valerie May
Neil McDaniel
Brian Milne
Pat Morrow
Freeman Patterson
Wilfried D. Schurig
Ervio Sian
Karl Sommerer
W. Samuel Tripp
John de Visser
Richard Vroom

The Art of Canadian Nature Photography

Edited by J. A. Kraulis

Hurtig Publishers / Edmonton / 1980

Hurtig Publishers Ltd.
10560 105 Street
Edmonton, Alberta

Canadian Cataloguing in Publication Data

Kraulis, J. A., 1949-
 The art of Canadian nature photography

 ISBN 0-88830-182-0

 1. Nature photography. 2. Photographers—Canada.
3. Natural history—Pictorial works. I. Title.

TR721.K73 778.9'3 C80-091010-9

Edited by Sarah Reid
Designed by David John Shaw
Endpaper design by Howard Laxson
Composition by Attic Typesetting
Film preparation by Flintlock Productions Ltd.
Lithographed by McLaren Morris & Todd Ltd.
Bound by T. H. Best Printing Company Ltd.

Manufactured in Canada

Introduction

Not so many generations ago, the visual record of this land consisted of a relatively small number of drawings, made mostly from memory by men whose chief profession was exploration, or by artists who imaged things as best they could from written chronicles. The Europeans of that day viewed pictures of a Niagara Falls four times its actual height and of strange beavers the likes of which have never been seen on Earth. To them, photography would have seemed nothing less than utter magic. They could never have conceived of pointing a little box at a scene, pressing a button, and, in an interval briefer than the blink of an eye, transferring that scene in precise detail and colour onto a thin lamination a fraction the thickness of a human hair.

Today, the magic of photography is commonplace, and we are inundated with pictures that give us an accurate impression of practically every thing and every place that exists. But the explorer, and the artist who follows the explorer, are with us still, though their methods and tools may have changed. The land has been revealed in its vastness and rich diversity, and because of that fact, rather than in spite of it, our comprehension of the land continually recedes from our grasp. For those who search and for those who show, the task is never-ending.

This book is about the work of a particular kind of artist and explorer, the nature photographer. Canada has inspired its share of craftsmen in the field, and some of their best pictures, along with the stories of the efforts and experiences behind the making of those pictures, have been assembled in this collection. Among the photographers included are some with long-standing international reputations and some whose work has never before been published; some for whom nature is but a part of their work and others who specialize in just one particular facet of nature photography. Some of the pictures are from the remotest reaches of the country, others were made when the photographer was—literally—at home. Together, the images speak of the unfathomable wealth of our primeval heritage.

What makes a good photograph? When photography was in its infancy, every photograph was a marvel, simply because of its uncommon realism. That time has passed, and the photographer who wants to touch our feelings, to communicate something beyond pure information, must do more—much more—than provide an accurate record of a subject.

The nature photographer must confront the severe limitations of the medium. Despite the magic box, nothing can be captured of the cool caress of a sea breeze, the aroma of a pine forest in spring, the salutary taste of a clear mountain brook, or the enthusiastic songs of birds early in the morning. Nor can the viewer be taken on a walk to breathe the freedom of grand spaces. The photographer is restricted to a flat, static image.

Even in the hands of an expert, the limitations of photography often prove too great, and the end result is nothing more than a pale ghost of a reality made lifeless. But in photography, as in any medium, the art lies in embracing its limitations as the very essence of its power.

The photographer who works with skill and with feeling uses the framed, two-dimensional view to concentrate the visual experience into a more intense state. From an alpine meadow, for example, he or she might extract the single grouping of rocks and wildflowers that, out of hundreds of others, evokes most purely the essential spirit of that meadow. Studying a tree, he or she may

select the one angle, the single viewpoint that crystallizes the strength and character of that tree. At the same time, the still condition of a photograph gives the photographer power over time, the ability to preserve the rare and the transient. The burst of surf, the flash of lightning, the beat of a bird's wing; all can be frozen for prolonged study. The fleeting light of dawn on a mountain wall can be held, the evaporation of dew drops from a spider's web can be prevented, and elusive wildlife can be suspended in classic pose. Searching and selecting, the photographer creates a distilled vision.

The exploring eye of the nature photographer can take us to places where we might never go, introduce us to creatures we may never encounter, show us phenomena we could seldom expect to witness, illuminate patterns and details we often miss, and capture for us that which is too fast or too small for us to see clearly. To achieve this is not easy, and it may demand initiative, resourcefulness, patience, tenacity, and even courage.

But perhaps the quality the nature photographer needs most is the capacity for wonder, the wonder which sustains the artistic eye, wonder for the indefinable, the unknowable, the infinite.

Consider a blade of grass. Hold it in your hand and weigh it. Science tells us that that blade of grass consists of hundreds of millions of cells, each one of which is more elaborate in function and design than the most expensive automatic camera available. And the manner in which that blade of grass germinated and grew involves processes and an organization more sophisticated than those upon which the entire photographic industry is founded. There is something awesome, and at the same time profoundly reassuring, in just a blade of grass. And consider the hand that holds it and the eye that regards it and all the forces, rhythms, and links in between. We cannot marvel enough at the miracle of it all.

This book is by those who have a capacity for wonder at this miracle which we label "nature". It is for those with a similar capacity; it is for all of us.

Foreword

How a photographer finds, perceives, and deals with his subject ought to be far more interesting and informative than how he operates the buttons and dials on his camera equipment. Thus I have generally avoided mentioning technical information in the text accompanying the photographs, except when I felt it really enhanced an understanding of the picture.

One piece of information that is mentioned fairly often is the focal length of the lens used for a picture. Strictly speaking, it makes little sense to do so without also indicating the format of camera used. But, because almost every photograph in the book was made with a 35mm camera, repetition of that fact would become tedious. When a 35mm camera was not used (for only 6 out of the 115 pictures), it has been indicated.

The focal length of the lens need not be a meaningless number to the non-photographer, if it is kept in mind that, when a photographer chooses a lens, he is choosing an angle of view, or how much of the scene will appear in the viewfinder. For 35mm photography, the "standard" lens usually purchased with the camera has a focal length of roughly 50mm. Longer, telephoto lenses provide a narrower angle of view. Anything seen through a 100mm lens, for example, will appear twice as high and twice as wide in the picture frame. Other things being constant, the linear dimensions on film of a subject are directly proportional to the focal length of the lens used. The shorter the focal length, on the other hand, the wider the angle of view offered by the lens. A 20mm lens encompasses a considerably wide angle, and focal lengths much shorter than that begin to distort straight lines into curves.

All the photographs in this book were taken on colour transparency film. The vast majority are Kodachromes, except for those not made on 35mm film, which are Ektachromes.

For reasons of relevance as well as honesty, I have made no effort to include technical data with the exactitude with which it is presented accompanying pictures in many photography magazines. Because of the vast number of possible variables in equipment, materials, and lighting—not to mention in the evaluation of a picture—this data could, in most instances, be meaningful only to the photographer who took the picture. The translation of the original photo into print further reduces the worth of such exact data. Moreover, the exposure information one sees in photography magazines is almost invariably educated guesswork, perpetuating a myth that experienced photographers religiously write such information down. Few ever do, although it should be emphasized that careful note-taking is an invaluable, indeed essential procedure for the learning photographer and for the photographer confronted with unfamiliar situations.

Among the people to whom I am indebted for assistance in the preparation of this book are Mel Hurtig, Robert Curtis and Barbara Holmes, José and Suzanne Druker, Linda Küttis, David Shaw, Sarah Reid, Rita and Dzidris Silins, and my parents.

Most of all, I would like to thank the photographers who submitted their work, both those included here and the many more who deserved to be included but could not be due to the practical limits that have to be set on a book of this type. From them I learned a great deal, making my task both a privilege and a pleasure.

J. A. Kraulis
March 1980

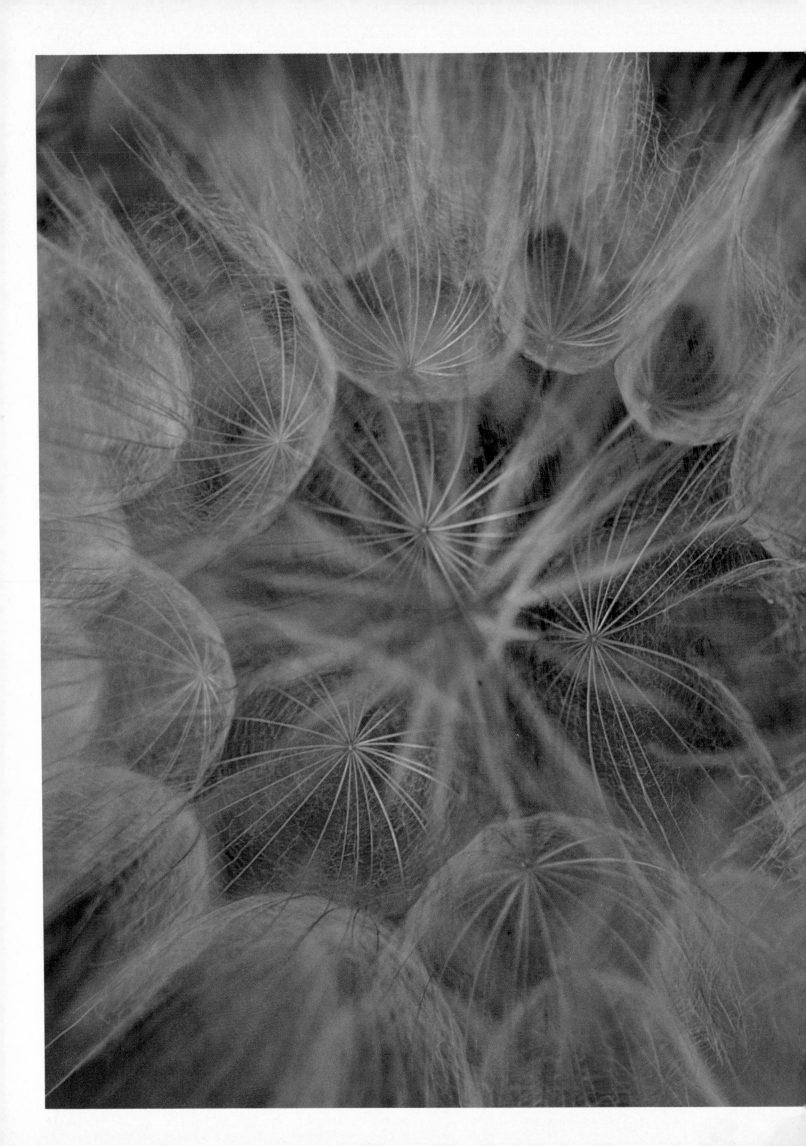

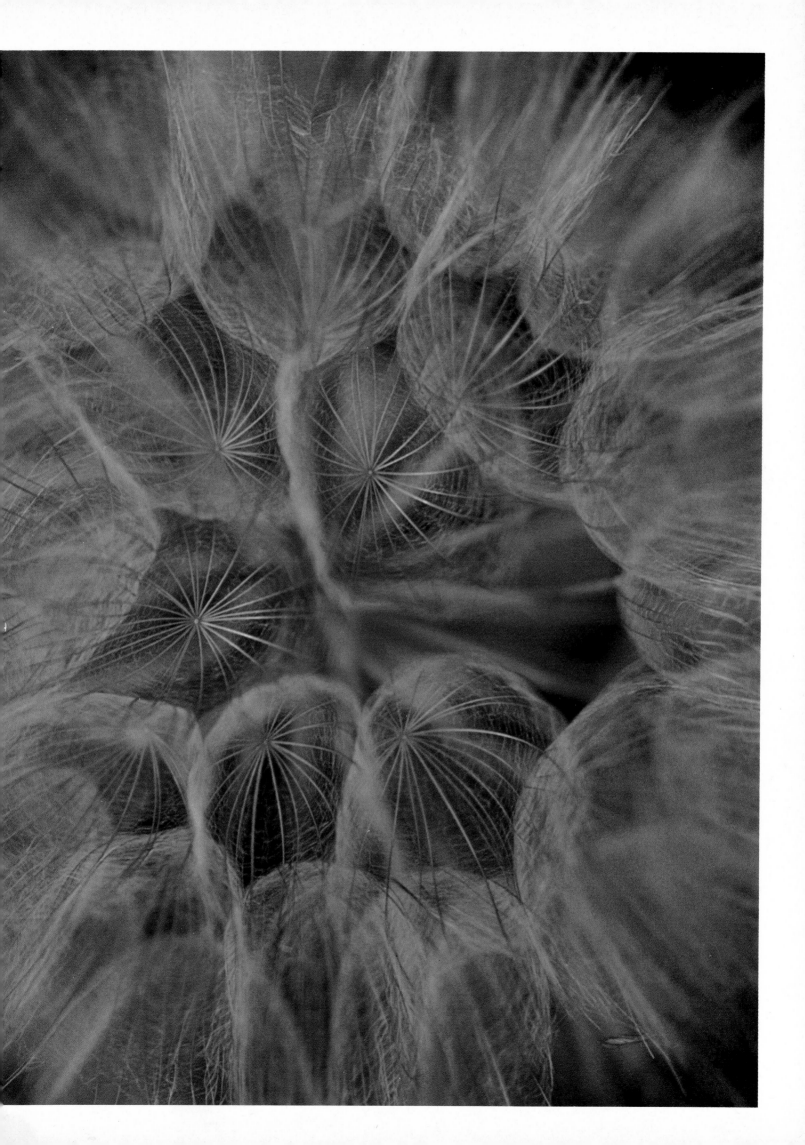

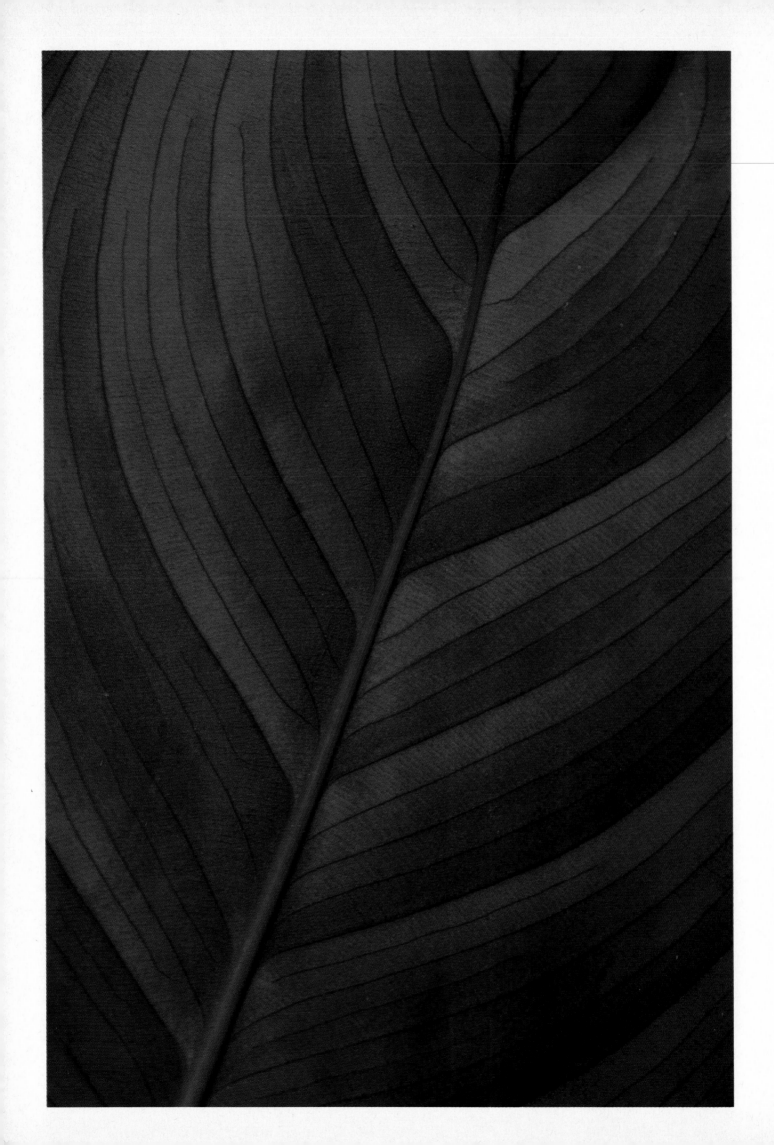

Precision. In a word, that is the essence of the equipment and materials of serious photography. It is an essence that Egon Bork consistently respects and appreciates.

Just as a master musician would be disturbed if his instrument was but infinitesimally out of tune, so Bork strives to get the most from tools that are manufactured to tolerances of exacting fineness. His conscientiously maintained cameras are among the best (and most expensive) available. If circumstances don't force otherwise, he always uses a tripod, always uses the slowest and most finely grained films, and, unless he needs a certain depth of field, always uses the apertures at which his lenses perform best. He never leaves filters over his lenses when they are not needed; his Leitz optics are coated to absorb ultraviolet radiation, so, although he will use ultraviolet filters sometimes to protect his lenses in dirty or wet environments, he always removes them before making an exposure. The only filter he occasion-ally employs for colour photography is a polarizer.

Like the audience of the master musician, only the most discriminating will notice the technical quality Bork achieves, the maximal sharpness and clarity. However, such an attitude of meticulous care also yields—some would say it is a prerequisite to—more universally apparent qualities. His compositions are balanced, complete, perfect. His eye for subject matter reveals a taste and vision refined through experience.

With his disciplined sensitivity, Bork has produced beautiful images of nature right in his own living room. The underside of the freshly unfurled leaf of a prayer plant, common in many households, revealed a delicate line study (opposite). Bork isolated the ten-centimeter-long segment, lit by diffuse daylight, with a macro lens on a bellows.

His needle-sharp rendering of frost on a window pane (below), again made in his living room, would be

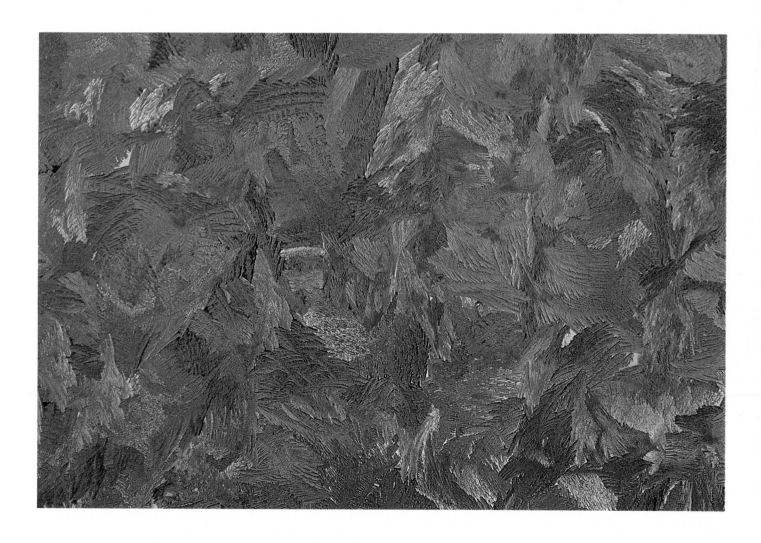

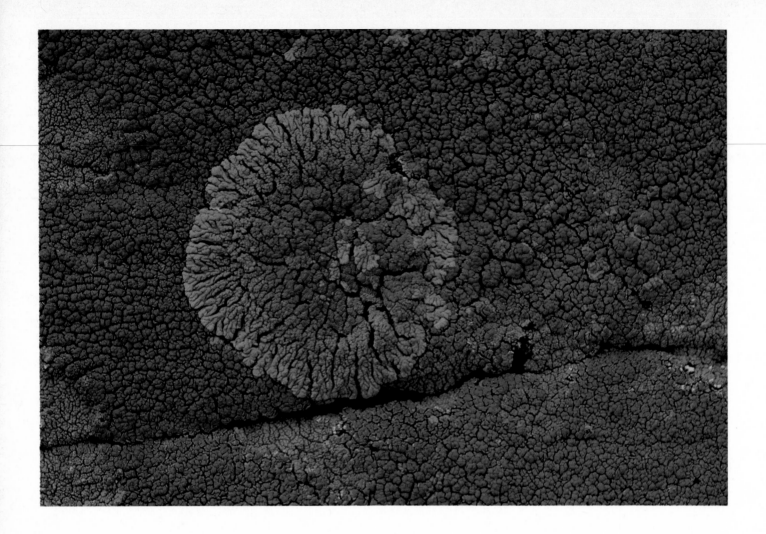

effective as an intricately-worked abstract mural. Actually reproduced here approximately life size, it was made with a 90mm lens fitted with a high quality close-up lens. The window was in shade on a bright, sunny, cold day. Light coming from the outside, refracted into a weave of subtle hues, accentuates the crystal-pure pattern.

Bork prefers to work outdoors, however. When not occupied with commercial assignments, he sets off from his Edmonton home to harvest new images from the varied and bountiful Alberta landscape. Unless he is planning a particularly strenuous hike, he takes into the field his equipment case, its interior designed by himself to neatly accommodate two camera bodies and a half-dozen lenses.

He has two tripods, a heavy one for use near his car and a more portable, lightweight one. With the help of a machinist, he modified the latter so that the legs could be splayed out nearly flat and the centre post could be taken apart and shortened. This permits him to use the tripod very close to the ground.

The modification proved useful for the lichens (above), which he found growing on a low rock in Writing on Stone Provincial Park. Bork made the photograph in morning sunlight with his 90mm lens plus a close-up lens, recording texture so crisply that one can almost feel it.

Hunting for compositions in Dinosaur Provincial Park, Bork discovered bold rhythms scored in grooves of eroded bentonite, a soft rock formed from prehistoric volcanic ash (opposite). The badlands of the park, a labyrinth of furrowed knolls and gullies, have often lured him on excursions of visual exploration. On this occasion, he had spent a long day concentrating on overall scenes of the environment.

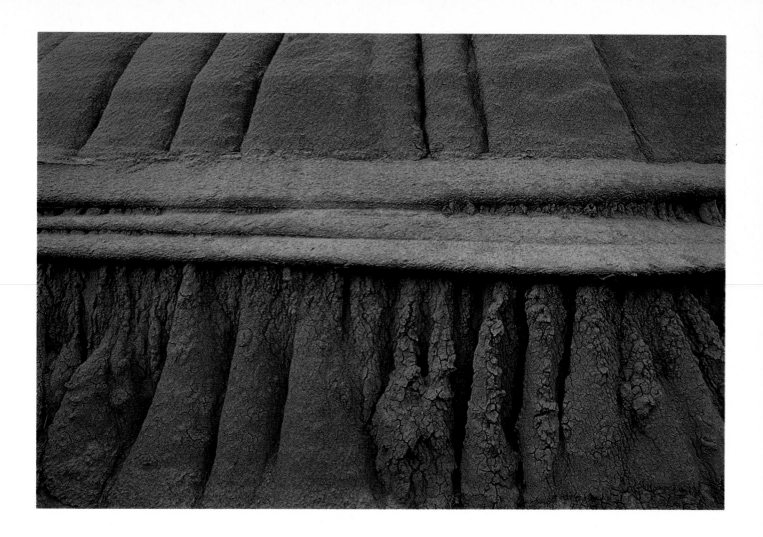

EGON BORK

When the setting sun left the landscape in shadow, he turned to more intimate views, his keen powers of observation not yet exhausted.

Such ability to sustain a fresh perception of one's surroundings is fundamental to producing images that are more than mere records, or that are not imitations of other photographs. "Many times we take photos not really of what we see, but rather, of clichés we have seen and to which we have become accustomed," says Bork.

"It is important to be open minded. Some things often do not appear to be very interesting at first, but if one looks long enough and keeps an open mind, one can take good photos at any time. Very often the best photos come about unexpectedly."

In Cypress Hills Provincial Park, Bork had been investigating the fluffy seedheads of goatsbeard flowers when he discovered this perfectly matched pair (pages 8/9). A case of two being more than twice as good as one, the strong design was possible because the stalks of the adjacent plants grew to the same height. Bork photographed the twin seedheads exactly as he found them, since he prefers to disturb his subjects as little as possible.

He experimented with different effects by focusing to different distances with his 90mm lens. In this instance, he used a large aperture and selectively focused on the radiating latticework at the top of the translucent globes. The shallow depth of field dissolved competing detail and clarified the image while giving it a soft, silky quality.

Although this was not a photograph which he wanted to be razor sharp from edge to edge, Bork still resorted to his tripod. The light was constantly changing and a slight breeze periodically disturbed the plants. The tripod gave him control in a situation where trying to maintain the precise centring and focusing of the composition while hand-holding the camera would have been frustrating. Bork waited until the goatsbeards were still at the same moment as the sun was obscured by cloud, giving him the diffuse, even illumination he wanted for this beautiful essay on structure and symmetry.

It was a sunny day in late fall when Bork photographed the floating decorations which evolved from the breeze that brushed across a leaf-spangled pond in Elk Island National Park (below). By underexposing considerably from his meter reading, he rendered the water dark, eliminating the distracting details of submerged rocks while at the same time creating vibrant contrast in this elegant arrangement of white and gold on black.

Bork often returns to places he has visited many times before to see if he can improve upon a previous photograph as well as to look for new possibilities in familiar surroundings. One location he visits a dozen times a year is Beaverhill Lake east of Edmonton. Out late in September to photograph the migrating shore birds that use the lake as a stopping-off point, Bork took this evening view (opposite) with his 28mm lens. Despite the dramatic light of the setting sun, it is a picture of considerable subtlety, a sophisticated balance of texture, tone, and symmetry.

Egon Bork's photographs are the kind that one can study often and for a long time. They reveal a profound sense of the order, harmony, and infinite beauty of nature.

EGON BORK

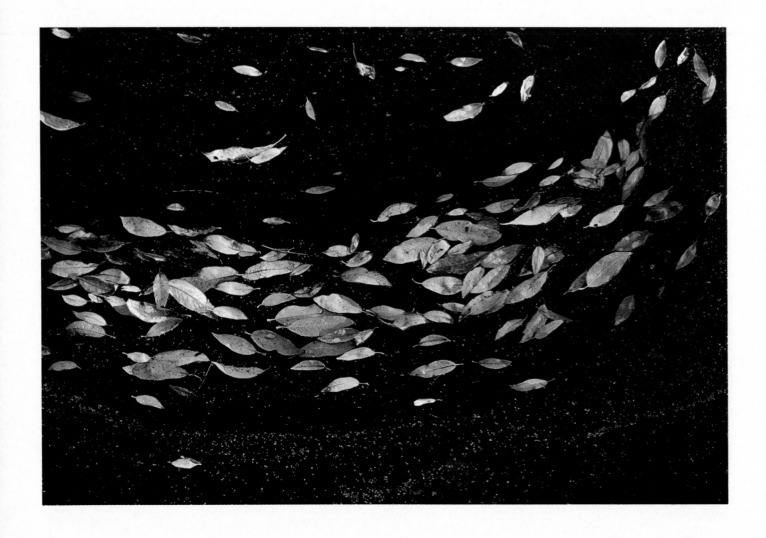

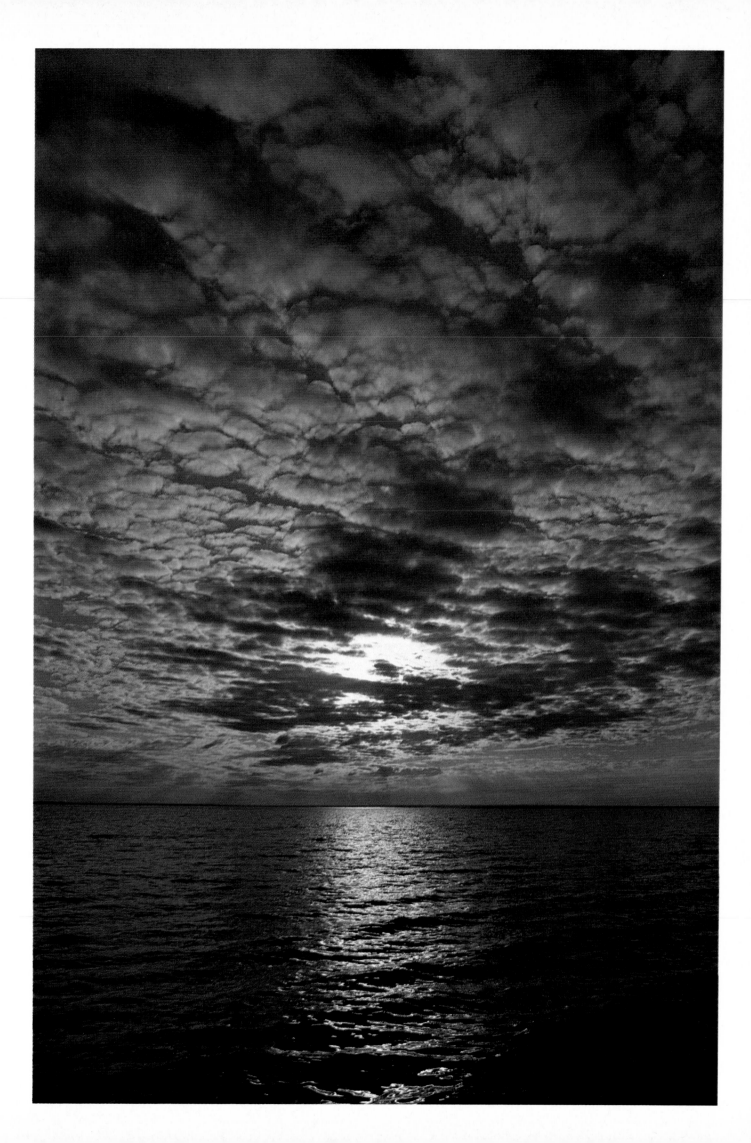

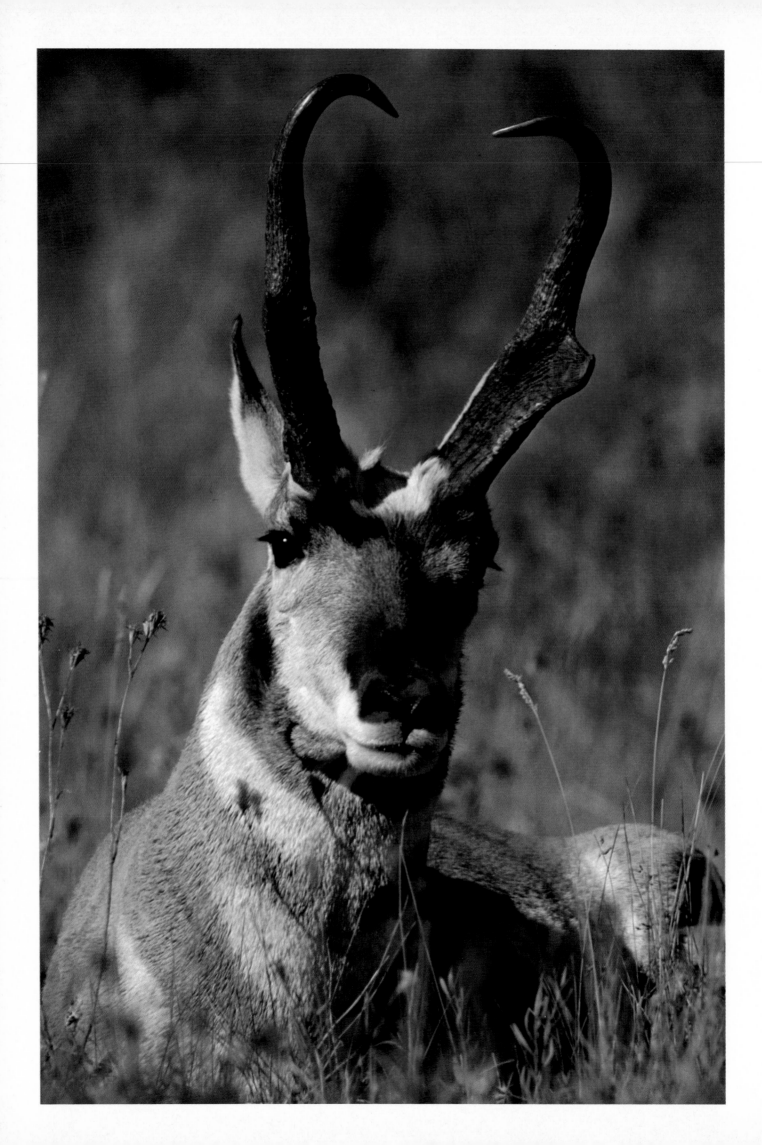

WILFRIED D. SCHURIG

Always very interested in nature, Wilfried Schurig spent his first earned money on a camera. Today he owns and works with 35mm, 2¼ x 2¼-inch and large format cameras, and he occasionally makes movies of wildlife. He is an expert with black-and-white as well as colour materials, and is equally at home with natural or artificial light. In spite of such competence, Schurig does not earn his living from photography; the realities of supporting himself and his family always seemed to demand another career. Motivated by passion rather than profit, he has accumulated a portfolio of pictures that would be the envy of many who work at photography full time.

His portrait of a solitary male pronghorn (opposite) was made near a secondary road not far from the Alberta-Montana border. The fine buck, endowed with the incredible eyesight of its species, probably saw Schurig as clearly and in as much detail as the powerful 500mm lens used for the photograph allowed Schurig to

view it. The animal gave him just enough time to set up his tripod and take the picture before it stood up and left. Pursuing it any further would likely have proved futile for Schurig; pronghorn antelope are the fastest runners in North America, capable of sustained speeds of eighty kilometers an hour.

Not quite as camera-shy as the pronghorn was the young bighorn ram and its associate (below) which Schurig photographed with a 300mm lens near Vermilion Lakes in Banff National Park. He spent several hours of a sunny October day with a small herd of the sheep which, used to tourists, were little concerned by his presence. The magpie was visiting a number of the sheep, and Schurig also managed to photograph it sitting on the back of a lamb. Magpies not infrequently feed on the ticks and insects which pester hoofed animals, although the birds will also peck at open wounds and can sometimes thus kill an animal, says Schurig.

National parks are usually the best

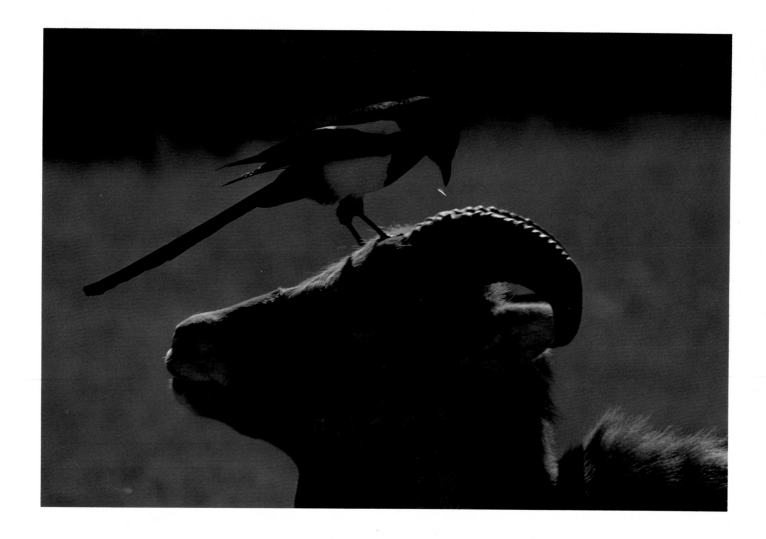

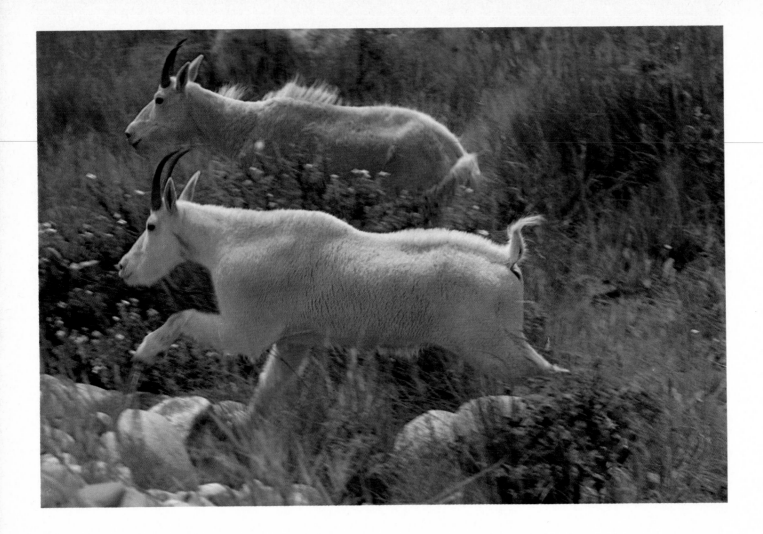

locations to photograph large mammals; because they are not traumatized by being hunted, the big animals there are less fearful of humans. Such was the case with the two mountain goats (above), which Schurig photographed not far from the road in Jasper National Park. The sure-footed but slow moving animals usually prefer the security of precipitous terrain. They have been encountered by alpinists in places where even the most experienced mountain climber would not go without a rope. However, this pair, photographed with a 180mm lens, is part of a herd that regularly forsakes the cliffs for a well-known mineral lick in the Athabasca River valley. Schurig has counted as many as thirty of the shaggy white animals at the spot.

Schurig likes to drive slowly and off the main roads. Travelling along the old highway through Banff, now abandoned by those in a hurry, he spotted a lynx in a stand of lodgepole pines. After some quick pictures out of

the car, he slowly walked towards the cat. It was feeding on the hindquarters of a deer, and wouldn't move away very far. "I had misgivings about how closely I should approach him," he says.

"I looked around and there were deep holes in the snow. There was hair and blood all around. You could see that there had been a really big struggle. I sunk in up to my knees; the lynx must have taken advantage of the situation. The carcass itself was buried, you could see the claw marks where the cat had covered it with snow."

Working with a 500mm lens on a 2¼ x 2¼ camera, Schurig photographed the predator (opposite) from as closely as the lens would focus— about three meters—and used a flash to fill in the shadow areas. Then he took some movie footage, spending some five hours with the animal. "He gave me lots of time," mentions Schurig, admitting a fact readily confirmed by his family, who spent the session waiting in the car.

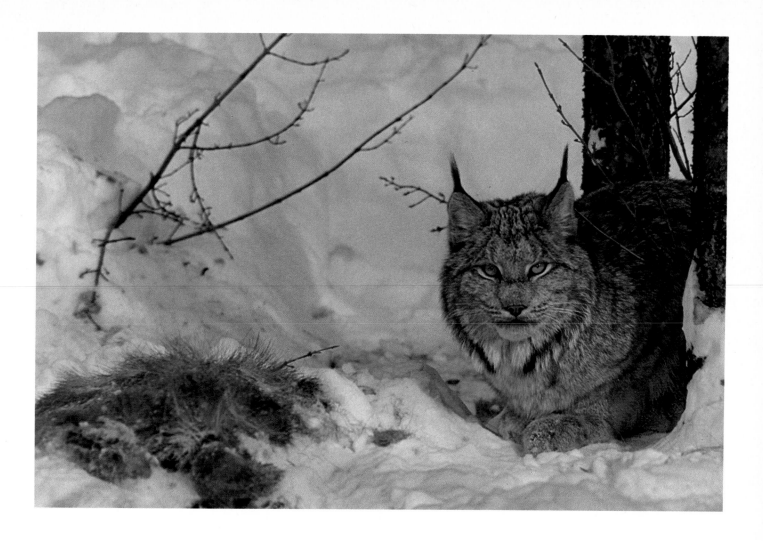

WILFRIED D. SCHURIG

When he drove by again two days later, only the rib cage of the deer was left. The lynx was still there, but so were some coyotes, ravens, and magpies, who were expressing interest in the spoils.

A group of audacious entertainers or a gang of non-conformist youths could not have struck a more imaginative and engaging pose than that which Schurig has caught in his family portrait of long-eared owls (page 20). Not present for the sitting was the father, who was out in the woods hunting, and the two eldest children, who had left the nest and were perched on branches nearby. It is characteristic of owls that the mother continues to lay eggs long after beginning to incubate the first one, and that the young, which are born naked, hatch in succession as much as a week apart. Age difference accounts for the variety and individuality of this tough-looking brood, which nested five meters off the ground in Schurig's backyard, not far outside Calgary.

In another tree adjacent to the nest, Schurig clamped two flash heads and the length of lumber to which he had bolted the ball-and-socket tripod head that held his 2¼ x 2¼-inch camera. Controlling the ensemble from a blind on the ground, he spent all of three nights observing and photographing the predacious birds. With the main action of feeding time taking place just after sunset and just before dawn, there wasn't much to do for most of the night, but he never got bored. "It is a very nice experience," he maintains. "Because it is pitch black, your senses are focused much more on hearing than on seeing. You notice sounds that you don't hear during the day. I listened to bird calls which I had never encountered before, and I still haven't figured out what made some of the noises which I heard."

The yellow warbler feeding a cowbird (page 21) taken at Carsland, Alberta, is one of many crisp, intimate pictures of small birds which Schurig

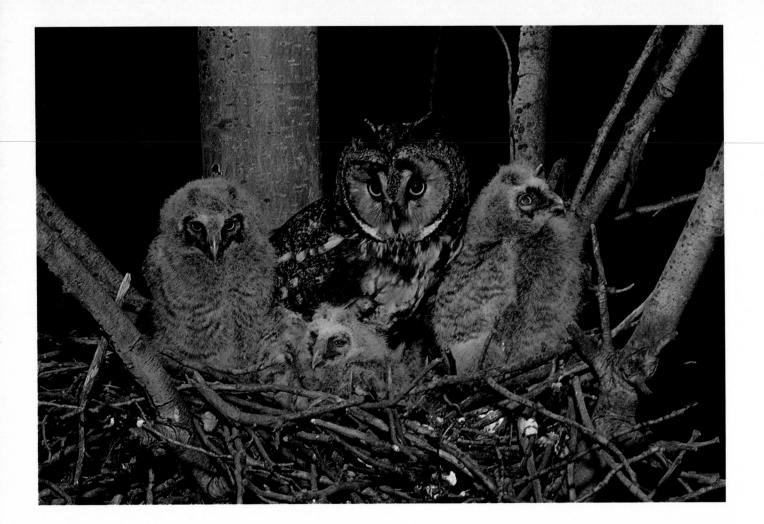

made on 4 x 5-inch transparency film, using a view camera and a 210mm lens. "I especially wanted to photograph a yellow warbler because of its splendid colour," he explains. "I watched the birds, and when I saw one flying around with food in its mouth, I followed it closely until it showed me its nest. In this case, there was a big cowbird in the nest, and a little warbler chick that was almost crowded out."

"The cowbird is a parasite that lays its eggs in the nests of a number of different host birds. These eggs usually hatch before those of the host bird, and because the cowbird chick grows more quickly and is more aggressive, it often shoves out the young of the host. During the session when I photographed this, the young warbler got pushed out of the nest and just vanished below."

To get such brilliant, unblurred photos of such small and active birds, Schurig uses three electronic flash heads, even though he works in daylight. He places one on either side of the camera, and the third above and

back a little. With a flash duration of only 1/7000 of a second from his powerful unit, he has managed to freeze motionless the beat of a hummingbird's wing. Together with the camera, which he triggers from a distance, readying the setup is a major operation, and after he has found a nest, he must usually return on subsequent days for the actual photography.

Schurig's thorough competence in photography is perhaps most convincingly demonstrated by the camera which he uses for pictures such as that of the yellow warbler. Unique among 4 x 5-inch cameras, it is one he built himself. A pattern-maker by trade, he produces models for parts that have to be cast in metal. During his spare time at an aluminum foundry, he created a hybrid of the two leading brands of view cameras after studying their promotional literature. To such abundant skill and resourcefulness, Schurig adds his love of nature when he goes out to work in the field. The impeccable quality of his images is thus not surprising.

WILFRIED D. SCHURIG

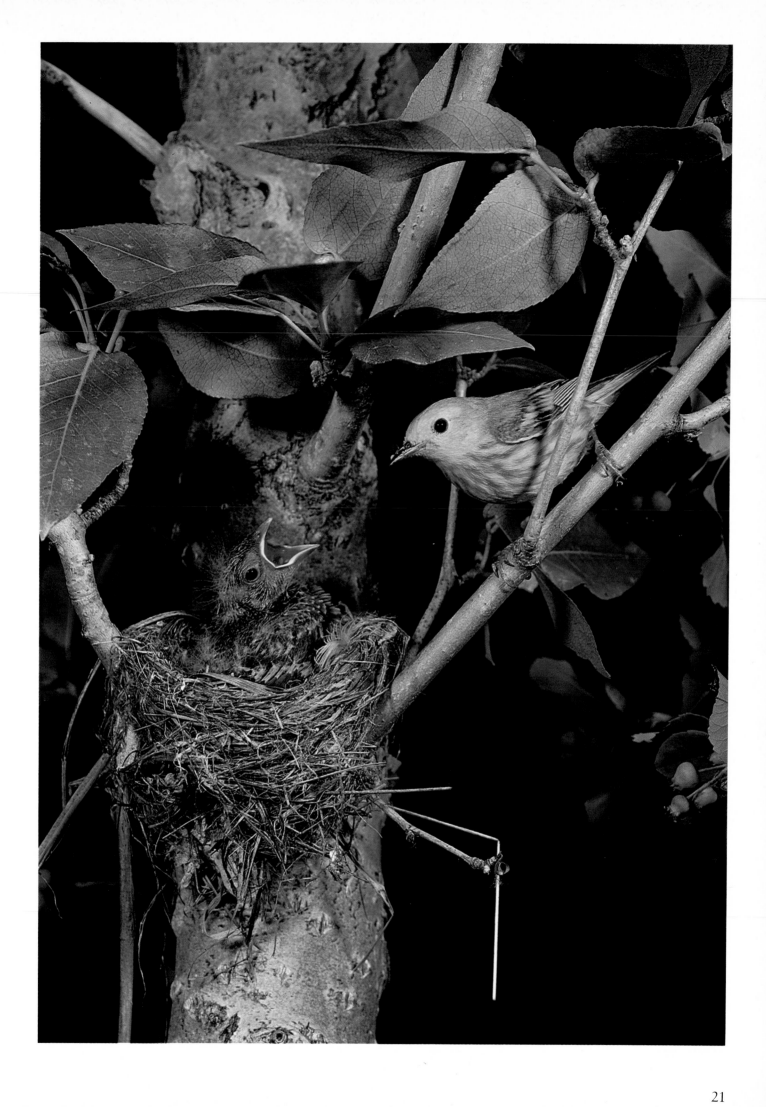

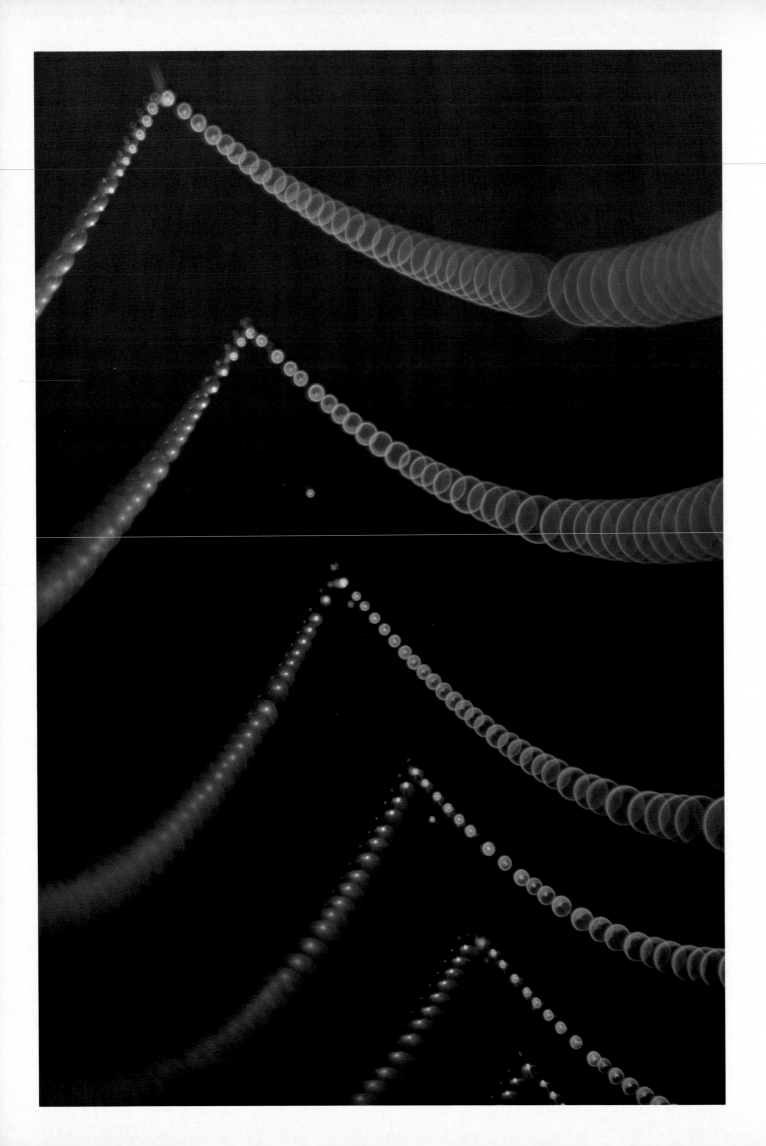

An acknowledged master of the art of seeing, Freeman Patterson speaks to as many as twenty thousand other photographers in the course of a year's seminars and slide talks, and reaches several times that number through his published work. With equipment that is less expensive and elaborate than that owned by many in his audiences, he has shown that through trained observation, limitless possibilities for visual delight can be found anywhere in the world around us.

Commenting on trends in his own work, Patterson says, "I am stripping down more all the time, getting simpler. A picture that is purely descriptive doesn't interest me as much anymore. I try to get the labels off things; I try to get beyond the literal document."

His interpretation of a spider's web covered with dew drops (opposite) is a good example of this approach. Rather than show a well-focused complete specimen of what could only be seen as unequivocally a spider's web, he has abstracted it, revealing essence rather than object. "On the one hand, they are very architectural," he says of webs, "while on the other hand, they are also like beautiful jewellery, like a string of pearls."

This is one photograph which, unlike his others shown here, he could not very easily previsualize without the camera. With a close-up lens on a 100mm macro lens, its aperture set wide open to register the out-of-focus dew drops as circles rather than polygons, Patterson explored the myriad design possibilities in a single web, using up several rolls of film. He found a tripod desirable in the situation; moving the camera a few millimeters meant losing a composition that could prove almost impossible to regain.

Somewhat more in the fashion of the "literal document", his *Peziza* (below), a member of a distinctive genus of fungi that thrives in sandy soil, is one of thousands of different photographs of mushrooms from his vast collection. "Every third summer or so, I go on a mushroom binge, crawling around for days on end—I just can't get enough of them," he says.

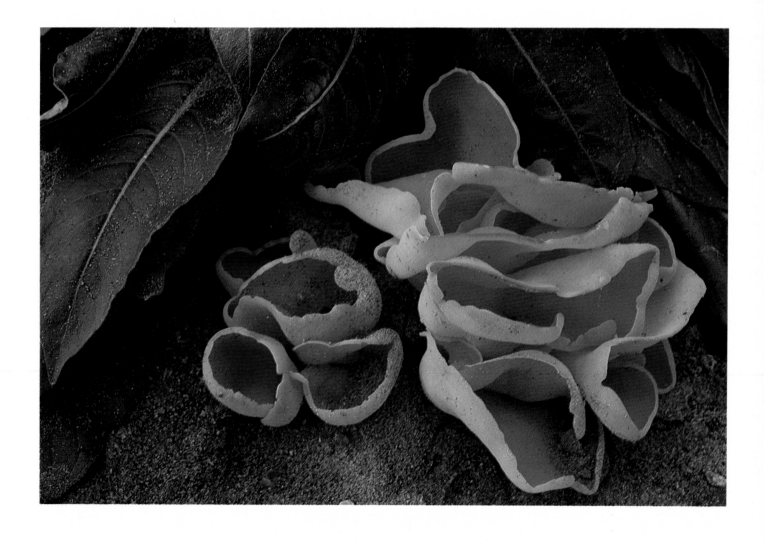

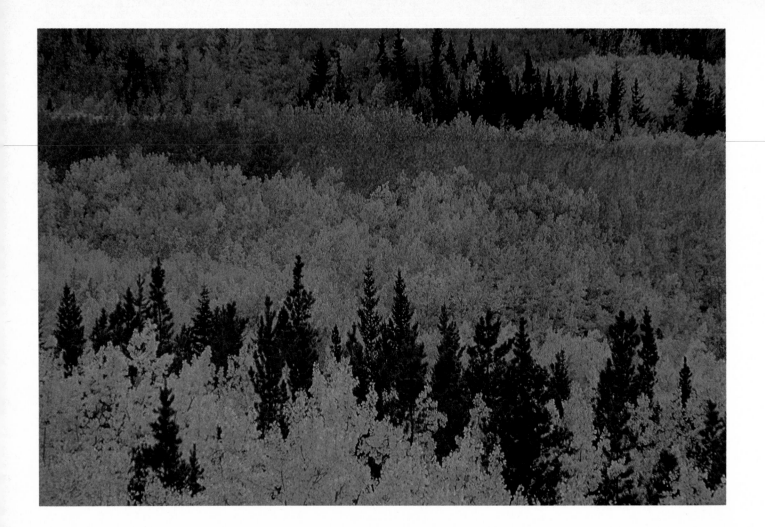

The whole subject of mushrooms and their role in the natural balance fascinates him. "There would be no book on the art of Canadian nature photography," he points out, "if it weren't for the work that fungi are doing in the woods."

About his monochrome of a sea cliff at low tide on Brier Island in Nova Scotia (opposite) he remarks, "I like, very much, working with a single colour and playing up and down the tonal scale. In this case, the predominantly blue colour, which I deliberately did not try to filter out, is caused by the fact that it was a very sunny day and I was photographing in the shade. The ocean was also bouncing some of the blue light from the sky into the shadow areas. In that kind of a situation, I will almost never use a filter, because part of my reason for photographing the scene is the colour that is there. I have to train myself to concentrate and make a mental correction to see the true colour the film will record; to the eye, the rocks here appeared quite red."

It was an overcast fall day when Patterson, using his 300mm lens, photographed the groves of changing aspens that gilded the Kananaskis Valley in the Alberta Rockies (above). "In the autumn, I always pray for rain and cloudy weather, because it makes the colours stand out," he explains. "I passed by this location for four days, and when the sun was shining, little bits of black shadow poked through the trees and disturbed the composition."

"I was interested in the horizontal movement of the ranks of trees across the picture frame, the alternating bars of yellows and greens," he continues. "The evergreens provided the kind of contrast, the dark anchoring tones, that I needed, and it is around them that the picture is organized."

Unlike many photographers who prefer to work with a single make of film, Patterson experiments with many kinds. For the aspens, he tried five different films and discovered that Ektachrome 64 rendered the yellows best; but only—he stresses—for that

FREEMAN PATTERSON

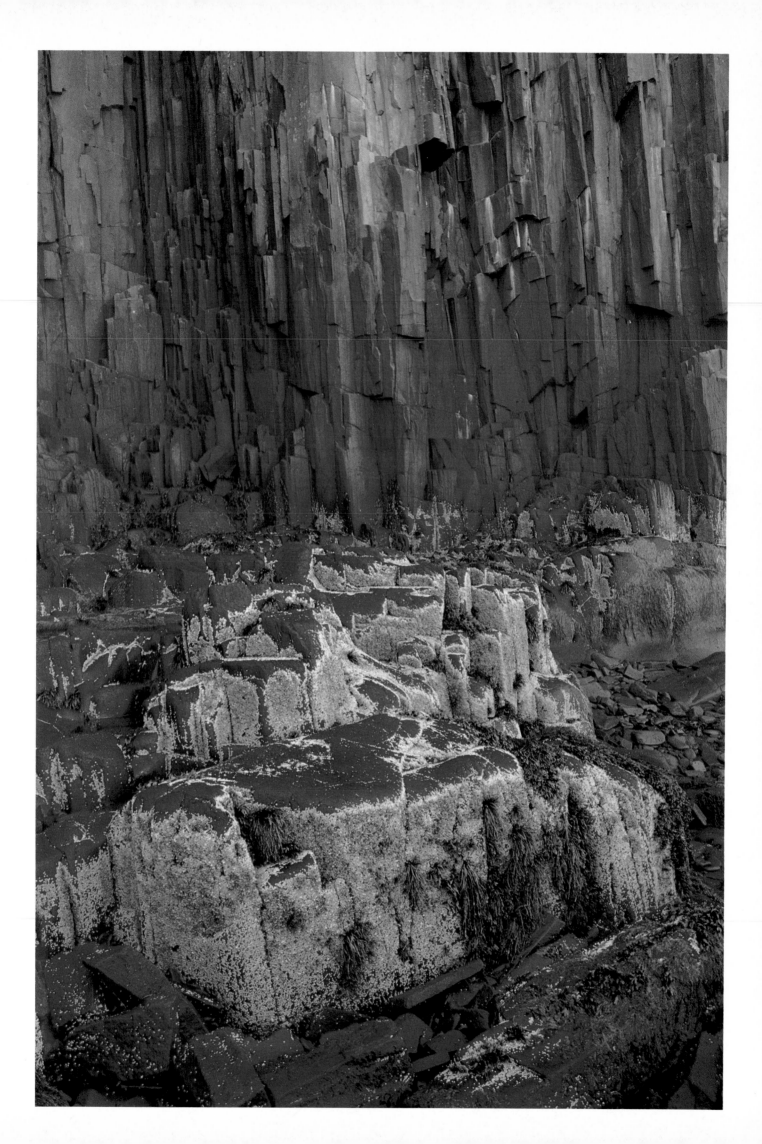

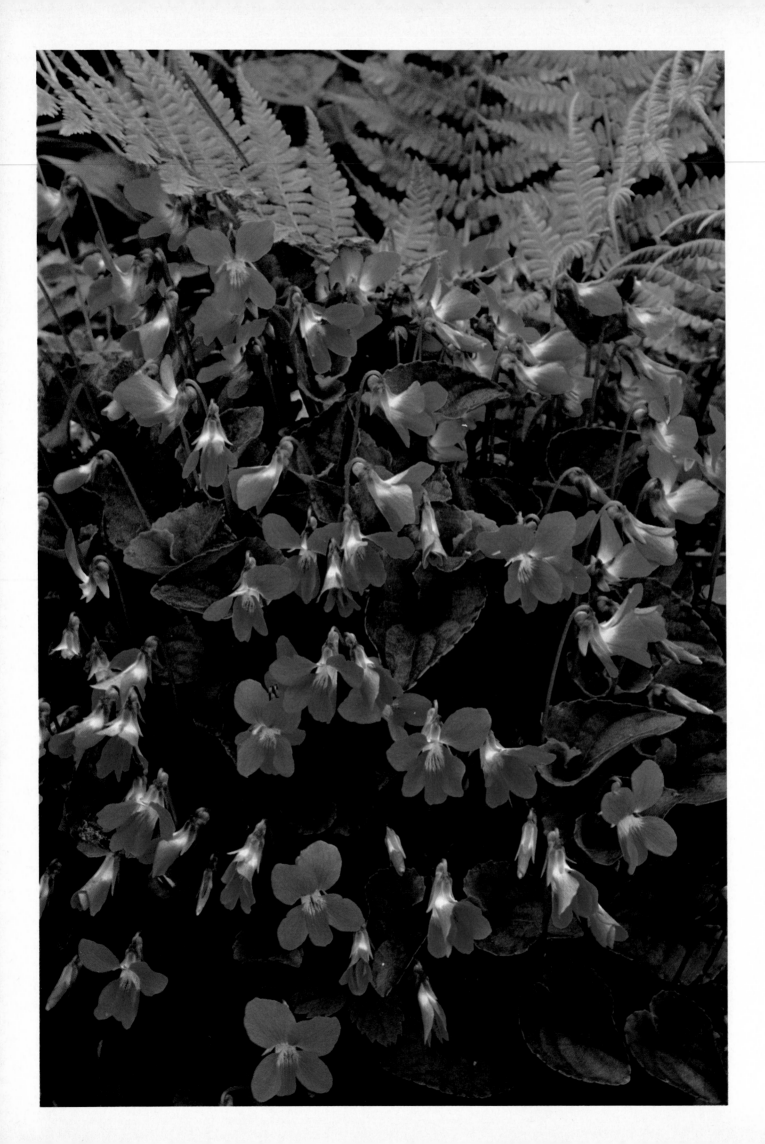

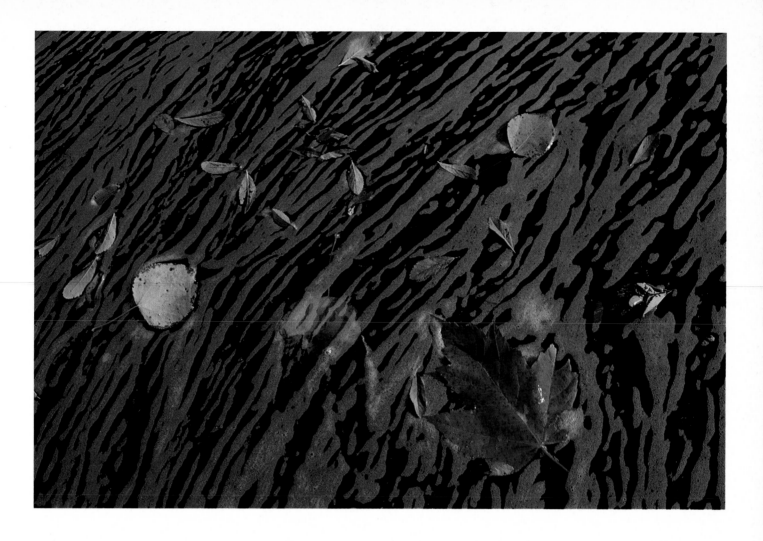

FREEMAN PATTERSON

particular subject matter at that time and in that place.

It is difficult to make generalizations about matching film to subject, he has discovered. In the damp alder woods just a couple of hundred meters from his New Brunswick home thrive dozens of lush clumps of violets, each of which brings forth several hundred blooms every May (opposite). "Each year that I photograph these, I will take Kodachrome 25 and Ektachrome 64, and I will do everything twice," he explains. "One year the Kodachrome is better and another year the Ektachrome is. It just depends on the atmospheric conditions." An overcast day, with the neutral white, even light it provides, was essential for this subject, he felt.

On a bright, sunny day at Rosseau Falls in the Muskoka region of Ontario, Patterson photographed autumn leaves as they swirled amidst a pattern of bubbles churned up in a pool below the cascades (above). Leaning out over the river to make the picture, he ignored his camera's light meter which,

pointed at the dark water, indicated an exposure that would have badly overexposed the leaves.

His photo of a mountain with its shadow cast by the rising sun onto the screen of nearby clouds (page 28) was made from the Kootenay Plains along the North Saskatchewan River in Alberta. It was one of those phenomena in nature that evoked a sudden rush of wonder, a feeling of having been given a special moment, he says.

Photographing the badlands of Alberta during the long days of June, Patterson would rise at 3:00 A.M., return to sleep in his tent during the hot midday hours, and get up again in the afternoon to resume work. With this routine, he caught dawn spilling from the rim of the prairie into the wrinkled landscape of Dinosaur Provincial Park (page 29). "I was interested in the beauty of the lines, the colour of the early morning light, and the detail that

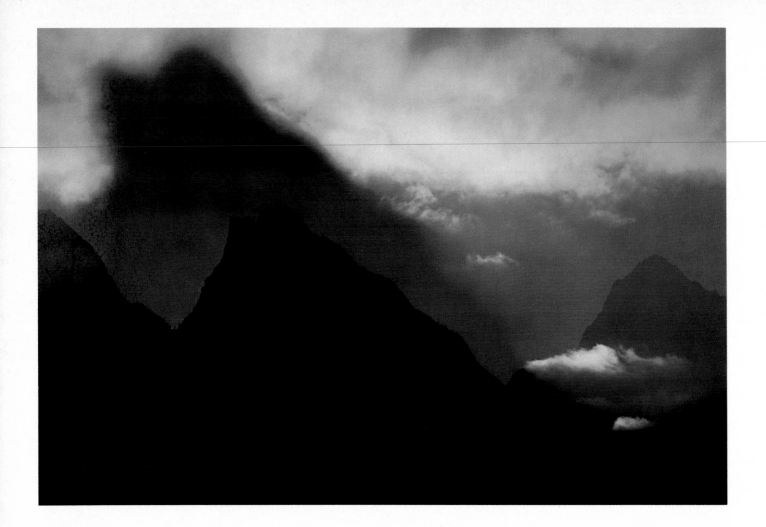

could be seen in the shadow areas," he remarks.

"The place gave me a sense of total timelessness," he continues. "I wandered for several days without seeing anybody, and I felt I could have been hundreds of years in the past or hundreds of years in the future. There was nothing to identify with the twentieth century."

Despite his demanding writing and speaking schedule, Patterson keeps in shape by doing a little photography all the time, even if it is of something as seemingly commonplace as the reflection off his refrigerator door. "What I normally do," he adds, "is pack all of my camera gear in the trunk of my car around the first of April. I keep it not in cases, but among old woolen army blankets, which serve as perfect insulation, even when I am in a hot parking lot. The equipment stays there until about the end of November, so that wherever I am—if I am away from home or at home—my cameras are with me."

Patterson's destiny as a nature photographer was probably determined long before he ever owned a camera. "I grew up in a rural area where I was the only kid my age," he tells. "My peers for those years were trees, rocks, flowers, cow paths, and that sort of thing. I think that a person's most powerful symbols are acquired during childhood, and that they affect very much the way one sees the world. So for me nature and the land have an overwhelming aesthetic and spiritual value which I don't even make any attempt to explain.

"Part of my interest in photography is scientific, but the more important part is not scientific at all. Although I am documenting natural history, I try to balance that by capturing its spiritual aspect, because it affects our spirits very profoundly.

"When I go out, I may be in a foul mood, but after making pictures for an hour, I am right on top of the world, everything is electric, I feel great."

Practicing what he teaches, Freeman Patterson pursues photography for the joy of it.

FREEMAN PATTERSON

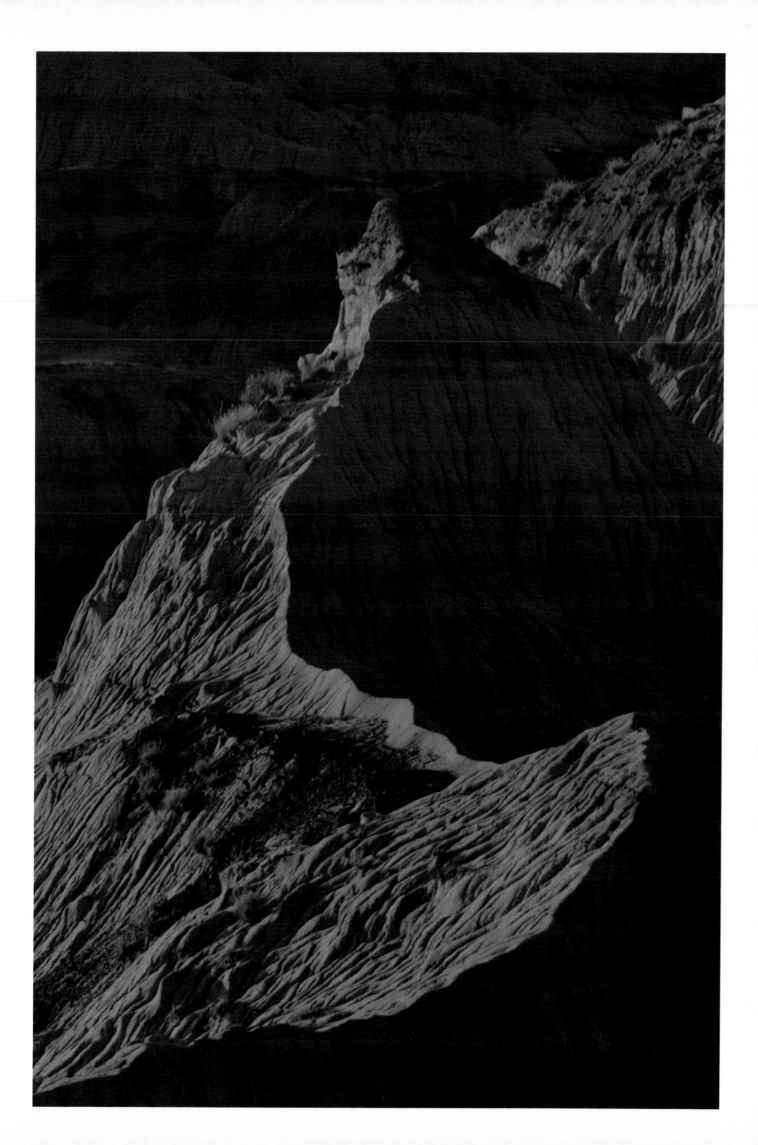

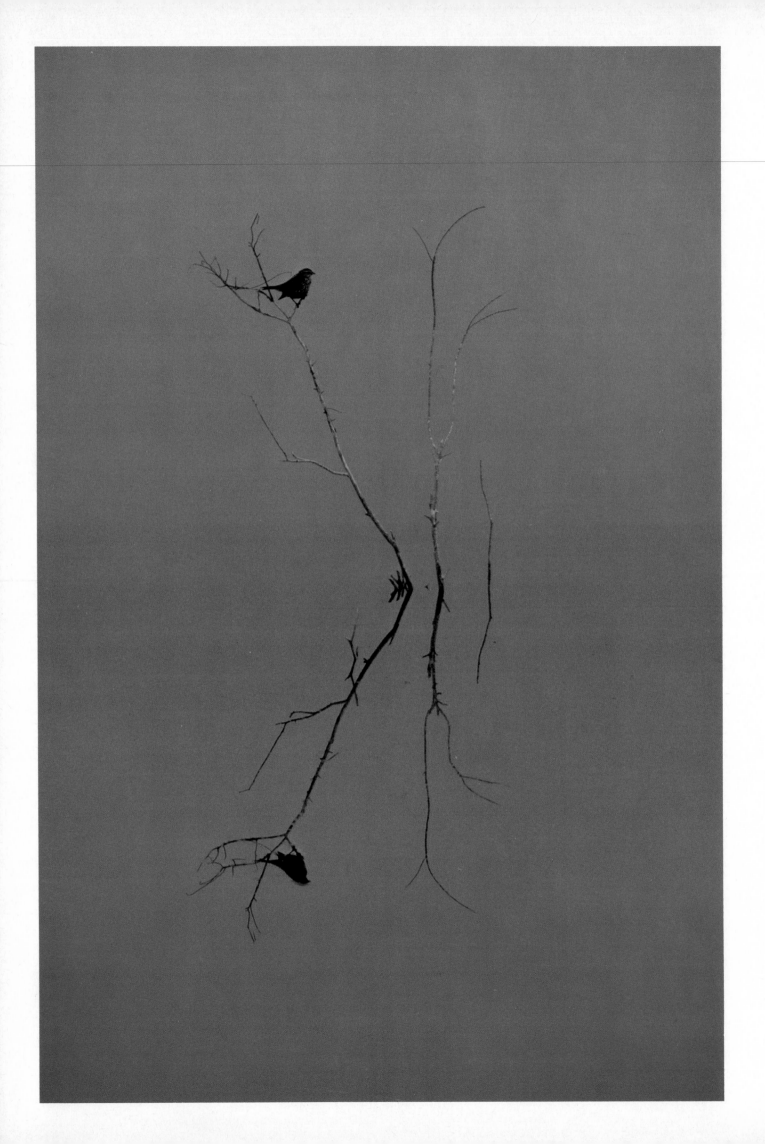

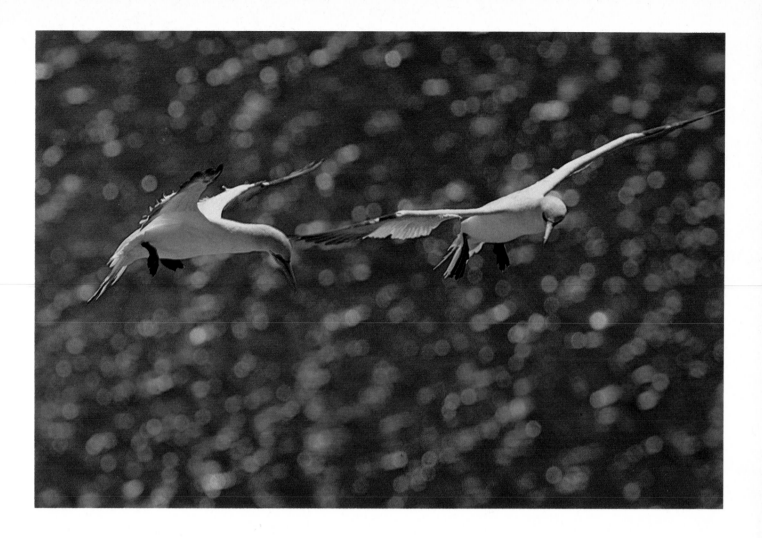

KARL SOMMERER

Many of the best photographers steadfastly believe in the discipline of the tripod, using one for almost every picture they take, even when any improvement in sharpness that might be achieved with it would be practically imperceptible. Other photographers consider the tripod an unnecessary encumbrance in most situations. Karl Sommerer is one who prefers to hand-hold his cameras whenever he can get away with it.

"One problem with a tripod is that often, by the time you have set the thing up, whatever it was that you wanted to photograph has flown away," says Sommerer, who, as an owner of twenty-five different cameras, cannot be accused of being equipment-shy. A persuasive, literal example for his argument is his perfect, yet ever so fragile picture of a bird on reeds (opposite). One almost expects that, upon looking at it a second time, the bird will have disappeared, and the delicate magic of the image will be gone.

Like many good photos, this one,

taken with a 135mm lens, came about serendipitously. Sommerer had been driving across Alberta and was east of Elk Island National Park when he was lured off the highway by the promise of photo opportunities evident in the passing landscape. Black thunderclouds and flooded fields of brilliant yellow rapeseed tempted him to search for images alongside the straight dirt tracks of farm roads, and led him unexpect-edly to the singing bird, mirrored in water becalmed before the approaching storm.

Next to nature, Sommerer's fa-vourite subject is motor sport. It is a long way from the roaring, bustling racetrack at Mosport to the wild, lonely beauty of Cape St. Mary's in Newfoundland; but the experience he had gained at the former proved useful in dealing with the seabirds that nested on the windy cape. In action photogra-phy, it takes a good deal of practice to develop the sense of timing necessary to anticipate and freeze, in his words, "that single moment of ultimate drama". His picture of two gannets,

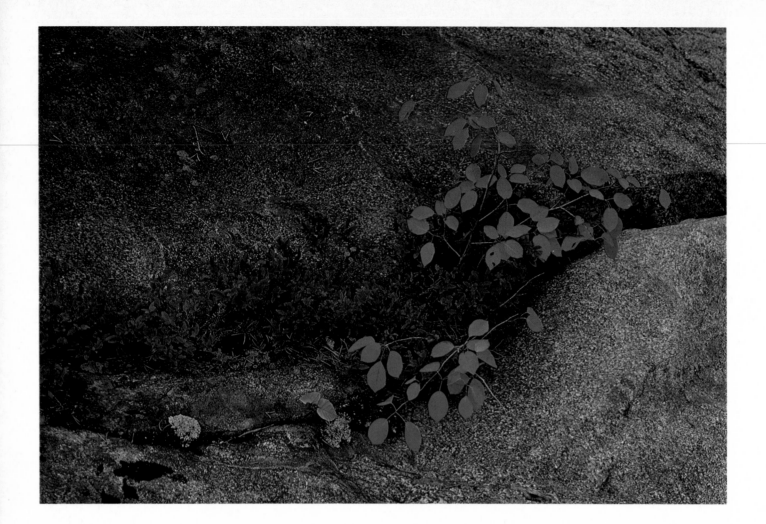

wingtip to wingtip, the one looking
back at the other in apparent mid-air
conversation (page 31), catches such a
singular instant, communicating
something of the freedom, grace, and
joy of the aerial dance that is flight.
Sommerer used a 250mm lens for the
photograph, maintaining the sparkling
background of the wind-ripped sea
effectively out of focus.

Every Sunday morning, free from
teaching photography at Cambrian
College or doing commercial work,
Sommerer leaves his Sudbury home
before dawn and heads up into the
rough country of the Canadian shield.
There he seeks out the uncommon
images to be found in the very common
landscape north of Capreol, Ontario.
His photo of a bright red shadbush
with juneberry and blueberry and one
tiny green birch seedling growing in a
crack in the shield (above) is from that
area. So is the simple but strong study
of line and colour selected from reeds
immobilized by a clear, fresh sheet of
ice (opposite). Sommerer has photo-
graphed these same reeds for five years.

These quiet Sunday mornings are
not without their hazards—Sommerer
seems to have picked up an unlucky
habit of falling through the ice. Once,
wandering across a frozen, snow-
smothered river, he disappeared
completely below the surface. Ballasted
with cameras, he hit bottom, three
meters down. Bouncing back up, he
struck his head on the underside of the
ice. By good fortune, he managed to
find the hole he had fallen through
and survived.

Such experiences aside, there is
probably no place where Sommerer
more enjoys taking photos than this
region which has become so familiar to
him through fifteen years of regular
visits. "When you go somewhere new
and spectacular, you get that wide-eyed
feeling, and you photograph the same
things that other people did the first
time they went there," he says. "But
this region, which has grown on me, is
absolutely low-key—nothing like the
Rockies, for example. And because it is
difficult to photograph, I find that you
try harder."

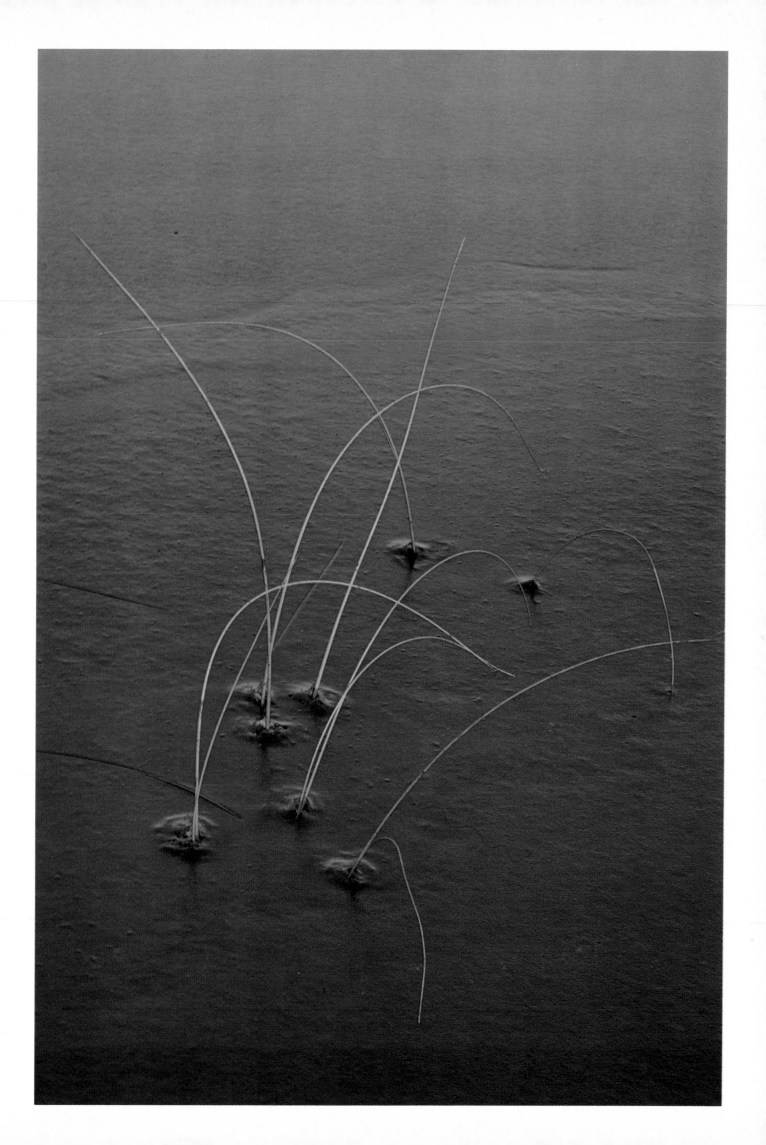

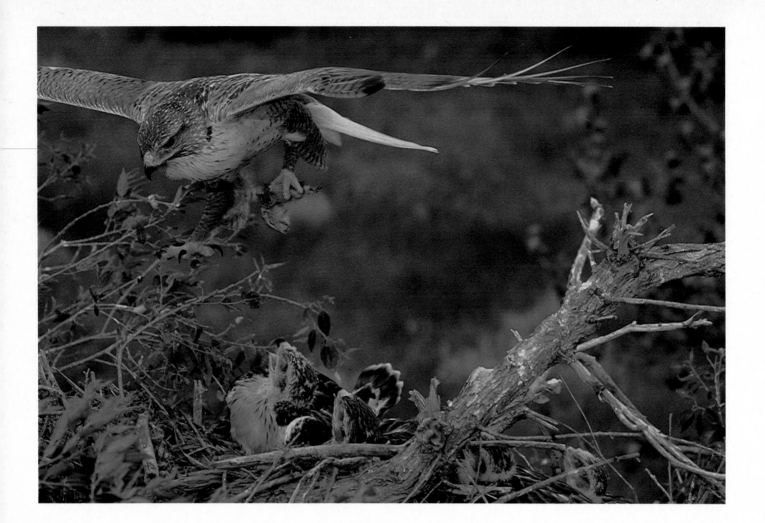

Raptors, birds of prey, have been Samuel Tripp's specialty for fifteen years. Typical of his work with these fierce creatures is his great horned owl, caught in a classic winged-victory attitude as it carries a mouse to its offspring (opposite); and his ferruginous hawk, streaking into its nest with the head of a Columbian ground squirrel brought from a cache (above).

Working with nesting hawks and owls in the region around his Medicine Hat, Alberta, home, Tripp waits until the young have hatched before he attempts to take pictures. This avoids the risk of frightening the adults into deserting the nest. With steel-tube scaffolding—the kind used in the construction industry—he constructs a tower with a nest-level platform for his blind. He works with two 2¼ x 2¼-inch cameras. One, with a 500mm lens, he takes into the blind. The other—with which he made these pictures—is equipped with a 250mm lens and, fixed outside the blind, is operated remotely and electronically with a push-button switch.

To illuminate his owls at night, Tripp uses two electronic flash heads fixed high and to one side of his scaffolding. A third flash mounted on the camera provides half as much light to fill in the shadows cast by the tandem pair. A battery lantern switched on the nest allows him to see the action, which requires split-second timing to capture. "The lantern doesn't bother the birds at all," he says. "They are only too happy to have extra light."

When he is photographing during daylight, as was the case with the ferruginous hawk, Tripp positions his blind so that the sun is behind him. He still uses the fill flash on his camera since the sun has a tendency to disappear behind a cloud at the wrong moment.

Tripp is so dedicated to his specialty that it influences the kind of car he buys; it has to be a station wagon with a roll-down rear window. With someone else doing the driving, he can lie in the back and photograph birds he might spot perched beside the road.

W. SAMUEL TRIPP

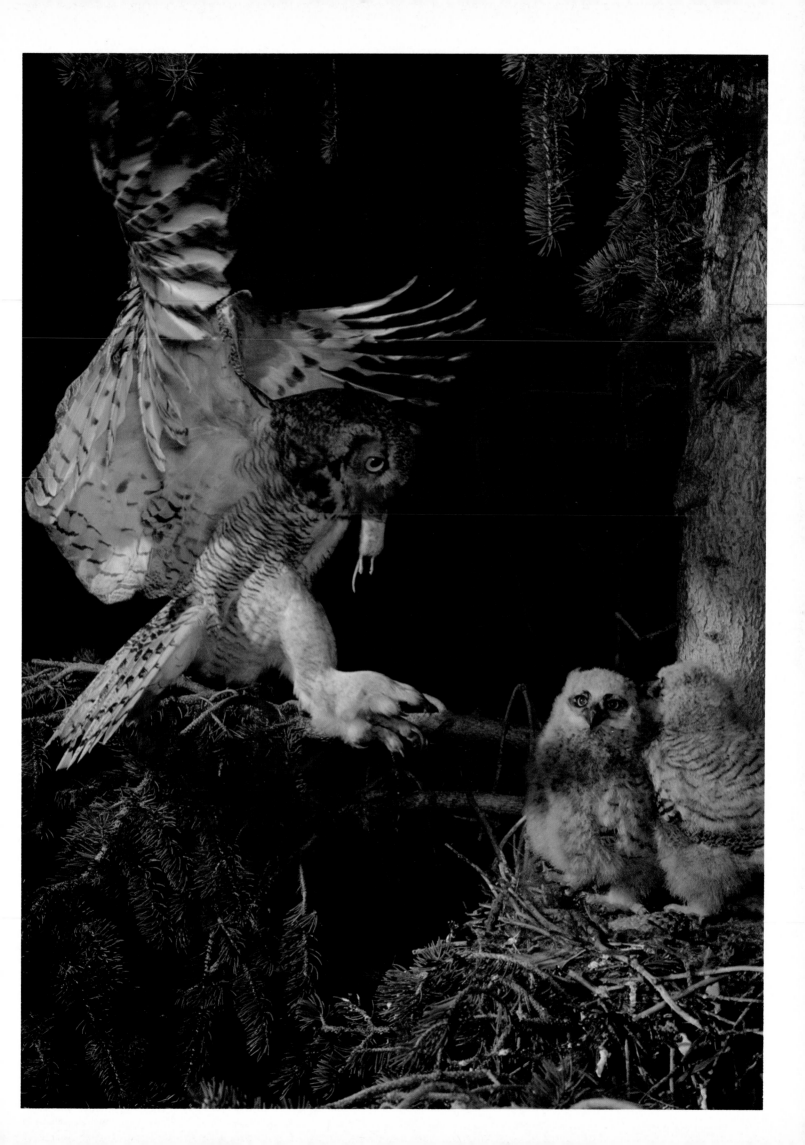

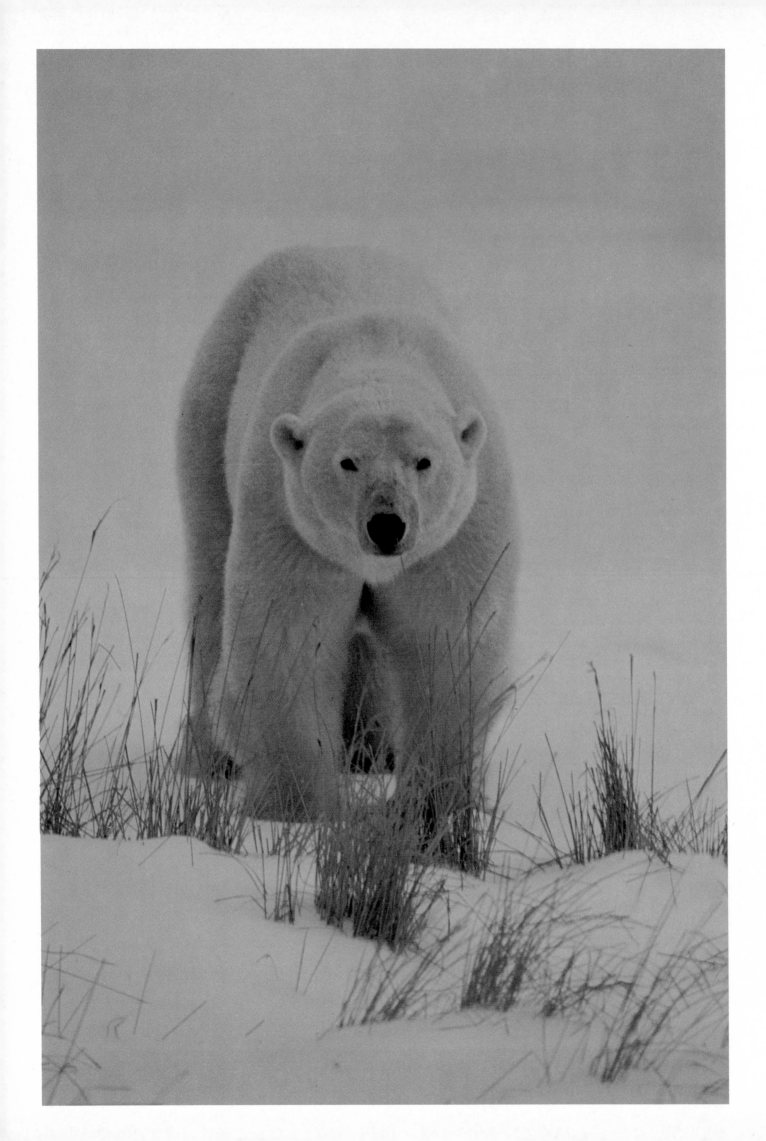

In the Arctic, where the polar bear lives, there are no trees. For the photographer who gets near one of the regal beasts, that is a sobering consideration. Fred Bruemmer has been as close as ten meters to one of the white bears, with no shelter to run to and armed with only a camera and his considerable knowledge of wildlife. "It's a question of judgment," he says. "Is he dangerous or isn't he dangerous? If you miscalculate, you are strictly out of luck.

"They are big, powerful animals with a great deal of individuality. Maybe ninety-five per cent are amiable and quite peaceful most of the time. And then you get the odd one, the cranky bear, who is a very hungry bear perhaps, who will attack. And if he does attack, there is absolutely nothing you can do. You are facing an animal that is quite capable of killing a three-hundred-kilogram bearded seal with one blow of its paw, and that certainly would have no trouble dealing with you or me."

The three-hundred-kilogram male in his photograph (opposite) was a friendly bear. "You can immediately tell by its whole attitude; the ears are out, the stance is low, but not too low," explains Bruemmer. "He was a very amiable bear, well fed, who wouldn't have done anybody any harm.

The bear, taken with a 135mm lens from a tracked vehicle, was one of dozens which Bruemmer photographed one year at and around Cape Churchill on Hudson Bay in October and the beginning of November.

For his photo of an all-male group of walruses resting on a rock ledge submerged at high tide (page 38), Bruemmer wore hip waders and joined the animals. "Before I did that, I asked quite a number of people what they thought," he says. "Even the top experts were divided. Some felt the walruses would attack me, others said they would flee." The opinions averaged out: the animals did neither. For a while, they were merely curious, though eventually fear and suspicion took over and they moved off.

This group, photographed with a

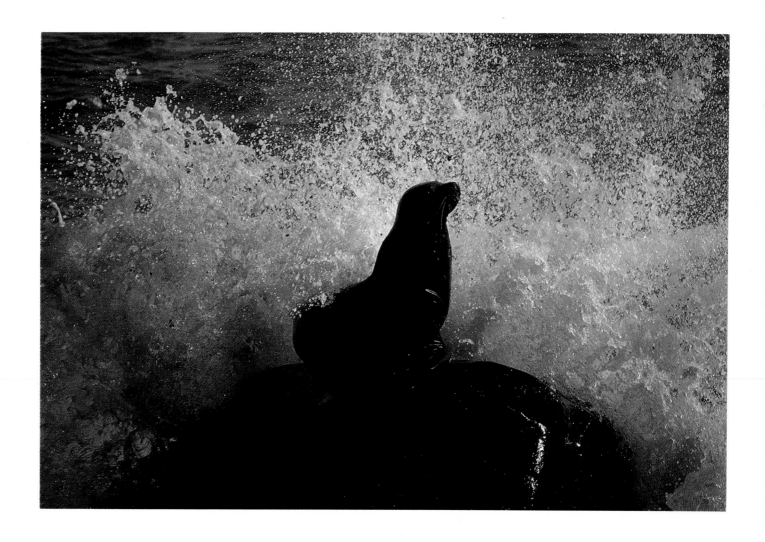

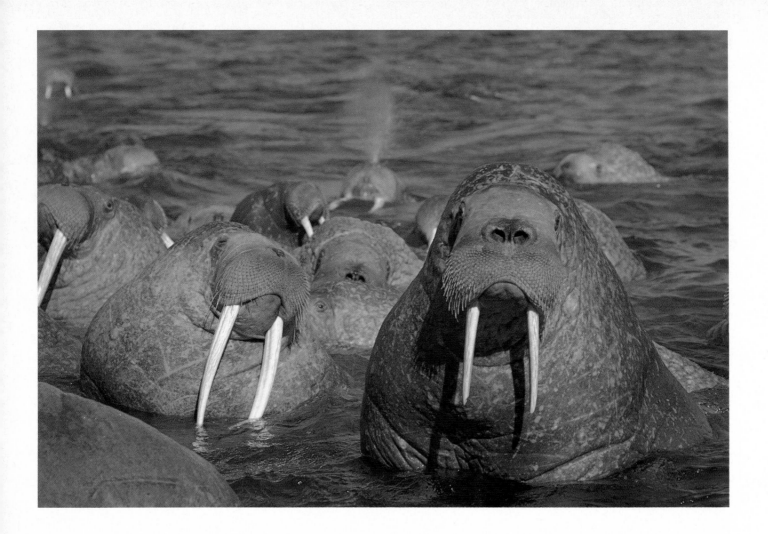

135mm lens, has been out of the water for some time, as is evident from their brick-red colour; when the animals have spent an extended period in the cold sea, their skin becomes a dark grey-brown, as a result of reduced blood supply. The geyser in the background is from a walrus blowing his nose just at the water surface.

Bruemmer hid behind a rock and used a 200mm lens to photograph the Steller's sea lion, revelling in exploding waves on a remote west coast island (page 37). This young male, weighing about three hundred kilograms, displays the inclination of this sociable species for hauling out on rocks exposed to battering surf. Bruemmer has often been amused to watch the animals compete for such a coveted position, pushing each other off.

The trio of Atlantic puffins (opposite) belongs to the large colony which nests on Great Island off the coast of Newfoundland. Bruemmer photographed them with his 200mm lens by simply sitting quietly near certain rocks on which the birds liked to land.

The one with the beakful of neatly arrayed fish has just returned from a long flight out to sea with the meal with which it now will stuff its single young. The obvious question is: how does the bird manage to catch one fish without letting the others go? "It is done with a very strongly serrated tongue," explains Bruemmer, who has counted as many as a dozen fish hanging from one bill. "The puffin pinches the fish with this tongue while it grabs for the next one."

Few photographers have spent as much time in isolation as has Bruemmer. Twenty years ago, he began his career by taking trips to the Arctic that lasted more than six months, and during which the only other people he saw were Inuit. His work with sea animals has regularly taken him—usually alone—to the most inaccessible islands off all our three coasts.

With the nearest camera repair shop perhaps several thousand miles away, he takes certain precautions with his equipment. He has three 35mm cameras, one of which he tries to leave

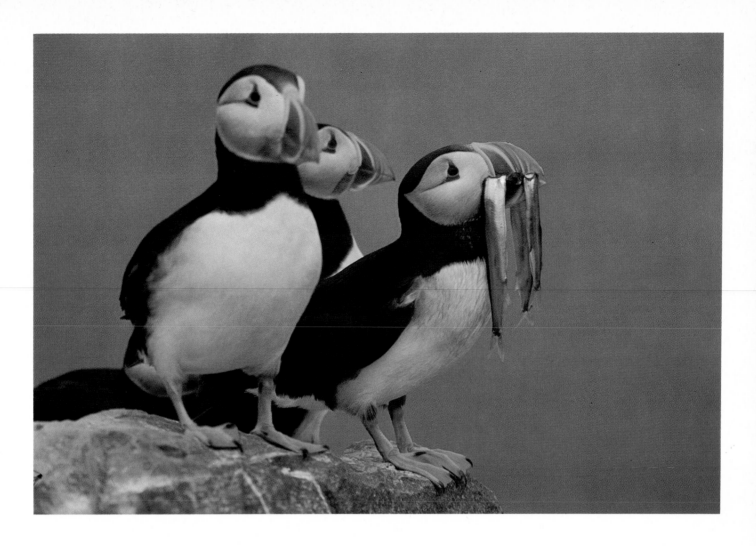

FRED BRUEMMER

as a spare with someone in his vicinity. He brings along two selenium-cell light meters (which function on the energy provided by ambient light). He does not use motor drives. "When I am away for as much as seven months at a stretch, the last thing I need is anything that runs on batteries," he points out.

He has photographed in the harshest of environments. In temperatures so low that open sea water—already well below 0°C —actually steamed, Bruemmer has frozen his cheeks and his fingertips black while operating his metal cameras. In such brittle cold, perforated 35mm film is very readily torn, and he usually carries a 2¼ x 2¼-inch camera which, using paper-backed roll film, avoids this problem. The larger controls of this camera are also easier to handle with gloved hands. To make certain his cameras function properly, he has them left unoiled after their yearly cleaning and maintenance. This does not much increase the wear on his equipment, but it does ensure that certain mechanisms will not become stiff in the cold.

One of his biggest problems is the bleak weather that prevails in the parts of the country he specializes in. "If you average one good shooting day a week, you are doing well," he says. Most photographers would find such a situation unbearably frustrating, but it doesn't disturb Bruemmer.

"Photography is just one part of what I am doing," he explains. "About twenty per cent of my effort is in picture taking and eighty per cent in observation and taking notes. I have stacks of notebooks which are very detailed, because I am more of a biologist than a photographer. I like to observe animals, and to study animal behaviour."

From his first-hand experience, Fred Bruemmer has written as well as illustrated seven books and some six hundred magazine articles. Perhaps more than any other person, he has illuminated the richness of the land and the life in the furthermost reaches of this country.

Photography and the outdoors are inseparable for Lorne Coulson and his wife. When they go on one of their extended canoe trips, along comes a big foam-padded aluminum case full of camera gear that goes into a backpack all its own. "You feel like a fool when you pull out this fancy case in the wilderness, and it means an extra trip at portages, but we've never been sorry," he says.

Despite trips to the ocean and to the mountains, they most enjoy their own native Manitoba, which, they have found, has as much to offer as any region, both in diversity and in spectacle. This illustration of Manitoba's tremendous natural heritage is from the Oak Hammock Marsh Wildlife Management Area, one of the greatest bird staging areas on the continent. During fall and spring migration, more than two hundred thousand geese and eighty thousand ducks descend on the marsh and the surrounding lure crops maintained by the government.

With his 400mm lens on a tripod, Coulson took the photograph by slowly approaching the mixed flock of Canada geese and snow geese a few steps at a time, and then waiting for the birds to burst into flight. The top portion of the picture by itself is marvelous as a fluid abstract pattern.

Coulson, who teaches photography, feels that a photographer's skills are developed over a lifetime, and gets particularly impatient with people who feel they have acquired some superior talent with the recent purchase of an expensive camera. "It is a craft," he says "and it takes fundamentals—and time."

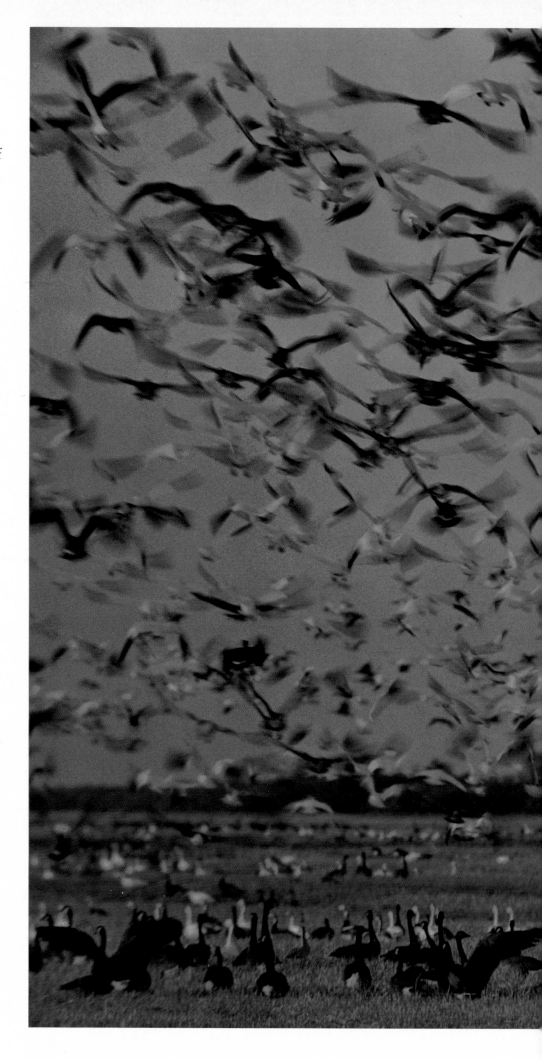

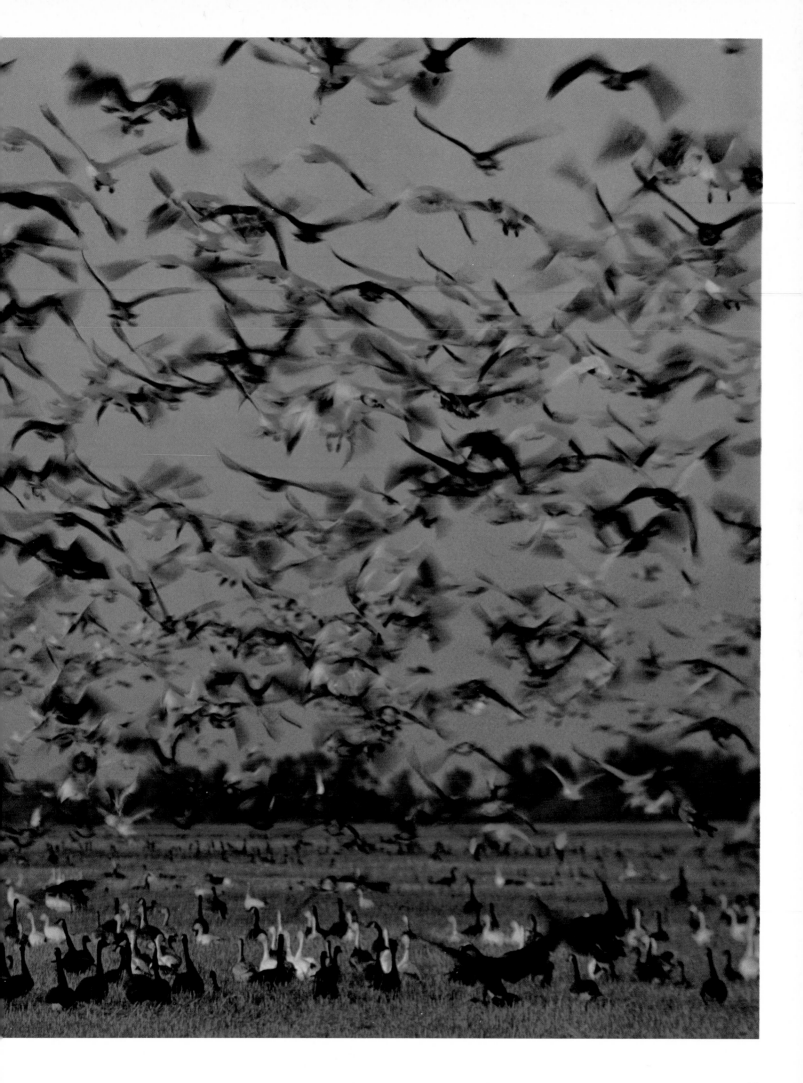

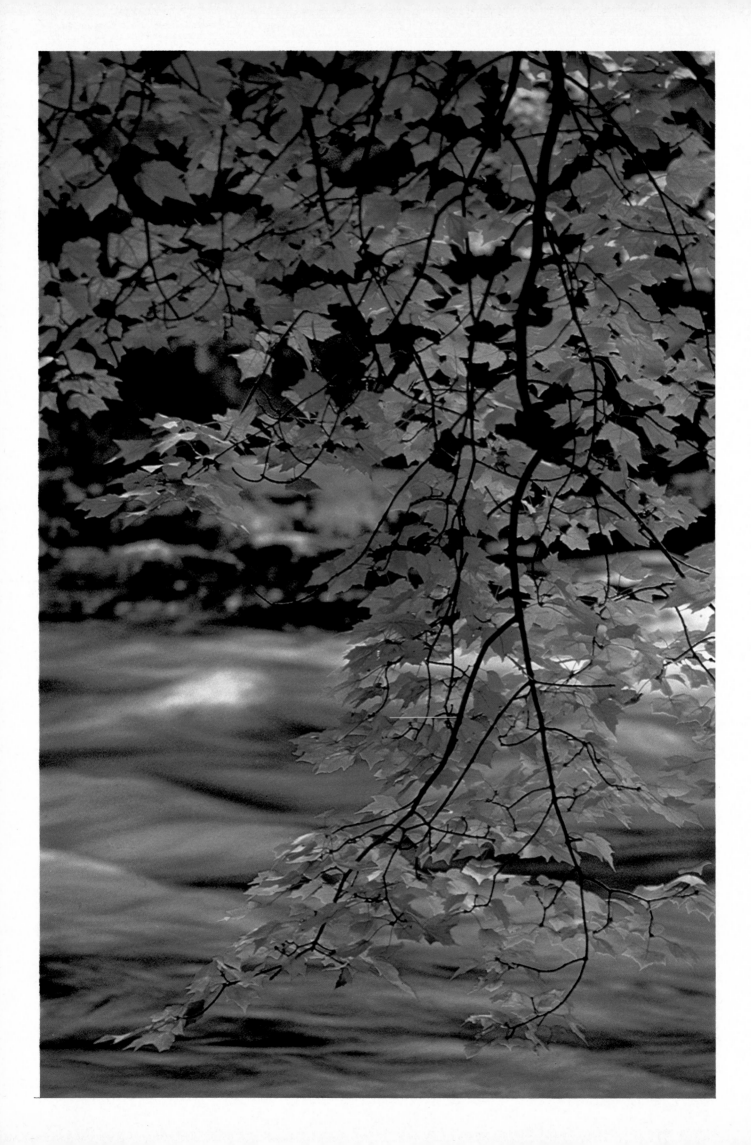

MARY E. ABBOTT

Once a year, the flame latent in the maple leaf brings scarlet glory to the country. Mary Abbott's quintessentially Canadian scene (opposite), resplendent with the foliage which has inspired flags and anthems, was photographed in the Muskoka region of Ontario.

"It is a land of myriads of lakes, large and small," she notes. "There are vast swamps and ranges of hills forested with maple, oak, spruce, pine, and hemlock. Turbulent rivers pour over massive rocks on their courses through the woods."

The dome of an overcast sky provided uniform illumination for the vivid colours, which she found along the banks of the Oxtongue River at the end of September. Abbott had to wait patiently for the breeze to stop and for the branches to become still so that—with her camera and 80-200mm zoom lens on a tripod—she could use the slow shutter speed of 1/8 of a second which gave the silky effect of smooth motion to the rapids.

For her photograph of a cardinal, perched in her London, Ontario,

backyard (below), she used a 200mm lens with a 2x teleconverter. Because of the relatively small maximum aperture of this combination and the dim light, a high speed film, Ektachrome 400, proved useful. Elegantly suited in its red tunic, the male bird was too distracted by the first snowfall of the year to notice Abbott, as she quietly opened the back door of her home to take the picture.

"This exotic species, once primarily a southern bird, has been gradually extending its range northward," she writes. "The first cardinal ever reported in London was in 1896. As was the custom then, the bird was 'taken', or shot. One was recorded in the winter of 1910. By 1930, cardinals had become quite numerous and were considered permanent residents."

Hers is a rare picture which provokes an immediate empathy; we can all identify with the resigned bird, who must live with both the peace and the harshness which winter brings.

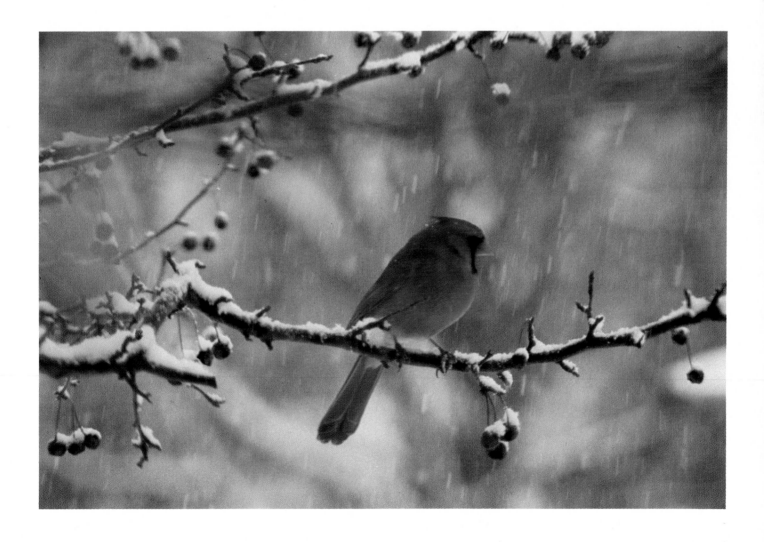

"It looks as if someone has thrown a handful of pearls into the blue," says Paul Guyot. "In the spring, first the honkers come, flock after flock. And then, after the honkers, we start seeing the snow geese. When I hear them, I run out like an excited kid. I can never overcome that feeling. To me, they are the true spirits of the north."

For the formation of the phantom-like white geese (below), migrating over his Winnipeg home in April, Guyot used a polarizing filter over his 105mm lens to increase the contrast between the flock and the sky. His camera was handy, as usual, in a quickly accessible place. "That camera is *always* loaded; the minute I take a film out, another one goes in," he emphasizes.

"If you must make a distinction between the professional and the average amateur, it would be this: when you hear someone say, 'Boy, I wish I had had a camera, what a shot I would have gotten!'—that's an amateur. A professional is prepared, always prepared."

Guyot's experience as a CBC cameraman has taught him to maintain a constant readiness that includes taking light meter readings even when he doesn't intend to use the camera. This habit of preparedness is with him when he goes on one of the long wilderness canoe trips that he loves. Around camp, his camera is left set up on a tripod, ready immediately should he need it. That kind of anticipation allowed him to catch the view of Solitude Lake (opposite), brushed by a fleeting interval of storm light.

Guyot, who has been on vacations where he paddled from morning until night, now prefers to spend the time getting familiar with one place in greater detail. "So many people go by an area and they see nothing," he says.

PAUL GUYOT

"How can you just punch a line through a lake and say, 'Oh, I know that lake'? You don't know that lake at all! You've got to see it early in the morning and at noon; you've got to see it through a storm; you've got to see it at night; you've got to see it when it's windy, dull, and bright, and from all angles."

He describes the lake in northern Ontario near the Manitoba border that he and his wife came to know: "I found it on a map. It had no name, so we baptized it Solitude because there was absolutely no one on it. It would take four days to paddle there, but we were flown in because we wanted to explore the lake. It had more than eighty islands on it, though it was only fifteen kilometers long by three kilometers across at its widest. There were small islands made of granite. There were islands with twisted pine trees clinging to the shore. There were big islands with stoney ridges and open spruce woods carpeted with moss, beautiful green moss. We walked so quietly in there.

"The north end was very shallow, because amongst the islands were huge pads of water lilies. I had never seen so many water lilies! We camped at the south end, where it was deeper, and stayed for two weeks. We caught lake trout for supper. We saw a woodland caribou swim right by our camp. We saw the most amazing sunsets.

"One afternoon, a vicious storm came through. It stopped raining and the thunder was still rumbling in the east after suppertime when the sun burst through and flushed the land-scape with that warm yellow evening light. I think it is just the greatest light. But it was a matter of—you turn around and there it is—and then it was gone." However, not before Guyot, with a 28mm lens, had preserved the magic moment.

"To me," he adds "photography is a passion."

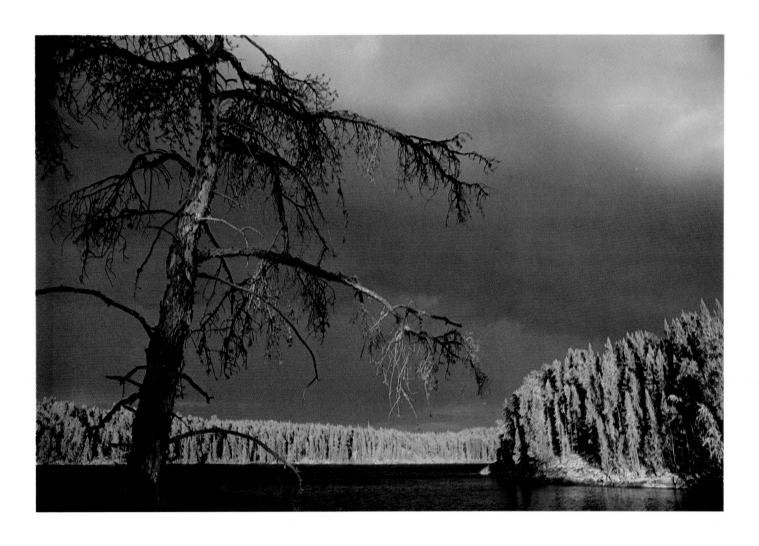

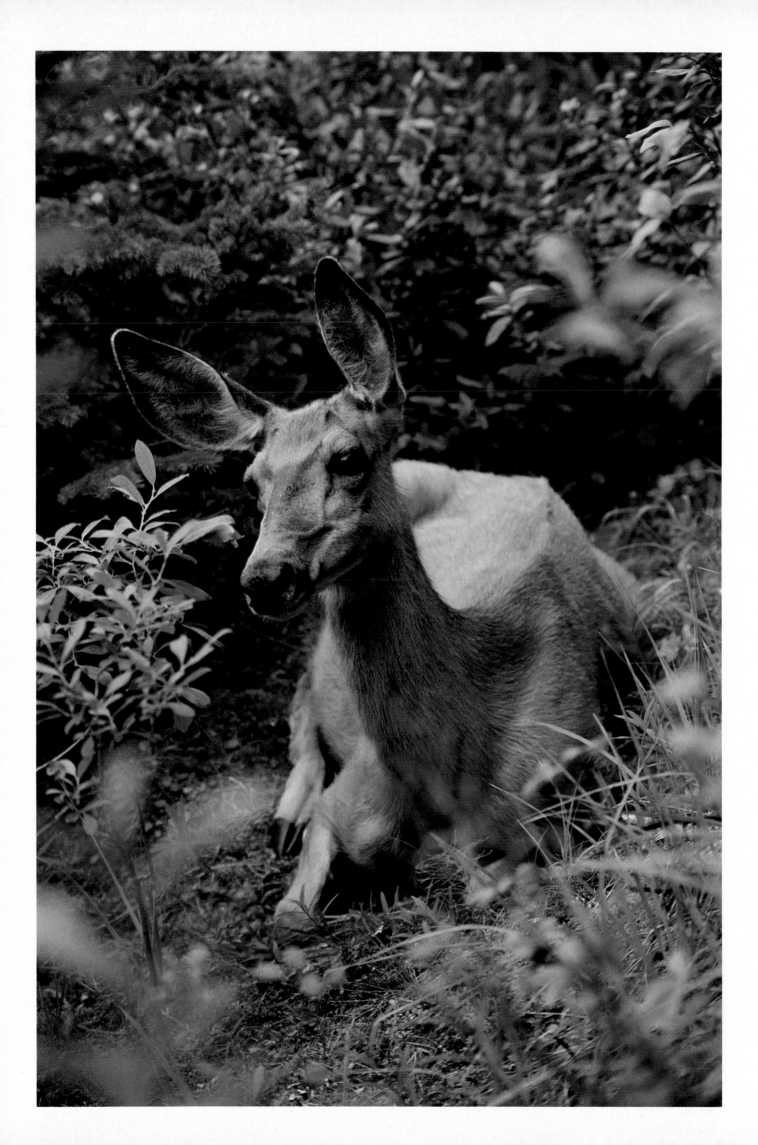

It is peripheral vision that often hooks the prize photographs. Out of the corner of his eye, Wayne Lankinen spotted a mule deer on a wooded hillside while driving through Banff National Park. Armed with his camera and an 80-200mm zoom lens, he climbed after the doe, half expecting it to disappear from sight in a couple of bouncing leaps. It didn't, allowing him to follow it around and even bedding down at one point, showing off the great ears for which its species is named (opposite).

"Wildlife photography depends very much on the mood of the individual animal," says Lankinen, who once spent a good part of a day running around trees to get away from an annoyed moose he was trying to photograph.

Vancouver's Stanley Park recalls for him another lesson in animal relations. The birds in the park had been oblivious to joggers and screaming children on bicycles, but when Lankinen casually strolled up to a pond, carrying his tripod under his arm with the legs extended straight forward, the tranquil waters erupted. "Everything flew away to the other side of the lake—they thought it was a shotgun!" he says, still astounded at the recollection.

When calm was restored, he used his 400mm lens to capture the male wood duck in fall plumage, corraled among lily pads (below).

Lankinen's ever alert eye caught sight of a circling hawk while he was driving near his northern Ontario home. He watched the bird until he had discovered its nest, twenty meters up in a tree, and then made plans to build a platform for his blind in an adjacent poplar. When he got halfway up the poplar, using climbing spurs purchased for such a purpose, a flying squirrel shot out of a hole in the trunk—the tree was hollow. Lankinen, who earns much of his income from logging and well knows the crash a falling tree makes, paused for a long time. Then, fatalistically, he proceeded to build his platform. The first day he spent in his blind the wind began to blow and the tree started shaking while

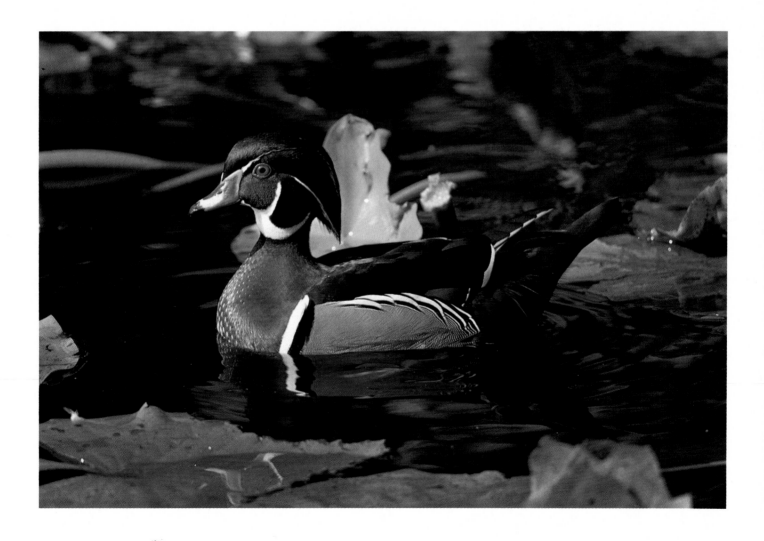

he pondered what extra stress his platform might have put on the tree. On another day, he worried he might have to kick a black bear out of his perch when it arrived and began to inspect the tree. Contending with lighting that, on account of heavy foliage, cast undesirable shadows and was acceptably uniform only a fraction of the time, Lankinen made the photo of the red-tailed hawk and its squirrel prey (below) with his 400mm lens.

The photograph of a female evening grosbeak (opposite), beautiful for its soft-focus background of another grosbeak in flight, was made in April near his home, again with the 400mm lens. Lankinen used a portable blind of his own design. Made from fibreglass wands and nylon cloth, it is so compact it fits into his vest pocket and he is able to take it with him wherever he goes.

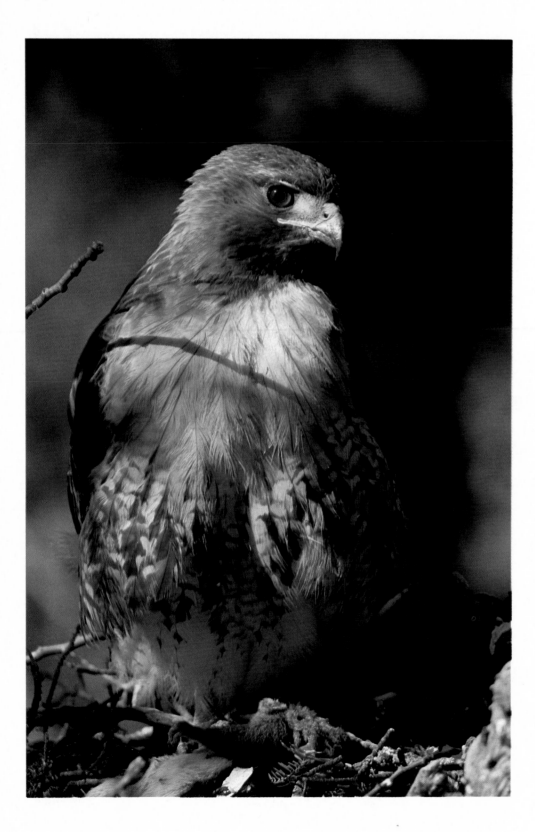

WAYNE LANKINEN

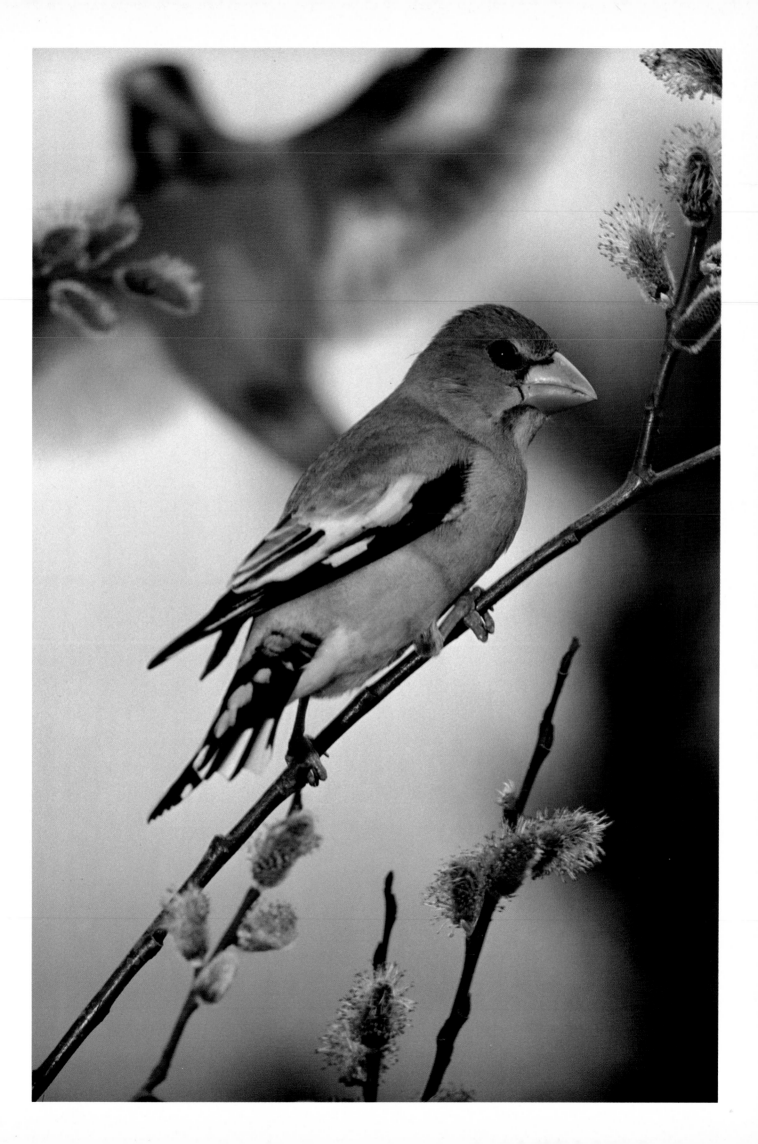

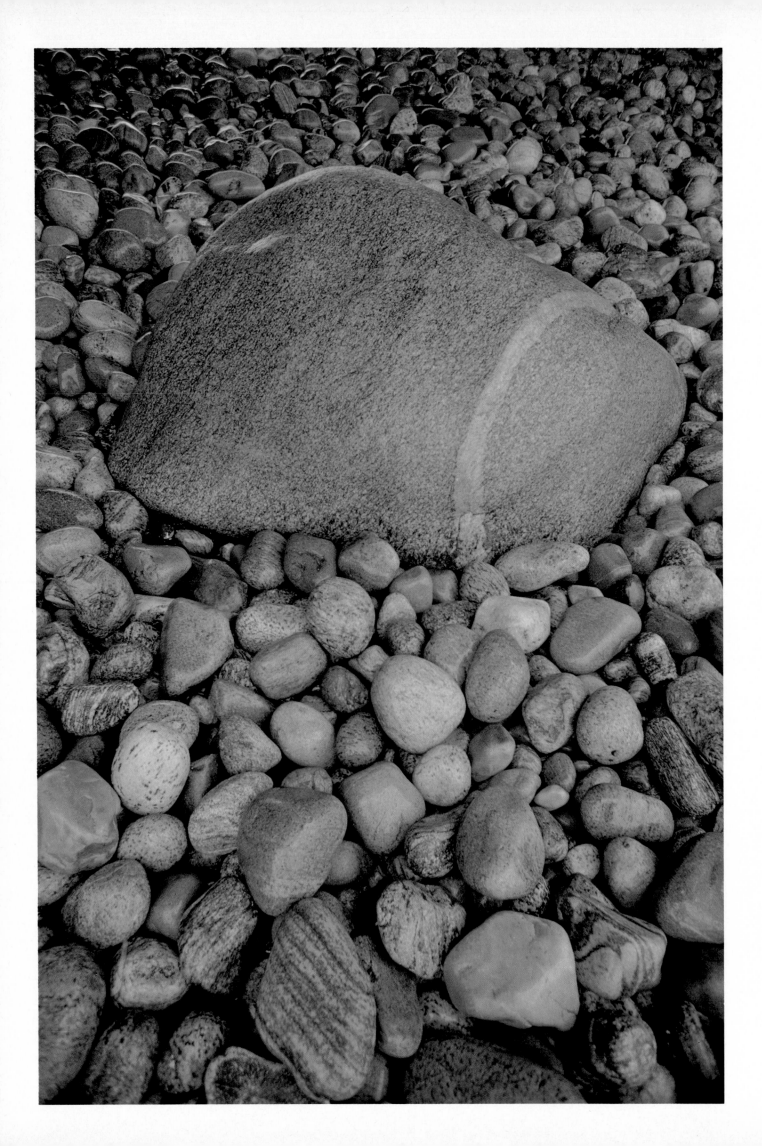

When he isn't making photographs on assignment for an impatient commercial client, John de Visser relentlessly makes photographs for himself. "I just like taking pictures, and I don't really want to do anything else," he explains.

"Usually it's a pretty fast process. Over the years I have gotten so used to working to a deadline that it has become a built-in go-go-go type of thing."

Sometimes he regrets not having a bit more time to work with a subject. "Once I had but a single day in which to photograph the Mackenzie River," he complains. "Another time, a magazine wanted me to cover the Kootenays in British Columbia within two days. That's an area bigger than Switzerland! It gets maddening, it really does."

His schedule may demand methods of summary execution, rather than of carefully considered trial, but as one of the most respected photographers in the country, he is running proof that a photo cannot be judged by the time it took to make it. With an efficiency earned through experience, he is remarkably perceptive as well as prolific.

His study of a rock and pebbles (opposite) was made in Newfoundland. Strolling along the beach on the Great Northern Peninsula, photographing sea arches that had been chiseled by the waves, he noticed the polished rock, which to him resembled an Eskimo animal carving. Breaking surf kept the mosaic wet and brought out the shiny colours.

"It's a matter of keeping your eyes open—constantly—and looking for things that may make a photograph, whatever they may be," he advises. Even dirty snow can be a thing of beauty (below), discovered by his selective eye. The coffee-hued monochrome was revealed by spring thaw in the Humber Arm region of Newfoundland.

A woodlot near Midland, Ontario, provided the view of beech leaves from below, their luminous green intensified by back-light (page 52). With a 20mm wide-angle lens, de Visser contrasted the freshly budded verdure against the

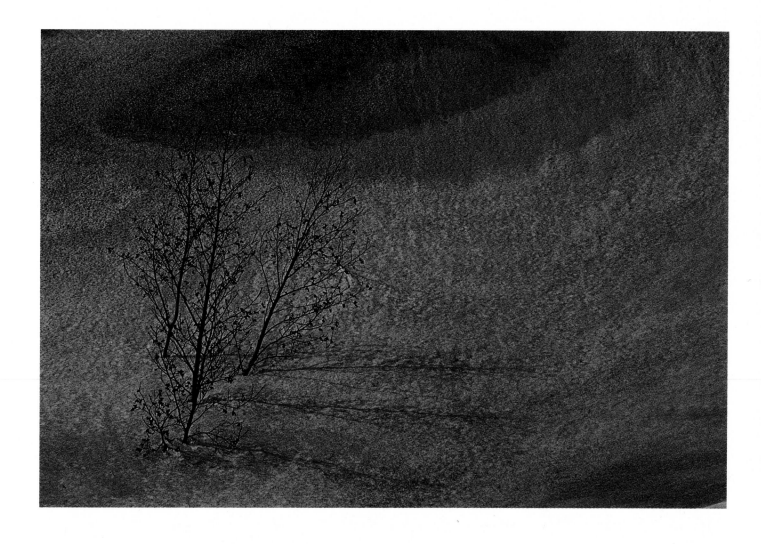

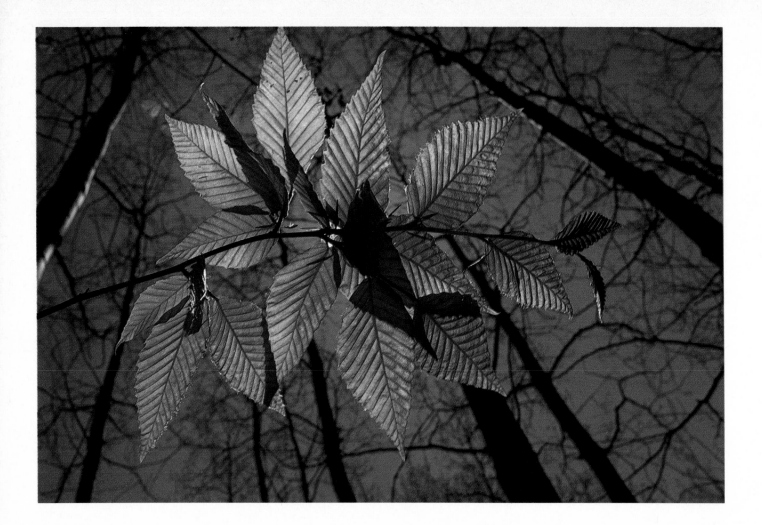

stark converging outlines of still bare trees. "I often get requests for pictures that depict spring," he remarks. "They are not that easy, because—what is spring?"

Some of de Visser's photos have occasionally been compared in mood and spirit to Group of Seven landscapes. Indeed, there is a semblance to a Tom Thompson painting in his rendering of a conifer in Vancouver's Stanley Park (opposite). But, although he likes the Group's work, he denies any conscious intention or desire to emulate them. "In the Canadian landscape, what the Group did is so representative and typical, that if you are out there taking pictures, you can't help but take a certain number of scenes that are like what they painted," he says.

In the course of his own work, de Visser gets to see the Canadian landscape from one sea to the other several times a year. On the go, he tries to limit the equipment he takes to "as little as possible". Like most photographers, he doesn't make notes about his photos, and could only guess at what lenses he might have used for most of his pictures.

As for a tripod, he seldom uses it. "Not often enough, I'm too lazy," he claims, but in fact the reason is that he is too busy. Not counting scores of articles in magazines and company publications, de Visser has illustrated eight of his own books and substantial parts of more than a hundred and fifty others. That's not a bad record for a man who got his start in photography "purely by accident, more through good salesmanship on the part of a guy in a camera store than anything else."

JOHN DE VISSER

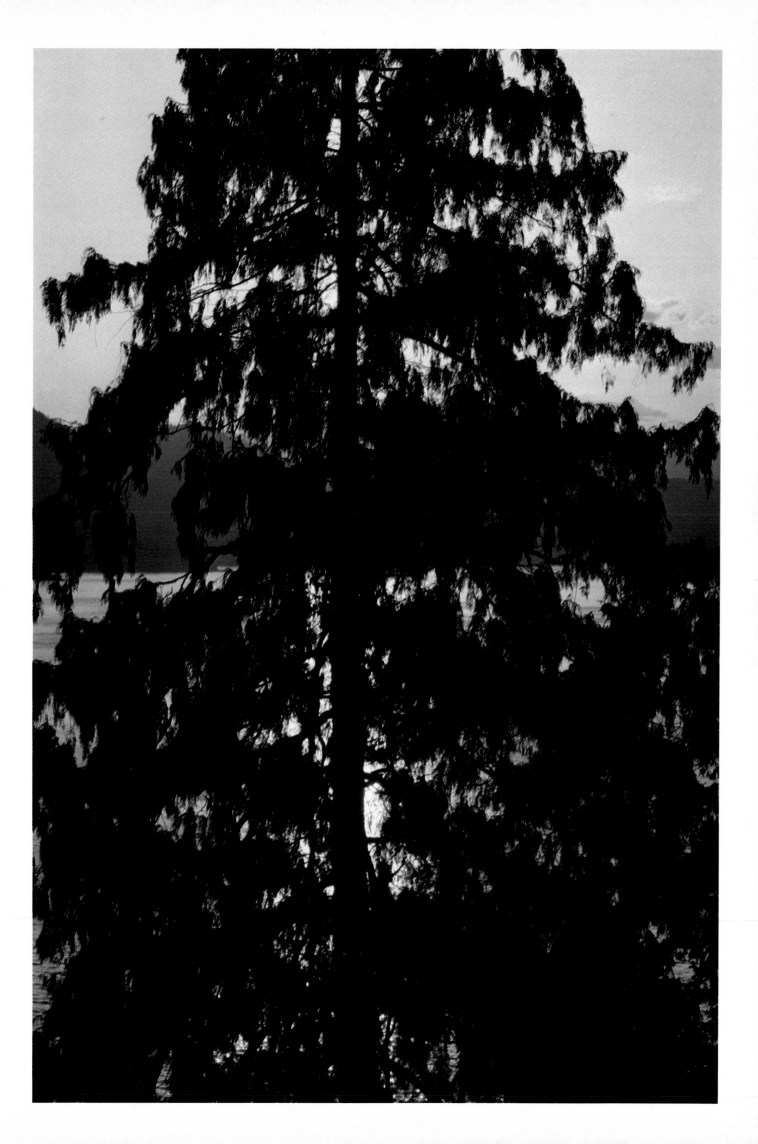

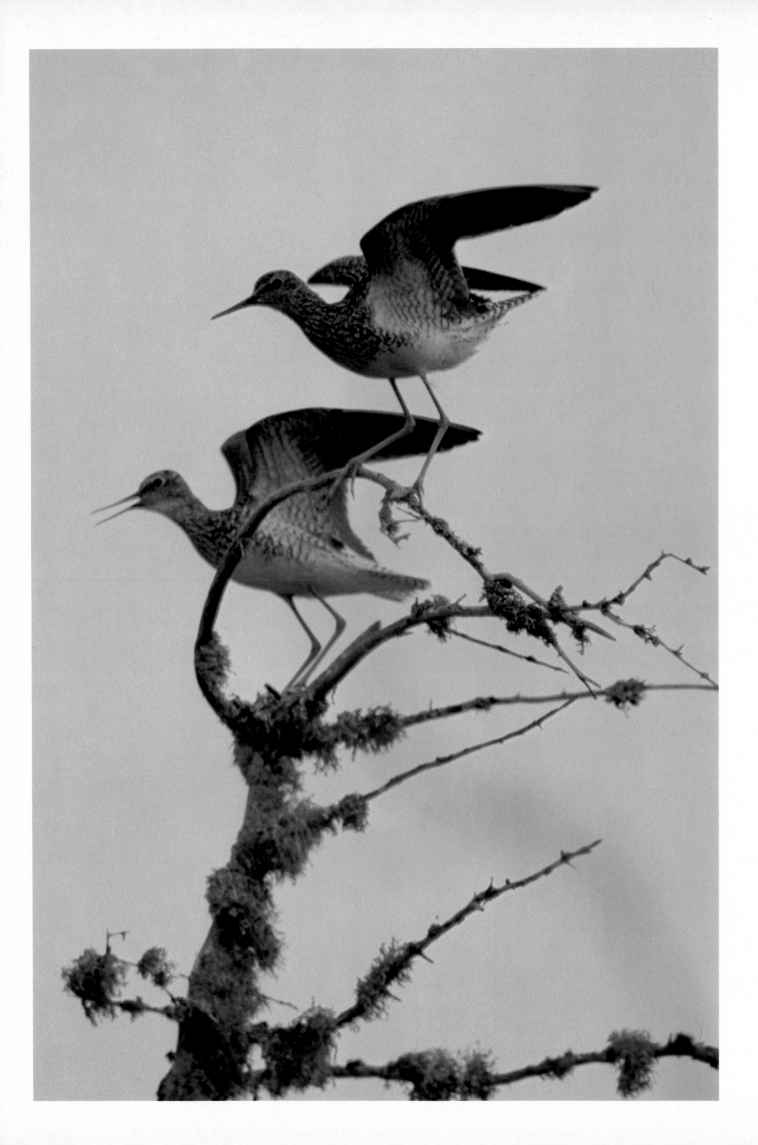

With elegant shapes gracefully balanced on a featureless background, Vince Claerhout's photographs of a mating pair of lesser yellowlegs (opposite) and of white-bark pines in silhouette with a mule deer (below) have the quality of repose and idealized beauty of oriental drawings.

The yellowlegs were photographed at tree line near Churchill, Manitoba, in July with a 500mm lens on a 2¼ x 2¼-inch format camera. Their stunted, moss-adorned perch put them within close reach of Claerhout, who was on a naturalists' excursion to the area. Tremendous hosts of blackflies and temperatures that dropped from about 20°C to below freezing within hours were among the things he had to contend with on the trip, he remembers.

The wind-forged pine pair, whose photogenic attributes Claerhout has profitted from many times, is on his property near Pincher Creek, Alberta. On this occasion, he worked quickly with a 300mm lens (on a 35mm camera) as several deer browsed by on an early spring day.

A game farm in Nova Scotia, lush after a passing rain, provided the exquisite scene of a white-tailed fawn contemplating mountain ash berries (overleaf), which Claerhout recorded with his 300m lens. He probably spent less time on this image than on any other picture, he admits. Remembering the little effort that went into its making, he doesn't consider this to be one of his favourite photographs. The minute he took to make it contrasts with the six hours he once spent crouched beside a hornets' nest, his unprotected face but twenty centimeters from the opening as he photographed it—slowly and cautiously.

While he was repeating the effort on another occasion, something alarmed the hornets and the entire garrison came charging out as Claerhout beat a hasty retreat. Though insects are actually one of his specialties, he hasn't photographed hornets since.

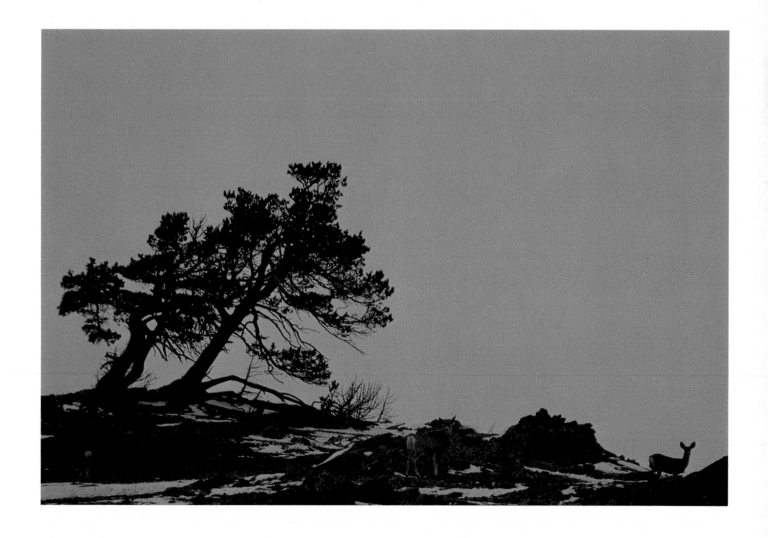

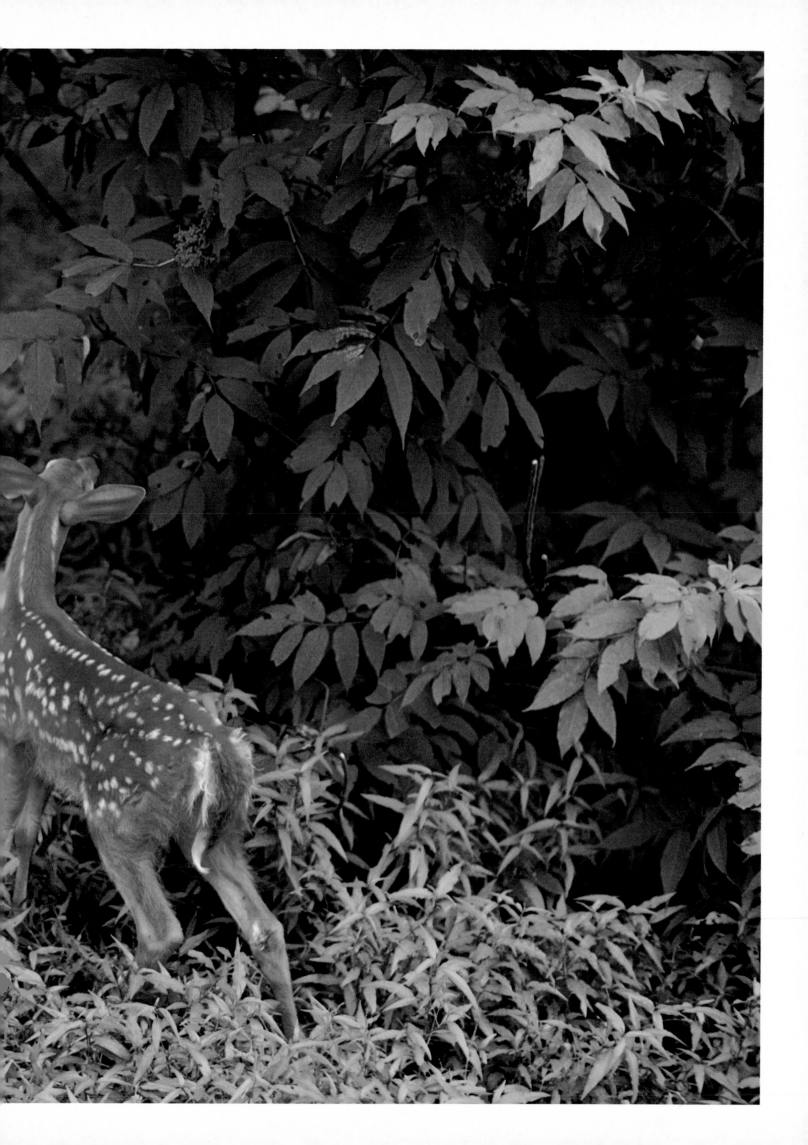

How do you get butterflies to sit still long enough for a close-up portrait? Photographers despairing of the almost futile exercise of chasing them in the wild have frozen, drugged, or simply killed the elusive insects. Mary Ferguson has a better way—she raises them.

In a homemade glass terrarium, she feeds the larvae of moths and butterflies almost daily during the summer months as they grow through numerous caterpillar stages, called instars. Then she keeps them over the winter while they metamorphose through the pupa phase, and finally she watches for the moment when they emerge early the next summer, winged wonders of delicate beauty.

"Immediately after they emerge, they are not very active," she explains. "Their wings are small, shrivelled up tight, and they cling to something stable as fluid is pumped from their bodies into the veins of the gradually expanding wings. Once the wings are fully extended, butterflies will wait for as much as an hour to allow them to harden before fluttering off."

It is during this brief interval, anticipated for almost a year, that Ferguson must act. For bright, even illumination, she prepares two electronic flash heads. One is placed to one side of her subject on a tripod and at a forty-five degree angle to the camera, which is also on a tripod. The other she holds by hand, usually above the subject and toward the opposite side. For the background, she uses a large piece of cardboard, coloured with opaque paint and chalk to look natural, and placed far enough back so as to be unobtrusively out of focus and not to pick up any shadows cast from the flash. She works indoors, having stopped photographing her butterflies outside when they consistently took off under the stimulus of the bright open sky. With everything in complete control, and with models that have not yet had a chance to tear their wings or lose scales, she gets photographs of a quality that would be virtually impossible to achieve in the wild, or, for that matter, with dead or anaesthetized specimens.

MARY FERGUSON

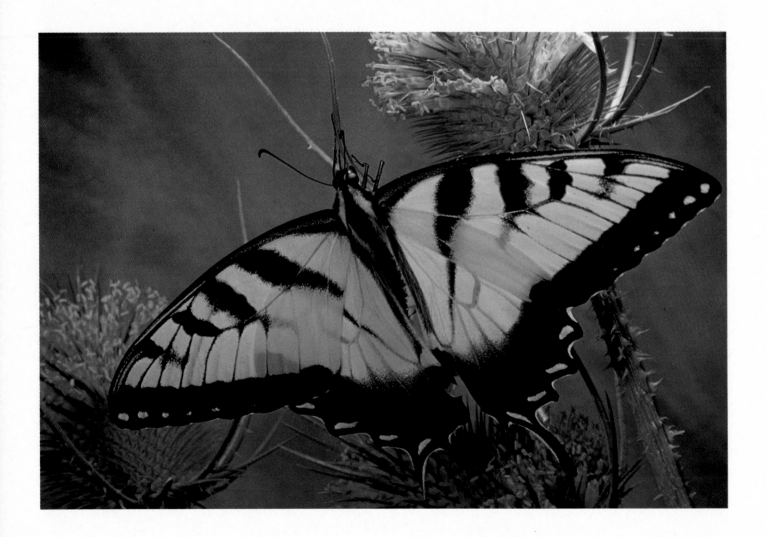

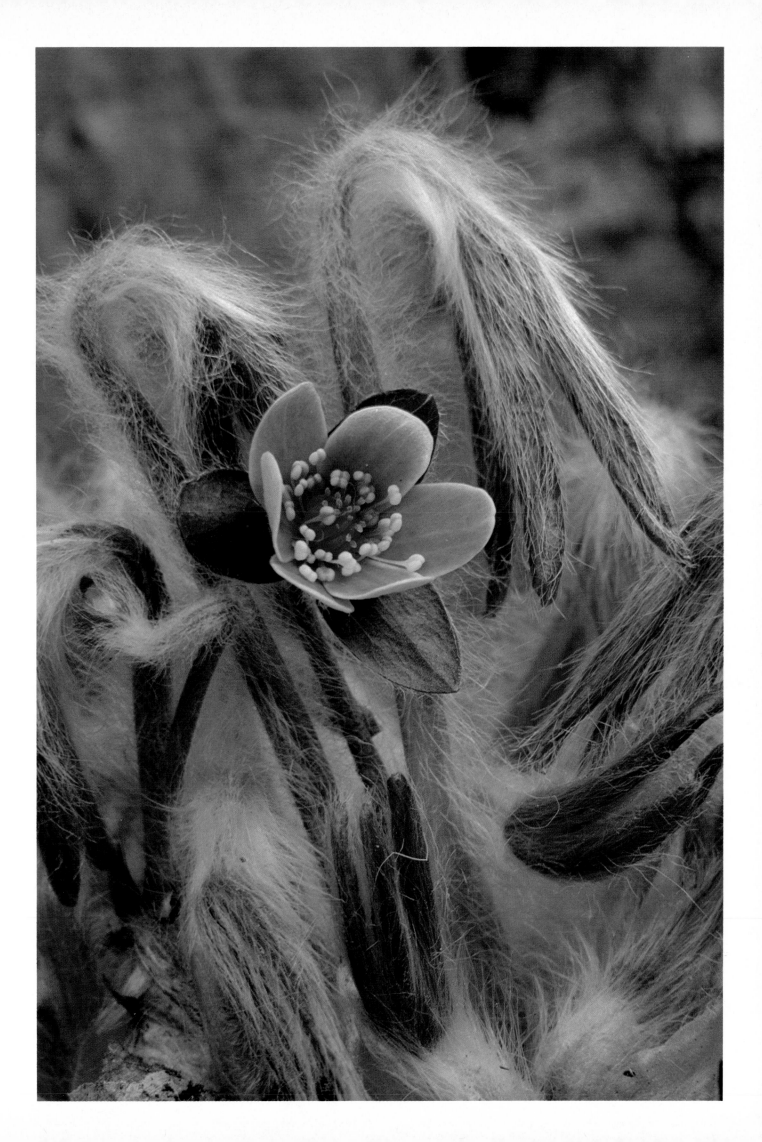

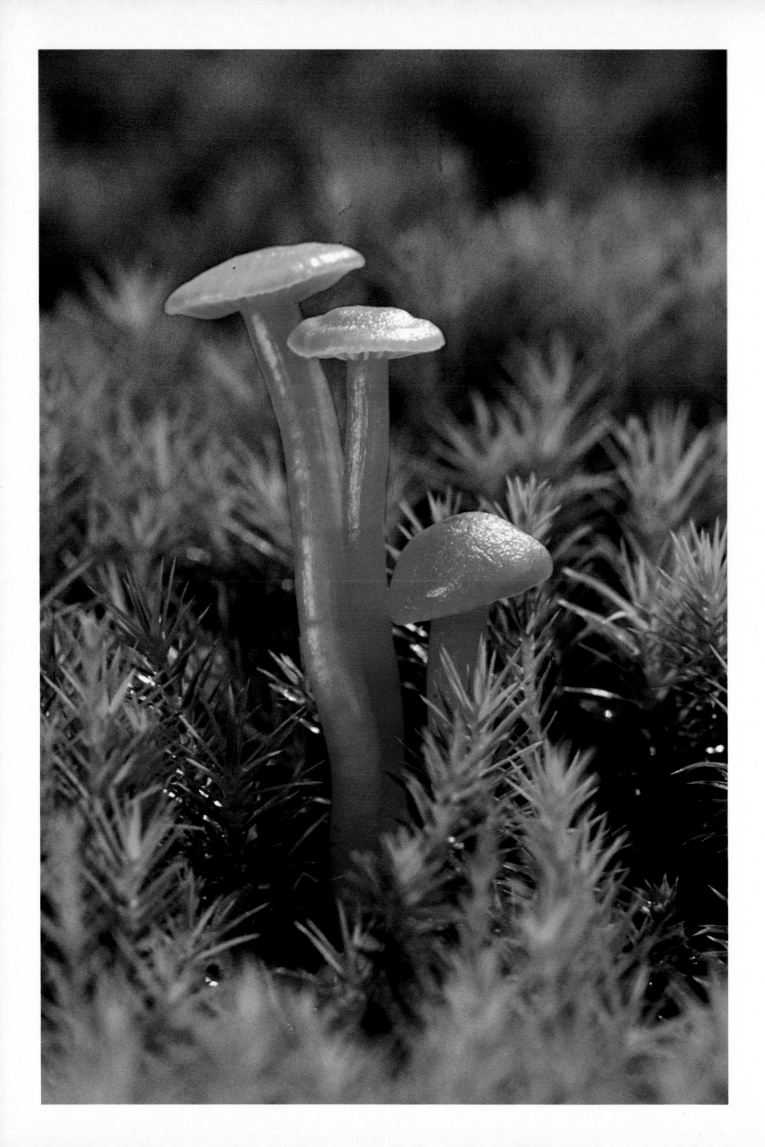

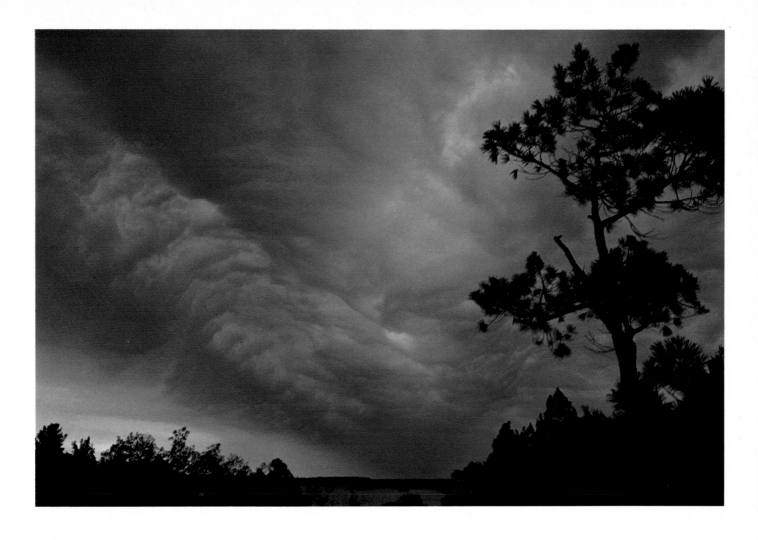

MARY FERGUSON

A magnificent example of the results she achieves is the fresh tiger swallowtail poised on a teasel minutes before its maiden flight (page 58).

In principle, moths are somewhat easier to deal with, she says, since after emerging they do not become active until night. However, photographing the antennae of the Cecropia moth (page 63), the largest in eastern North America, was not so simple. It is the male that sports this impressive head-gear, used for detecting the scent of potential mates as much as a kilometer away, and in her first effort at raising several individuals, she obtained only females.

When she did hatch a male, it proved very exacting to get both antennae entirely in proper focus simultaneously. At the very close distances involved, the camera, equipped with a 105mm short-mount lens on a bellows, had to be precisely aligned with the moth. Once this was achieved, if the moth moved even a couple of millimeters, it would go out of focus. With perseverance, Ferguson

achieved her perfect portrait in her fifth year of working with these unearthly creatures.

The ponderous caterpillar hanging from a wild cherry leaf (page 62) is also a Cecropia—perhaps even the same individual as that on the facing page— in the fifth instar, the last stage before the spinning of its cocoon. While photographing the slow-crawling caterpillars presents few technical problems for Ferguson, keeping them demands constant attention, since they consume vast quantities of leaves. They must make the most of their gluttonous youth; transformed into carefree winged adults, they will have no feeding parts and will die within about a week.

Ferguson began nature photography with wildflowers, which she has sensitively recorded in many parts of the world. The blue hepatica (page 59) represents an exceptional photograph of this species, since the flower usually blooms before the leaves unfold; but in this instance a freak hot spell in May brought out both at the same time. The

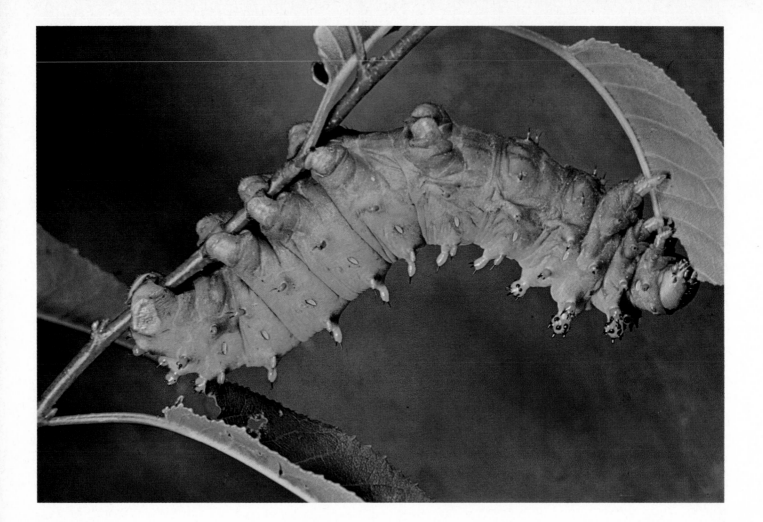

shot was taken on Beausoleil Island in Georgian Bay.

Another one of the some forty thousand islands in the bay is Ferguson's summer retreat, from which she has witnessed many a sudden tempest borne on the west wind that sweeps across the vast Huron waters. The line squall over a storm-stunted white pine (page 61), taken on a 28mm lens, gave her but a couple of minutes of working time as it rolled in, strafing the region with lightning and rain.

Whenever she works in the field, one item that always comes along in her camera bag is a reflector constructed from a hinged frying pan splash guard covered with aluminum foil. To bounce light into the shaded parts of a subject, this can be set up either based on one side in the shape of a triangular prism, or standing on edge like a screen. In the latter position, it can also serve as a wind shield to prevent subjects from being blurred by movement.

For flowers, mushrooms, or other low objects, Ferguson always uses the reflector to provide more even illumination if her subject is side- or back-lit. This was the case for the tiny red *Hygrophorus* (page 60) growing in moss, made with a 100mm macro lens during a sunny day on Beausoleil Island and showing none of the harsh, detracting shadows often obtained with such lighting.

Other items which Ferguson takes along in her camera bag include: a small magnifying glass for finding insect eggs and identifying minute features on plants; red napkins, strips of which serve to mark subjects which she wants to return to after first searching farther afield; a whistle in case she gets lost; a spider-like tripod (no longer manufactured) which folds into a variety of positions and allows her to place her camera close to the ground; and a few hair clips. The last she uses to temporarily pin aside plants that obscure the view of her camera, plants that most photographers would simply uproot or break off. It is with such care and patience that Mary Ferguson has become one of the best in her field.

MARY FERGUSON

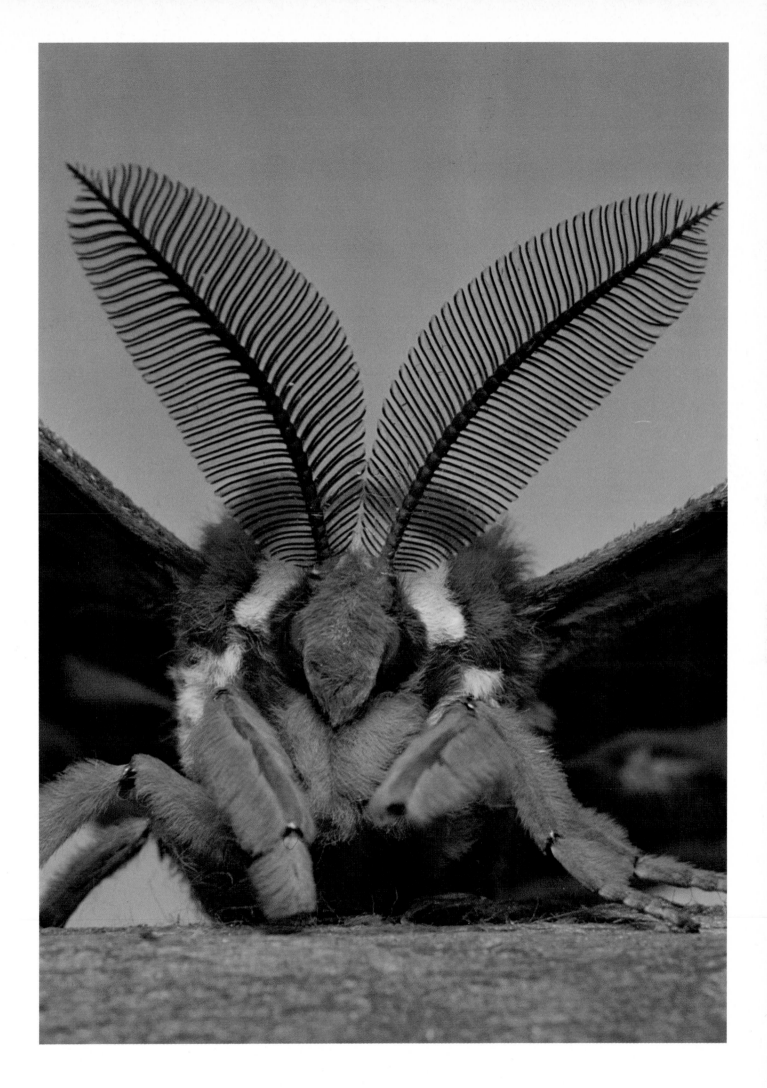

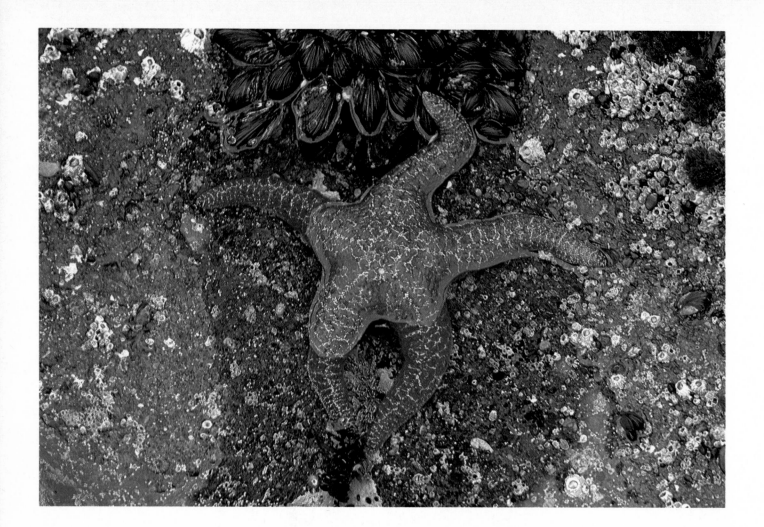

There are two kinds of good photographs. There are the kind that seize hold of our attention and our memory instantly, through strong composition, dramatic light, bold colour, unusual angle, or uncommon subject matter. These are photographs of impact. The next time we see them, the surprise is lost, though they may retain their power to move us. Then there are photographs which do not announce themselves so immediately, but which, upon second viewing, appear more beguiling. The more we look at them, the more compelling they become. Images of this quieter sort constitute the work of Brent Evans.

Evans discovered subdued colour and subtle design in a sea star left stranded by the tide (above), during one of his long leisurely walks, a nine-day backpacking trip along the wild shore of Pacific Rim National Park.

Though the distance can be hiked in half that time, slow was the only way to go as far as he and his photography-minded companions were concerned. Taking plenty of time to look, Evans searched through The Cribs, a formation of parallel rock ridges notable for the richness of its intertidal life. There were many groupings of sea stars, none of which satisfied him, and he finally decided that, in some instances, one is better than two. A polarizing filter on his 100mm lens was instrumental in cutting down surface glare from the band of water surrounding the starfish.

Another backpacking trip found Evans in Kootenay National Park at a spectacular time of year, as autumn brought alpine gold to larch-filled meadows. Turning his attention away from the distracting trees, he caught the early morning sun isolating for only a moment the moraine between Floe Lake and the Rock Wall (opposite).

It is interesting to find the geometric order in his selections from a basically heteromorphous environment. The stellar symmetry of the sea star is

BRENT EVANS

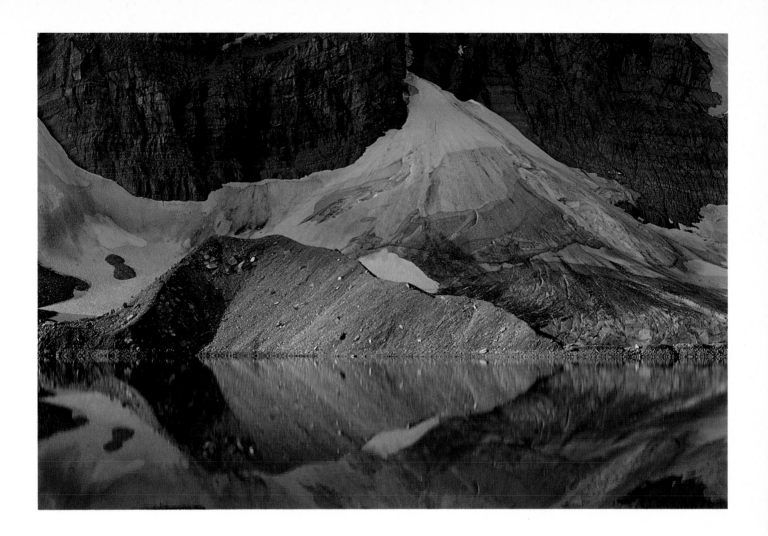

centred in a balanced grouping of rectangles; the Floe Lake picture resolves itself into a series of triangles. Such compositional analysis, however, is more relevant to the appreciation of photographs than it is to the making of them. "I don't consciously think about composition when I take a picture," admits Evans. His images, like those of probably the great majority of photographers, spring from emotional and intuitive reaction, rather than deliberate theorizing.

"Generally," he continues "I can walk right up to a subject that appeals to me, bring up my camera, and take the picture, making hardly any adjustments at all in the framing."

Composition has become automatic for him partly because he has been content with uncomplicated and uncluttered work methods. Virtually every single photograph he makes is framed horizontally, the way the eye sees most naturally. His equipment is very basic. For years he had just one lens, the 50mm (which he used for the Floe Lake picture). After acquiring 35mm and 100mm lenses, he often left the 50mm behind, preferring to be as unencumbered as possible on his wilderness photo treks.

Photo technology has a tendency to inspire the arms race approach, with photographers hoping to improve their shooting by stockpiling an arsenal of lenses and sophisticated gadgetry. It is reassuring to see someone like Evans do so well with so little.

A lion in winter, this cougar had killed a mule deer near the town of Banff and had dragged it off into the woods when Hälle Flygare learned about the drama from two witnesses. Flygare, who gives guided tours and specializes in nature photography, spent a week of bad weather trying to get close to the feeding tom, which slowly got used to him.

"The last day was nice and sunny and I brought a friend with me to the kill site," he writes. "The cougar had cleaned up the deer and there were only bones left. I knew that if we pushed him off the kill, he would follow the well-used path he had made over the last seven days. I found a good spot to hide close to the trail and rested my 300mm lens against a small pine tree. My friend spooked the cougar from the kill and the cat walked slowly towards me. When he spotted me, the cougar sat down and I was able to take several pictures before he left the trail and disappeared through the trees."

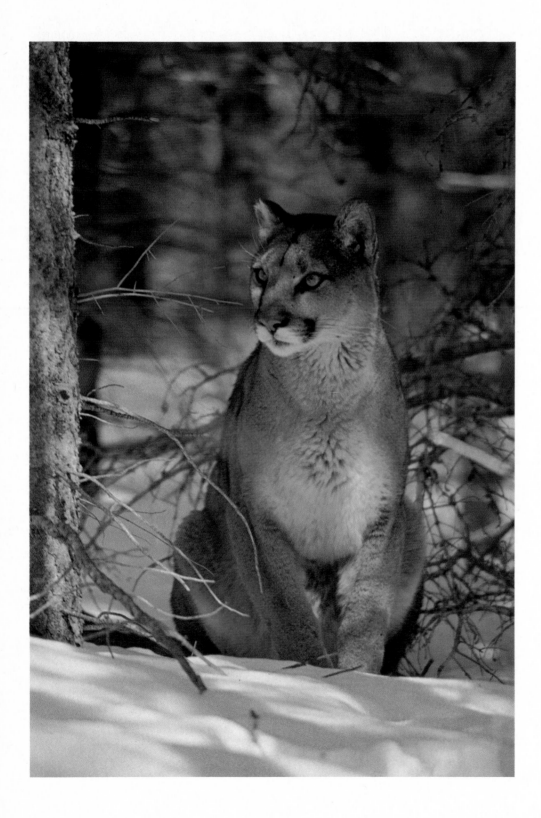

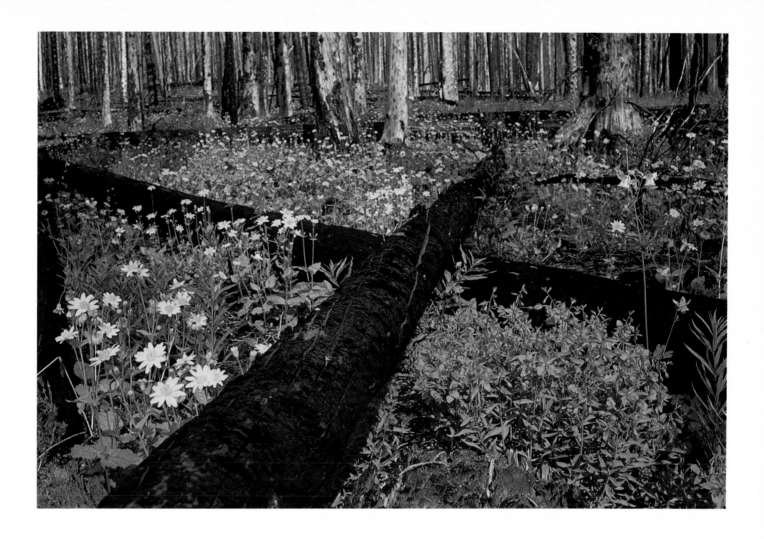

LEN HOLMES

"In death, new life" is the theme of an imaginative photo project conceived by Len and Joyce Holmes. They are documenting one of the great cycles in nature, the burning and regeneration of a forest.

In July of 1968 lightning set off a spectacular fire which stormed through two dozen square kilometers of mature timber in Kootenay National Park. Holmes and his wife arrived in the area two weeks later to witness a blackened scene of utter destruction and desolation, devoid of all signs of life. Every year since, they have journeyed from their Winnipeg home back to the park in order to photograph the changes for a slide presentation they present to naturalist organizations.

A forest fire is neither good nor bad, explains Holmes. The removal of the tree canopy allows different plants to thrive in the sunlight. Already by 1970, the fertile ground was a profusion of colour which, together with new vistas previously hidden by foliage, made the hiking trail through the burn one of the most spectacular in the mountain park.

Roaming off the trail in terrain stripped of impeding underbrush, Holmes made this picture in 1973, using his 35mm lens. The weathered colonnades of bleached trunks in the background will continue to stand for many years. In the foreground thrive yellow-blossomed heart-leaved arnica and broad-leaved willow herb, a type of fireweed.

Recently, Holmes has noted the re-establishment of some trees, and on each visit he returns to one particular lodgepole pine to document its progress. It is this species, growing straight and fast, that will first occupy the razed slopes in continuous, uniform ranks. But it will be another two centuries before the circle of succession closes and the stately spruce and fir rule a domain identical to the original climax forest.

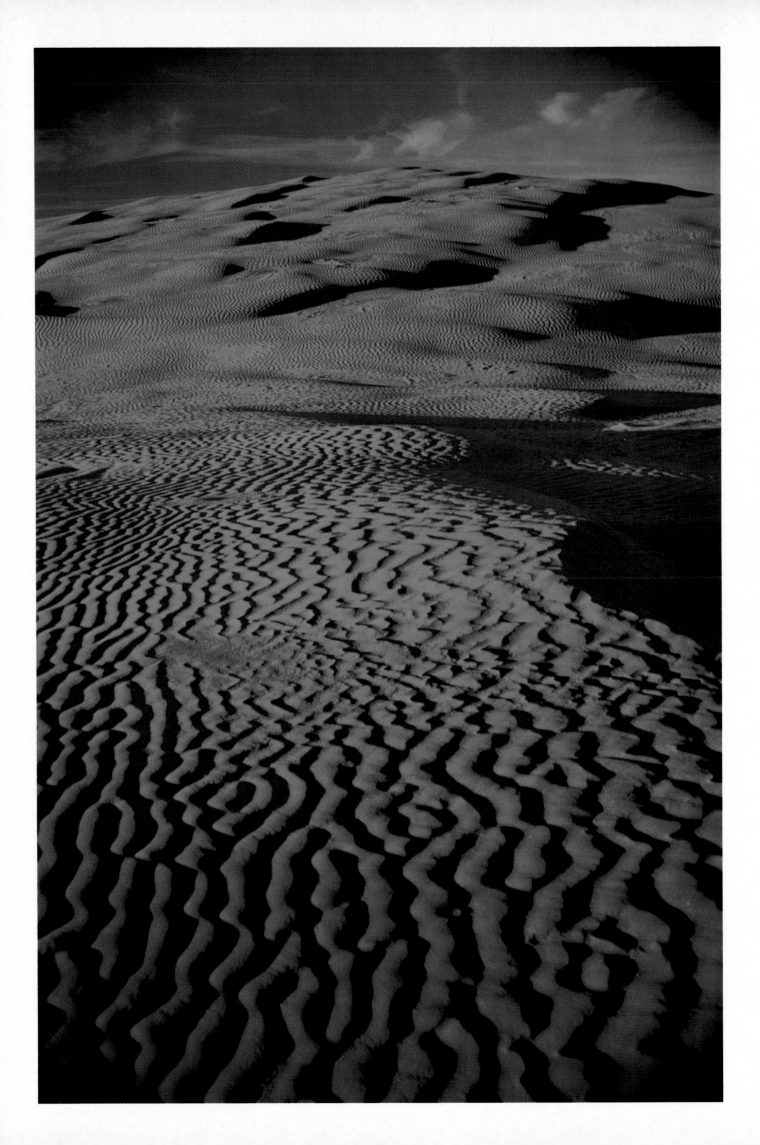

Saskatchewan, not the Sahara, is where Menno Fieguth took this stark sandscape (opposite).

"For years I went to bed with an atlas of my province and studied the variety of its physical peculiarities," he writes. "I had become tired of people saying, 'there is nothing in Saskatchewan except stubble and summerfallow,' because I knew that the province was far more than the Trans-Canada going through several hundred miles of wheat fields punctuated by prairie elevators.

"Among the things I became particularly interested in were rock formations and sand dune areas. I had photographed the Great Sandhills west of Swift Current on several occasions, but I knew that much more could be done with them. For six months I thought about them. One fall day I could stand it no longer. Informing my associates at work that I just had to take a day off and photograph the sand dunes that evening, I drove three hundred kilometers directly to the place where this picture was taken. I wanted the low angle of the sun to bring out the texture of the sand, increase contrast, and intensify the mood. I used a 35mm wide-angle lens for greater depth to give more vertical sweep to the picture, and a polarizing filter to darken the sky and separate it from the puffs of white cloud."

For his big sun (below), taken across Big Stone Lake near La Ronge, Saskatchewan, Fieguth had his camera on one tripod and a 400mm lens coupled to a 2x and a 3x teleconverter on another tripod. With the effective focal length of 2400mm, roughly equivalent to a fifty-power telescope, the sun tracked quite quickly across the picture frame, and he had to anticipate the composition in setting up the assembly. Using High Speed Ektachrome, he determined the exposure simply by taking the reading from his camera's built-in light meter.

An accomplished singer as well as a photographer, Fieguth sometimes combines his two loves. "Mass for Kodachrome, Bass, and Piano" is the title of one of several performances which he has produced.

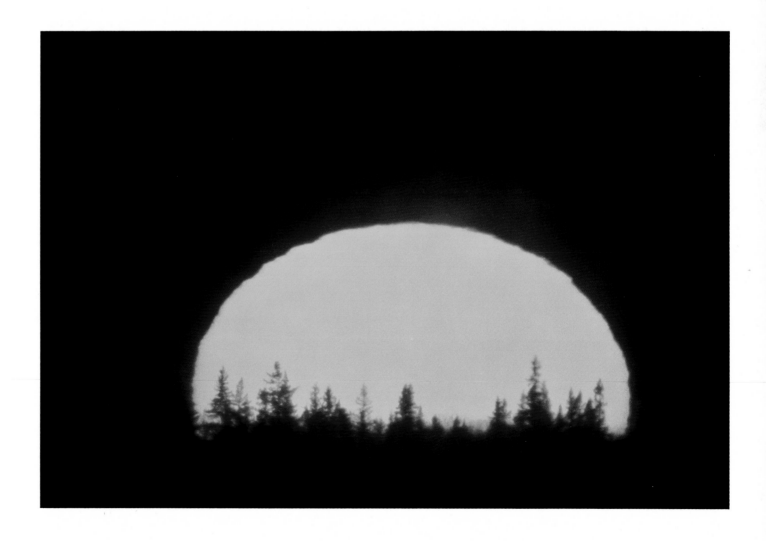

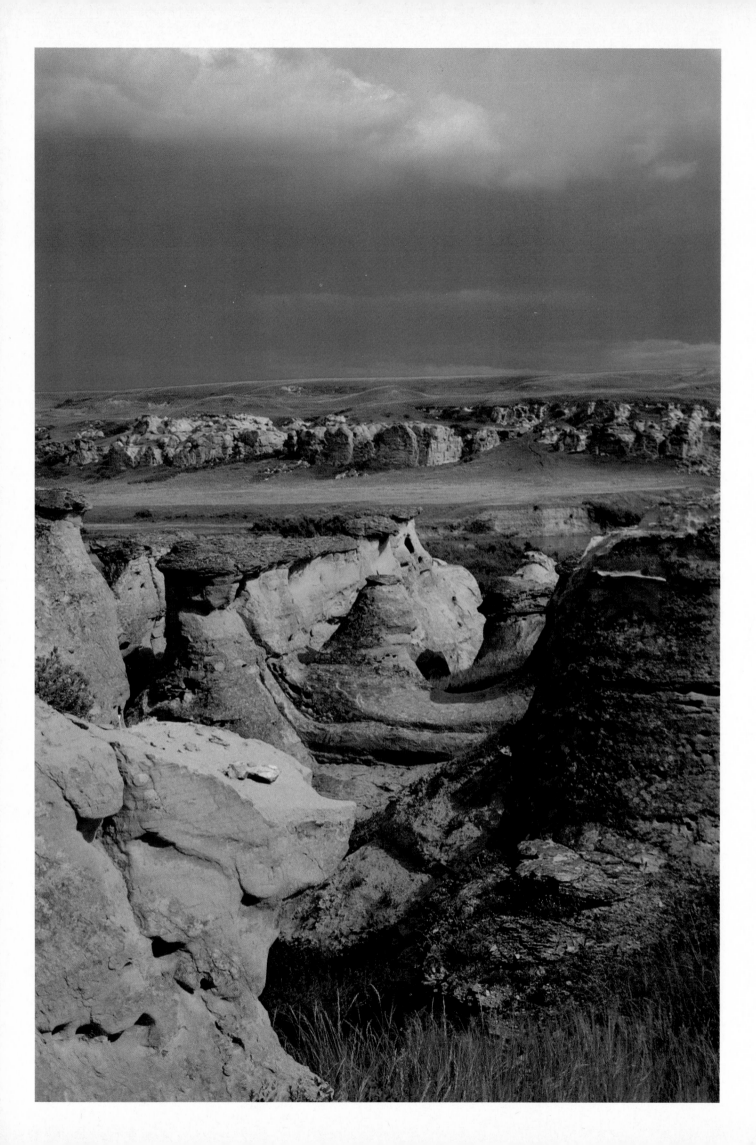

"You have to be crazy," confesses Brian Milne.

Stark naked, he once pursued a porcupine through prickly underbrush for nearly an hour. On another occasion, he spent an afternoon photographing on the prairie while wearing a cooking pot on his head. Under the circumstances, his attire, or lack of it, was actually not all that outrageous. The pot provided battle-helmet protection from a diving hawk that fiercely disapproved of his nearness to its nest. As for the porcupine, Milne spotted it wandering by the edge of a secluded wilderness hot spring in which he was relaxing. He did what any other resourceful photographer would have done, he grabbed his camera and chased after the subject.

However, when he donned hip waders to join grizzly bears fishing for Pacific salmon, he left sanity as most of us would probably define it behind on the river bank. It is in the character of some men to accept exposure to danger in the striving for a personal ideal, be it a speed record, a mountain summit, or

the solo navigation of an ocean. For Milne, the quest was the perfect photograph. His profile of a five-hundred-kilogram male grizzly surfacing (page 72) was "the picture that made the whole summer worthwhile".

On that occasion, he had flown into a remote west coast river in August, only to be disappointed by rain on seven out of the eight days planned for. Photographing while waist deep in running water proved to be somewhat of a hindrance as well. Sometimes the water was deep enough to come in over the tops of his waders. The tripod he always likes to use, particularly for lenses as long as the 300mm employed here, proved to be worse than useless in some instances, since it was subject to vibrations induced by the river current. He had an anxious moment when, stepping on a slippery boulder, he nearly submerged himself along with several thousand dollars worth of lenses and cameras.

Finally, making the most of the one sunny day he had, he caught this boar grizzly shaking the water from its head

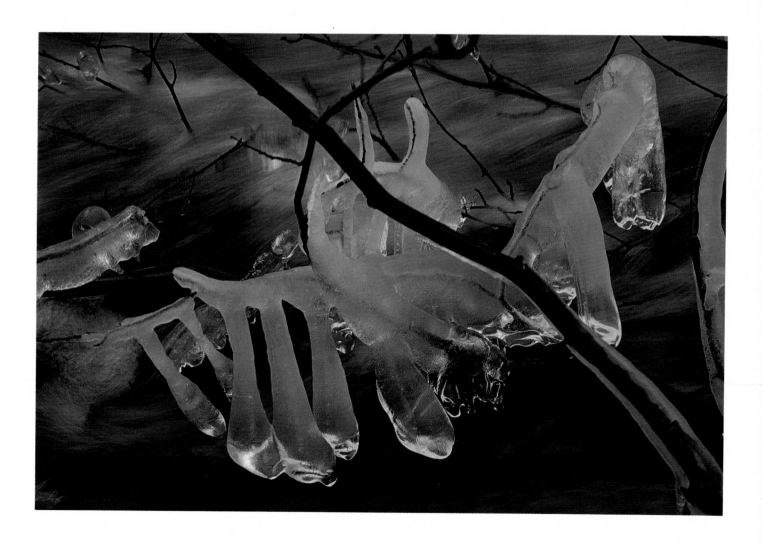

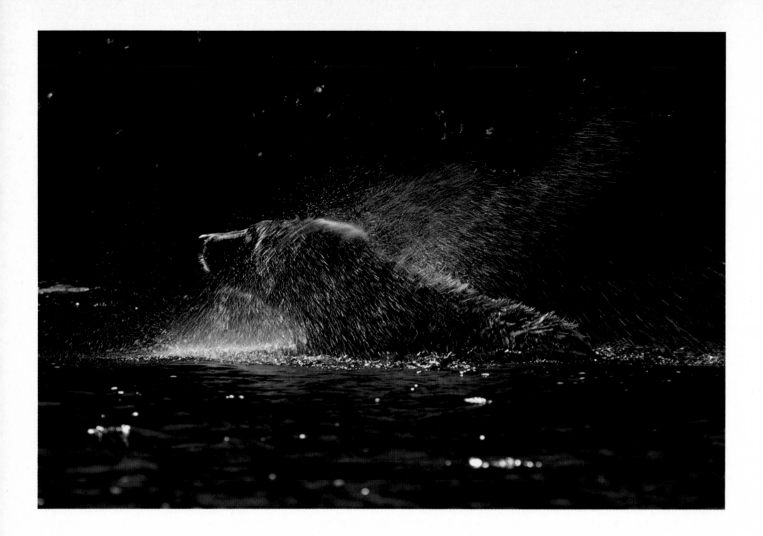

after it had taken an unsuccessful dive for fish. The dramatic contrast in the back-lit view was created by overriding the camera's automatic exposure capabilities and underexposing by two stops.

Milne, who never carries a gun and won't sell his work to hunting magazines, admits the very considerable risks that were involved. "It's not recommended," he stresses. "That's a situation where there's nobody there but you and the bear. At one point on this river, there were some fifty bears within just over a kilometer. And they were big bears, and they could get mean. I was chased off by a couple. It was a hairy situation."

He realizes that these magnificent beasts have no malice in their hearts, and are merely concerned with protecting their fishing rights. However, many of the animals have been wounded by vandals wantonly shooting at them from passing boats. This makes for a nasty bear, and, Milne feels, these bears are the dangerous bears.

Milne doesn't need to take chances to get outstanding photographs, as his work with less formidable subjects shows. His view across Police Coulee, just off the Milk River in southern Alberta (page 70), was taken in the low slanting light of evening with an incoming storm darkening the sky to the southwest.

"It was incredible country, with beautiful canyons, high sandstone cliffs and wild grassland," notes Milne. "There were deer, beaver dams, and strange hoodoo formations to photograph. The weather in the mornings and in the afternoons provided some great light. I went there for a weekend and spent a week."

An exquisite scene of black and white recorded in full colour, resembling so many musical notes, his magical monochrome of an ice-covered branch beside a stream (page 71) was made in Sibley Provincial Park, near his Thunder Bay home.

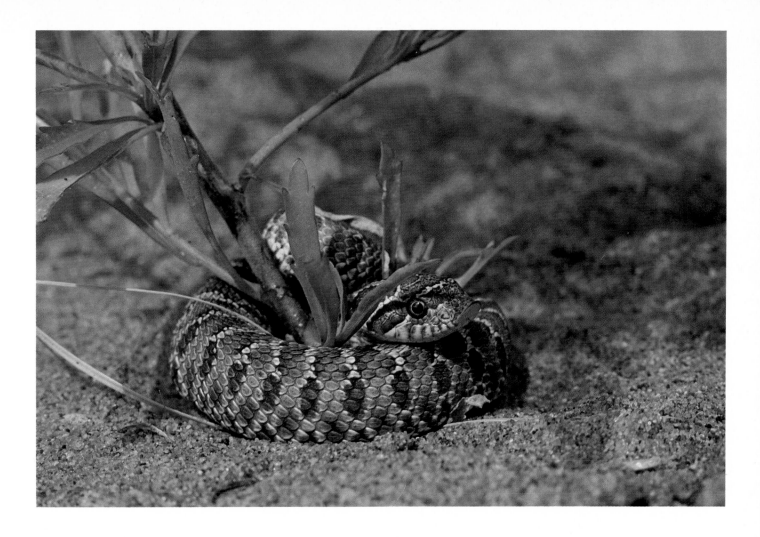

BRIAN MILNE

"The creek had already iced over and so had all the lakes when we got a freak winter storm that dropped about twenty centimeters of rain," he says. "Everything flooded. There were ice formations all over the place and I spent the entire day going up and down this creek photographing them."

The hognose snake (above) was photographed in Spruce Woods Provincial Park in Manitoba. A naturalist directed Milne to a spot that was a sunning area for quite a number of the well-camouflaged reptiles. For a while, he followed this individual, which was only about thirty centimeters long. When it coiled up, Milne dug his elbows into the sand as a substitute for his tripod, and photographed it using his 55mm macro lens.

However, no matter what he decides to photograph in the future, his efforts with grizzlies will likely remain the most memorable. Like most people who engage in hazardous activities, he has his share of close-call stories. One concerns a bear he and a friend had been following down a river bank.

When it disappeared into a thick stand of alders, he cautiously tried to ascertain whether or not the animal had gone on through.

"All of a sudden it came out of the bush," tells Milne. "It stood up on its hind legs and hissed and spit, the saliva running down its jowls. And there we stood, just frozen. I started yelling and clapping my hands, and the thing went down on its four legs and charged towards us and I really yelled and it stood right back up and hissed again and I just kept yelling and yelling and finally it backed down and walked into the bush."

"I didn't get a picture," he recalls with dismay.

Showing up for work with wet pants is nothing unusual for Bob Herger. The drive to downtown Vancouver from his home takes more than an hour, and he often leaves early, taking advantage of the long trip to do a little photography. Often this means wading through a field of still dew-laden grass and bushes in order to reach a subject that has caught his eye. But he would rather get his picture than worry about soaking his trouser bottoms; they are seldom noticed in his behind-the-counter job in a camera store.

Herger is an incurable pre-dawn riser who knows the importance of being early; the photographer who is working at sunrise often catches the best light, and can face the rest of the day with the gratifying feeling of accomplishment. With his family still sound asleep at home, he made this photograph of sunlight streaking through the trees growing on a spit in the Alouette River (opposite) before six o'clock on a calm Saturday morning. He was walking along the banks of the river, intrigued by some cougar tracks, when the sun came up and burst through the mist. Using his 28mm lens, he captured the scene before (in an-other minute or two) the sun was too high and too bright, and the effect disappeared.

Herger was attracted to the contrast between fresh spring growth and the dead debris of a forest floor when he photographed the new leaves of queen cup (below), while returning from a hike in Manning Provincial Park, British Columbia. Year-old spruce cones, recently dropped by squirrels which gleefully bombed the surround-ings beneath their tree-top stations, add a touch of brown to the composition. Never one to give up the stimulating and enriching search for details which may yield good photographs, Herger took this one in the shade of late afternoon.

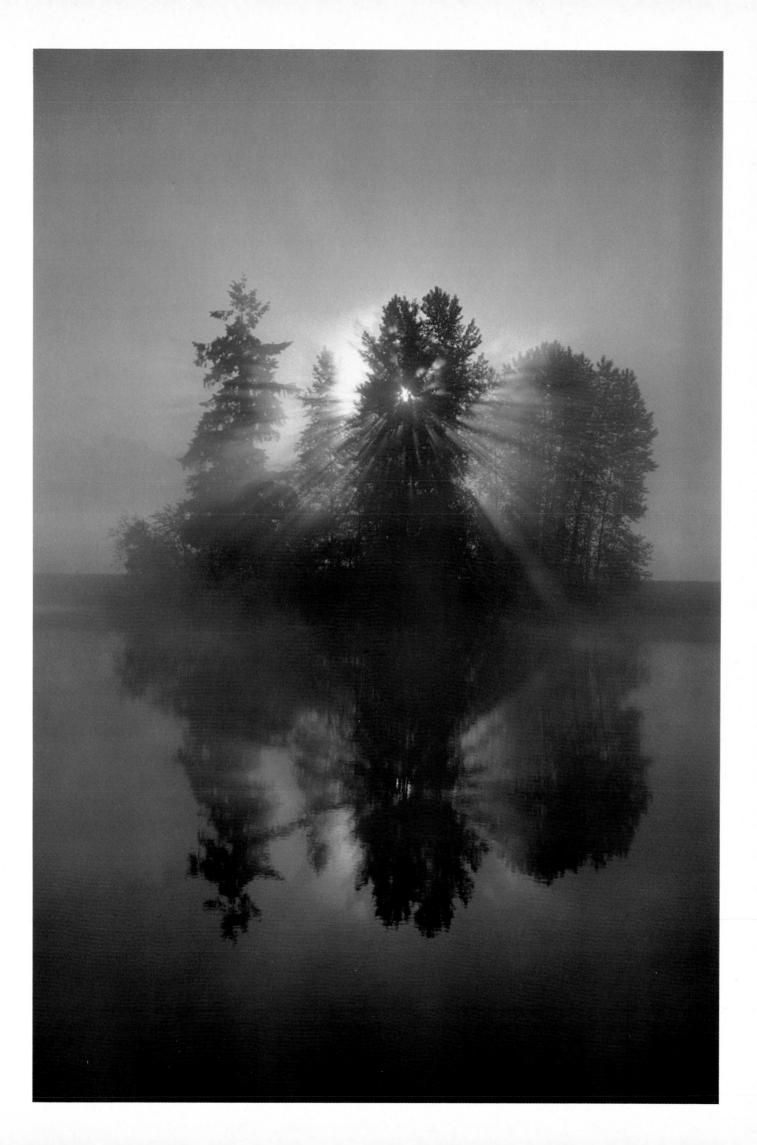

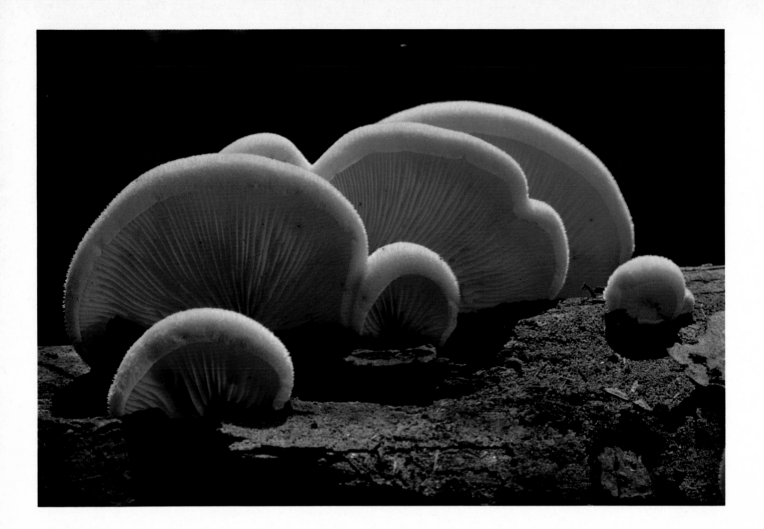

Late summer and early autumn is mushroom season and there is scarcely a nature photographer who has not, at some time, been fascinated by the different forms, colours, and textures to be found in the many varieties of fungus.

Walking in the woods near Toronto on a bright October day, Betty Greenacre discovered this group of *Phyllotopsis nidulans*, recognizeable by its disagreeable odour. Carefully, she rolled over the rotting log on which the cluster thrived so as to be able to photograph the radiating gills underneath. By positioning the ensemble so that the sun was behind it, she created the brilliant luminescence around the rims of the mushrooms. With crumpled kitchen foil taped onto a small piece of cardboard, she reflected sunlight onto the shaded front of the group. The reflector was set at an angle in order to avoid flat, shadowless light, thus defining the structure of the gills.

An umbrella, placed to cast a shadow behind the mushrooms, eliminated distracting spots of light from the background. With her camera on a tripod, Greenacre made the photograph using her 50mm macro lens stopped down to its minimum aperture for maximumn depth of field.

With its balanced recurrence of like forms outlined by strong light, the picture brings to mind the kind of cadence which permeates architecture and music, and which suggests the essential order underlying existence. In this repeating design growing out of the chaos of decay, Greenacre has produced an image which evinces the eternal, inexorable rhythms that generate life.

BETTY GREENACRE

RICK FILLER

Colour is one of those irreducibles which we can label, but never hope to describe. Try to explain what red or green looks or feels like. It's impossible. And this is one of the reasons why Rick Filler prefers to express his feelings for nature with photography rather than with words.

"Colour is so much a part of my pictures," he says. "Often it is what attracts me to a scene. It's an emotional response—colour does something for me."

His photograph of yellow maple leaves early in October is compelling in its emphasis on brilliant colour set against surroundings of pristine black and white. The picture was made possible by the small difference in elevation provided by a hill in the Laurentians near Mont Laurier, Quebec. During the night, an unseasonable snowfall had blanketted the trees at the top of the hill, while nearby lower areas received only rain. Filler, who guides photographic safaris to

Canadian wilderness areas and operates a print gallery, was out for a weekend drive during his favourite time of year when he came to the crest of the hill. Recognizing the potential, he reaped a variety of images, including this one made with the 35mm lens which is the standard for the majority of his photographs. He was struck as much by the fresh tranquility of the scene as he was by the purity of its isolated colour.

"It was like being in a sound studio, surrounded by walls of foam," he recalls. "It was a strange, otherworldly feeling. Sounds were so muffled, so soft; you didn't hear your footsteps the way you usually do. Everything was so peaceful."

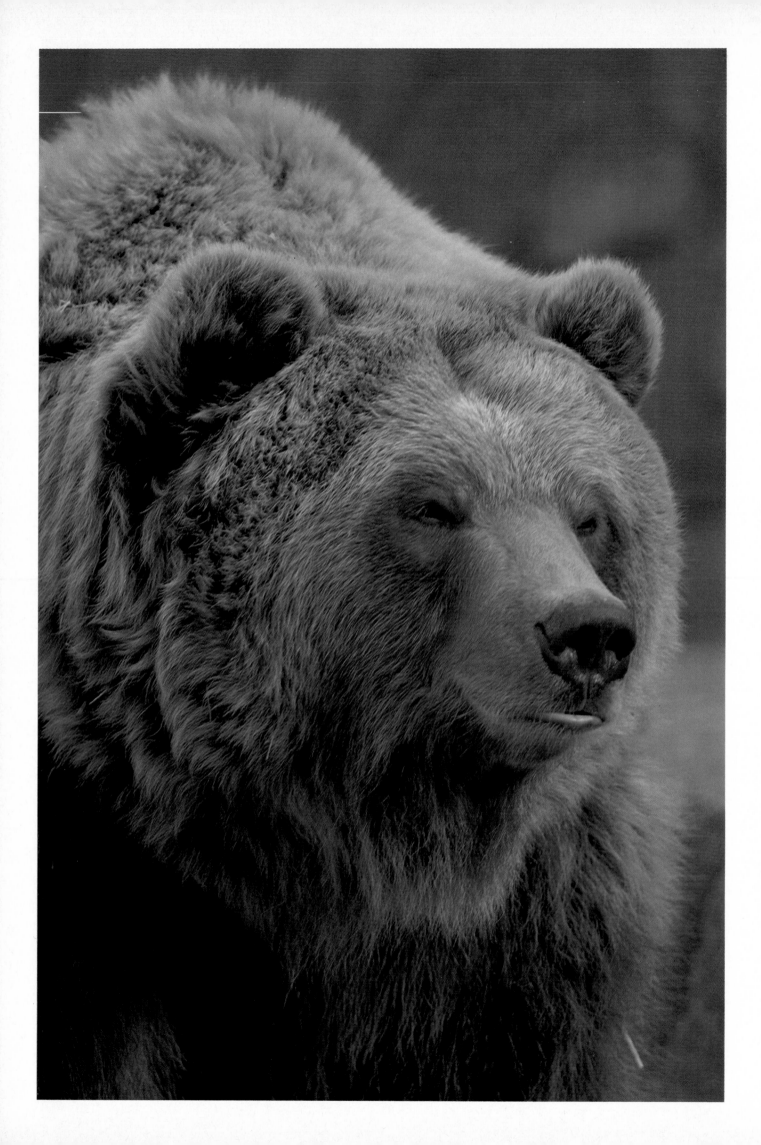

"There is a rule of thumb," warns Stephen Krasemann, "that says, if you are using a 200mm lens and the grizzly bear fills your frame, you're in trouble." His fabulous mug shot of a big mama bear (opposite) was taken with a 400mm lens, but less than half the beast is in the picture, so by the definition, he is in trouble. The sow, which had two cubs, was browsing beside a primitive road near the Yukon-Alaska border. Krasemann was photographing her from the roof of his van, a platform he often uses to achieve a better angle over the tops of obscuring bushes.

"Later on, that bear tried to catch me," he relates. "Usually, it is all just bluff, but this was unlike any charge I had seen. I was looking through my lens, and all of a sudden she just flew at me. I slammed the tripod down on the roof and bailed into my truck. I jumped into my seat and was about to pull the door, when I heard a big crash on the roof. Just as I slammed the door shut, she fell down by the front of the

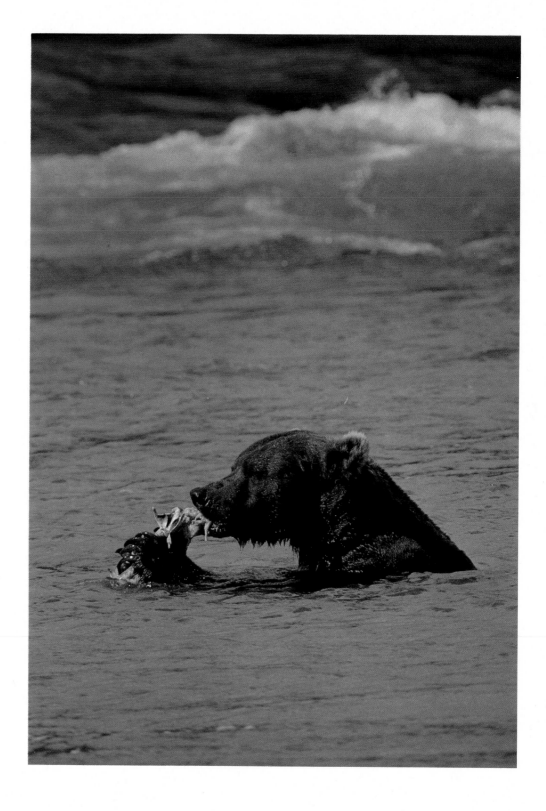

truck. Had she fallen where I couldn't have closed the door—I don't know what would have happened. It was too close."

"She was just being very protective," he adds, with a hint of fondness that leaves superficial any questions as to why he pursues such a risky business.

The experience was not typical for Krasemann—generally he works in places where there is no vehicle to run to. He prefers to spend his time in remote wilderness, often alone, sometimes for three weeks at a stretch. There he lives out of a backpack weighing as much as forty kilograms. Probably half of that weight is camera gear and film.

He had been dropped off by float plane on a very isolated west coast river when he photographed the boar grizzly relishing his salmon dinner (page 79). He used his 600mm lens to keep a polite distance. Fishing bears are well fed, territorially aggressive only in the immediate vicinity of their staked-out stretch of rapids, and will usually leave you alone, he says. While he was

working, however, he did not notice another of the many grizzlies in the area as it approached the river for its afternoon snack. It trudged along to within a couple of meters of Krasemann, who froze motionless. "The bear looked at me, clicked its teeth a bit, and then just walked right on by," he recalls.

"For controlled danger, the most exciting animal to photograph is the moose," according to Krasemann. The rutting season is the chanciest time, when the bellowing males are in a mood to bulldoze anything that moves. A female with young is no less dangerous; a defensive mother can kill with one lightning blow from her steely front feet. Krasemann captured the cow with twins (above) near his cabin in northern Ontario. Knowing where dependable trees are is a prerequisite to approaching this species, he advises from experience.

The Dall ewe posed with her newborn lamb (opposite), taken with a 400mm lens, represents a missed opportunity for Krasemann, who had

STEPHEN J. KRASEMANN

STEPHEN J. KRASEMANN

hoped to photograph the actual birth of a baby sheep. With binoculars, he had picked out and observed this ewe which was bedded down on a craggy mountainside in Kluane National Park.

"I looked again the next day and saw the little head of the lamb," he tells. "When I climbed up there, the lamb was not pink anymore, as they are from afterbirth stains when they've just been born. So earlier, while I had thought that nothing was happening, the ewe had been giving birth. The day-old lamb was still so wobbly, it could hardly even scramble up on the rocks."

The two red fox cubs playing outside their den (opposite), photographed with an 80-200mm zoom lens, prompt another story from Krasemann. "One day one of the parents came back with a ground squirrel but the young weren't anywhere to be found. They had run off somewhere, or gone out with the other parent for a hunting lesson. The adult came over with the ground squirrel and looked at me after he had tried to find the young.

Then he threw the squirrel out in front of me. I looked at him; I didn't do anything; I was photographing. He picked it up and threw it a little closer. Still, I was just photographing him. Finally he took the ground squirrel, came up to me as if to say 'you idiot, can't you tell what I'm doing?' and set it right on top of my boot. He was giving me the ground squirrel. That's probably the most I've been accepted by any animal."

Krasemann spent eight days with the foxes, giving them enough time to gradually get to know him. He didn't have that opportunity with the bobcat he spotted just off the road in southwestern Alberta (above), which he took with his 400mm lens. Luckily, the animal did not run away as he approached it; it was an extremely hot day and no doubt the bobcat was reluctant to leave its shady rest.

To obtain the fierce profile of a bald eagle (page 84), Krasemann had himself flown to a Pacific island where he had been told there was a nest. At first he couldn't find a trace of the

lordly birds. "I was looking around for a nest, for eagles, for anything," he says. "Then, just completely out of nowhere—*whoosh*—the wind ruffled the back of my hair. It was that close."

From out of the sky, one of the adults had swooped down to check him out, and perhaps warn him. He was near the nest. Having once seen a man knocked unconscious and out of a tree by a tiny hawk, he knew enough to keep a respectful distance. For three days he left his motorized camera empty, but ran the motor-drive every time he approached the nest, each time going a little closer. With the birds used to him and the click-whirr noise of the

camera, the fourth and fifth days became exhilaratingly productive.

Krasemann did not hope to spend much more than half-a-dozen hours with the caribou feeding on dwarf willow (opposite), taken with a 400mm lens near the Firth River in the northern Yukon. A member of a far-ranging species with a tireless stride, this animal might have been two dozen kilometers away the next day. Neat in his summer suit, he is an exceptional bull, sporting double shovels (flat lower tines) on his still-growing velvet-covered antlers.

Krasemann's pure, idealized images of nature include many still subjects. He photographed the fern in a field of

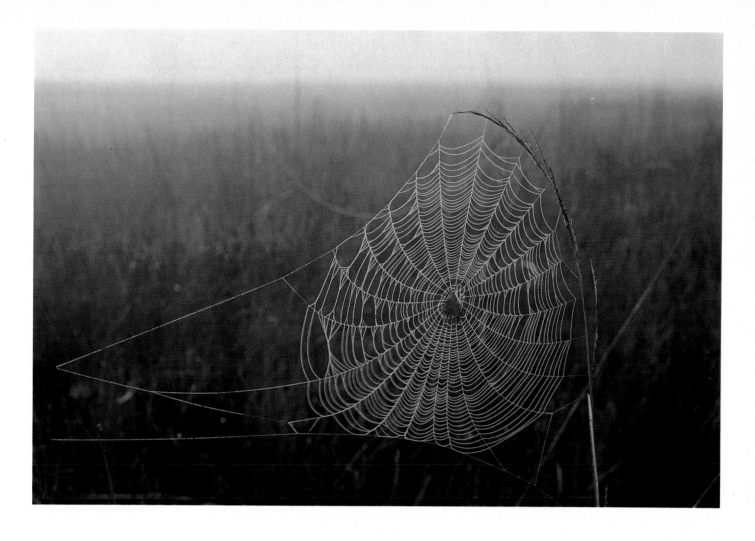

STEPHEN J. KRASEMANN

equisetum (opposite) near Dawson Creek at the start of the Alaska Highway, the long lonely road north which he has driven so often. The orb spider web, its perfectly engineered structure outlined by morning dew (above), was taken on his property near Thunder Bay, Ontario. Both pictures were made with a 55mm lens.

Wildlife, however, is Krasemann's main passion, his ultimate challenge. Apart from spending a great deal of time in the bush, what does he do to get such clean, well-posed portraits of such elusive and uncoercible subjects? To start with, he has established many contacts with game wardens and naturalists who are able to direct him to many of his animals. He makes regular use of his longer telephoto lenses, and always carries a tripod. (The latter gets so much abuse when he throws it across rivers and down cliffs in order to facilitate his own negotiation of such obstacles, that he has to buy a new one each year.) With his motor-driven cameras, he runs through a lot of film—more than forty rolls in a

single day on some occasions. But for anyone who is concerned with getting the best possible results from moving and unpredictable subjects, and who depends solely on the sale of his picture rights for a living, that is by no means unusual.

More than anything else, however, Krasemann's success is due to the way he approaches wildlife: slowly, openly, and in carefully restrained stages. "It's a matter of progression," he explains. "I start from a good distance, and much as I could get closer to an animal, I won't get closer. I might pitch my tent for the night, let it see me wandering around and doing my camp chores. There is a point where you can go too far too soon, and you'll blow it all. You can try to approach the animal for a month after that and you'll never get anything."

Krasemann is rewarded for his efforts not just with outstanding photographs, but with memorable encounters with animals that are an integral part of the lifestyle he leads and loves.

Acrobatic architects, cliff swallows construct their predator-proof nests from little balls of mud which they cement together with their own saliva. Richard Vroom found this abandoned colony under an overhanging rock ledge seven meters up a cliff in Writing on Stone Provincial Park, Alberta. Light-coloured surroundings which bounced around the slightly diffuse sunshine of a hazy August day account for the even illumination of the shaded dwellings, photographed from the ground with a 180mm lens.

Vroom made the picture while living in a motor home and photographing his way across Canada. This was one of the many assignments which have taken him to some forty different countries.

Summing up his approach and what his career involves, Vroom says: "Basically, you are working with light.

Hence you have to develop an awareness of where and when to find the best light, as well as the ability to recognize and use it. It is a matter of organizing your whole life around being at certain places at the right time in order to capitalize on the kind of illumination you want for your photographs. This often requires getting up very early and working very late, working through meal times and working beyond the hours that most people normally work. Nature photography requires a totally unconventional lifestyle—a very demanding one—which takes you right out of everything else that you might have been pursuing."

RICHARD VROOM

DOUGLAS HEARD

"It is, without question, one of the greatest spectacles in North America," says Douglas Heard. Watching the long march of a hundred and fifty thousand Barren Ground caribou is part of his job of monitoring the Bathurst herd for the Northwest Territories Wildlife Service. One of five major herds in the Arctic, each named for the area of their calving grounds, this one migrates along the tree line in its trek from Bathurst Inlet to the area around Artillery Lake east of Great Slave Lake.

Heard was transported by helicopter to a ridge overlooking a frozen lake a couple of hundred kilometers northeast of Yellowknife, in a remote part of the Territories void of place names. On one tripod he set up his camera with the 500mm lens he used for this picture. On another tripod rested his spotting scope. While the animals streamed by for hours on end, he huddled in the −20°C. temperatures and took notes. Often the great exodus was too overwhelming to log with pen and paper, and Heard had to resort to a tape recorder.

"It was mid-October, early winter in the Northwest Territories, and the peak of breeding activity for the caribou," he relates. "Barren Ground caribou are always on the move. On this occasion, the cows were spearheading the migration to the winter ranges, while mature bulls paused frequently to spar and fight. The clatter of their enormous antlers accompanied the ceaseless flow of animals.

"Many drifted right past my station, completely unconcerned about my presence. On one occasion, a bull was chasing four cows that didn't appear to see me. I thought I was going to be run over accidentally. Once in a while, a nearby animal would pause and look at me with those soft big brown eyes of theirs. It was a tremendous experience to be there."

"My concern is not to get a picture of something, my concern is to get something in a picture," says Tim Fitzharris. To achieve that subtle, yet immense difference, he has often persevered for months on a single subject.

Such was the case for his superb uncropped photo of a male mallard hunched in powerful flight (above). To get close enough to these speedy birds, he found a frozen pond with a circle of open water only a couple of meters in diameter, which was frequented by several dozen ducks. That done, the problem was to catch a bird in the right attitude and in perfect focus. With a fast flyer such as the mallard at the close distance of three meters and with a lens with the relatively long focal length of 200mm, the problem was roughly equivalent in difficulty to throwing a penny into a beer glass on the other side of a large room. With a bit of luck and enough tries, eventually one *might* succeed. Fitzharris stood in the hand-numbing cold through several January weekends for two years in a row and made some two hundred

exposures in order to produce this masterpiece, sharp right down to the frost on the duck's retracted landing gear.

Fitzharris has spent a lot of his time designing and testing blinds, of which he has made quite a few floating models. His early attempts fell apart in the wind or took him for a ride. One of his successful versions is built around a slab of styrofoam which, with his legs in chest waders, he propels either by walking, when the water is shallow, or by frog-kicking, when it is deep. Working with it in the salt-water lagoons around Vancouver Island, he tries to avoid distracting thoughts about curious sharks or killer whales, and keeps a close watch on the wind and the current to make sure he isn't carried out to sea.

Another of his favourite blinds consists of fabric sewn around a series of hula hoops. Worn attached by a pole to a harness, it collapses to adjust to his level when he wades in the water. His camera, in this blind, is carried on a bipod of his own design which he

TIM FITZHARRIS

90

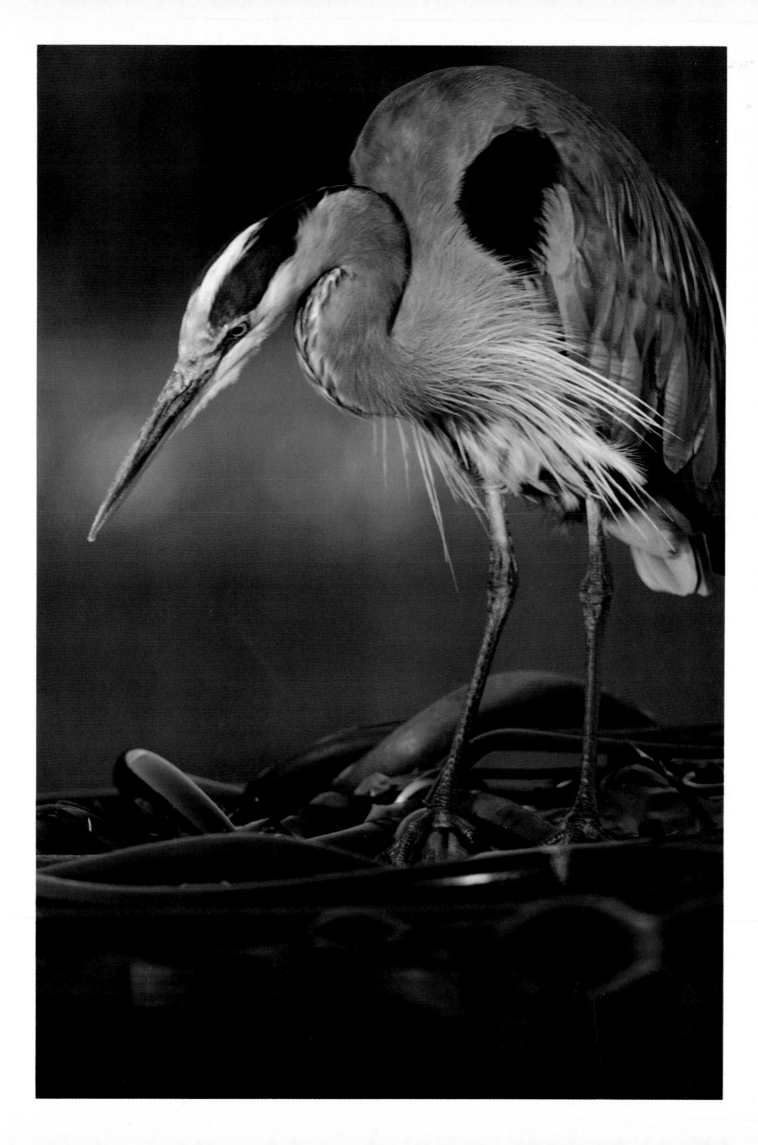

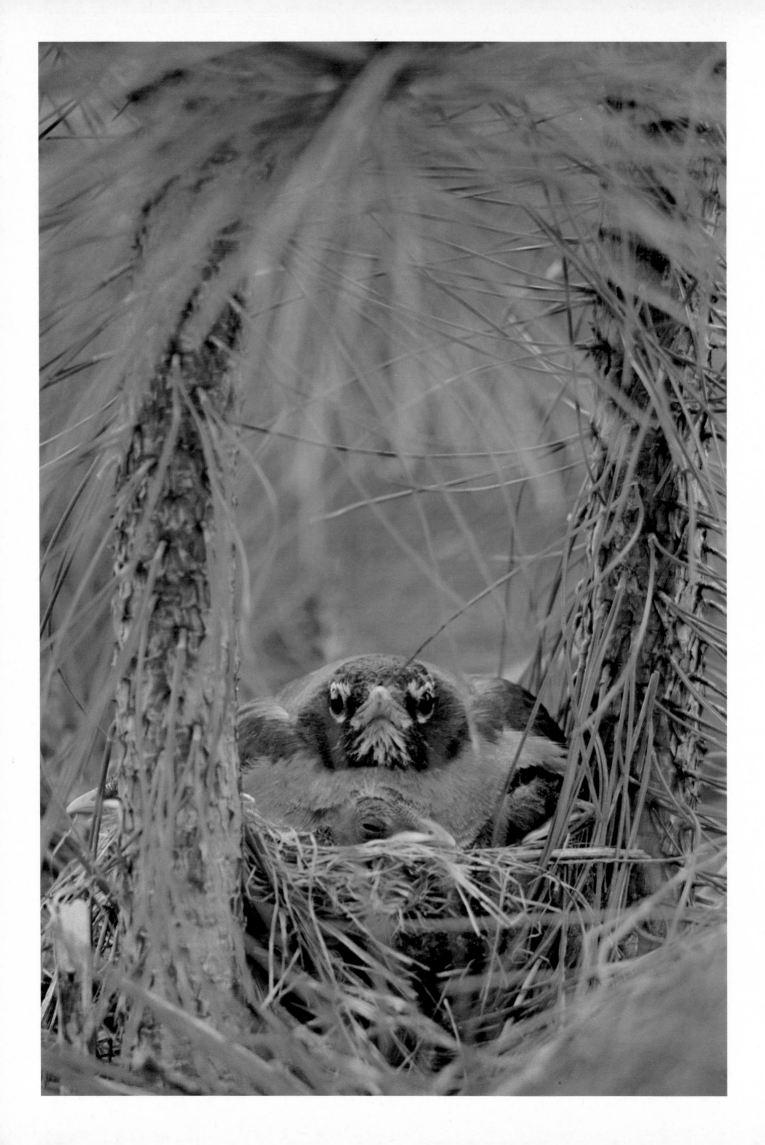

finds much easier to manoeuvre than a tripod.

Sneaking up to certain particularly shy birds has to be begun from quite a distance. Once, while dressed up in this concertina-like blind, Fitzharris slowly crept across half a kilometer of open field, crossing fences and railroad tracks before silently folding into the water. There were no reports of a strange creature seen gliding across the countryside in the next day's newspapers, so probably his strenuous efforts went unnoticed, which is a bit of a shame.

Fitzharris used a floating blind for the heron fishing from a raft of kelp in a lagoon near Victoria, British Columbia (page 91); for the wary bittern amidst reeds in early spring in southern Ontario (below); and for the muskrat building its lodge in a slough south of Calgary in late fall (page 95). By the patient use of such mobile blinds, he is able to obtain the exact framing and the exact background he wants for an elusive animal. He pays particular attention to the direction of the light; if the sun is out, he will always manoeuvre so that it is centred

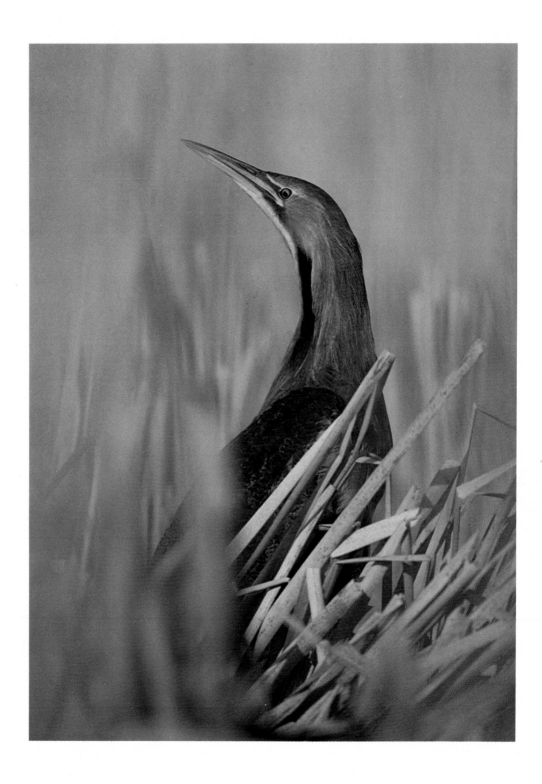

directly behind him, minimizing any shadows on his often colourful subjects. In his floating blind, he takes only one camera and one lens, the 400mm.

For his photo of a robin on her nest, taken in a tree farm in the Kitchener-Waterloo region of Ontario (page 92), and of a marten (below), he also used the 400mm but no blind. For the marten, which was in a game farm, it was impossible to maintain the very active animal in focus with the long lens. With the camera and lens set up on a tripod, he observed the marten's habits and focused on one spot the

animal frequently returned to, releasing his shutter when it paused at the predetermined spot.

Future plans for Fitzharris include the building of a blind on wheels for approaching pronghorn antelope. In order to disguise his scent, he plans to cover the blind with cow manure. When your concern is perfection, nothing is too far-fetched.

TIM FITZHARRIS

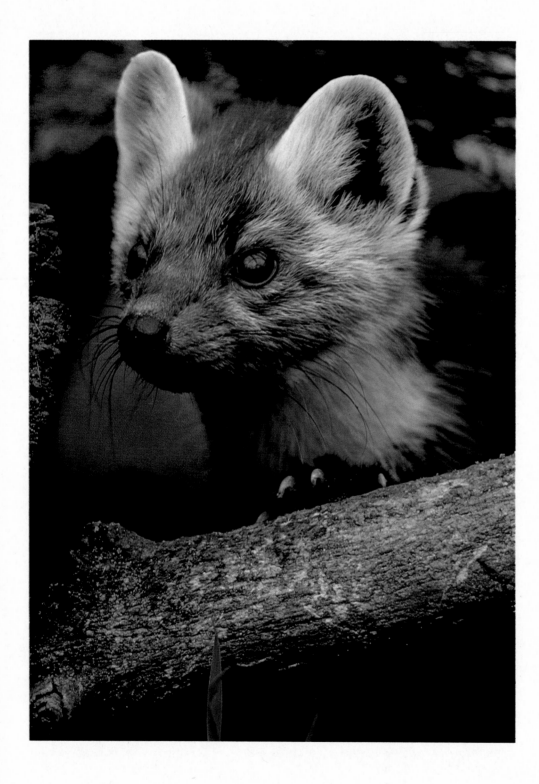

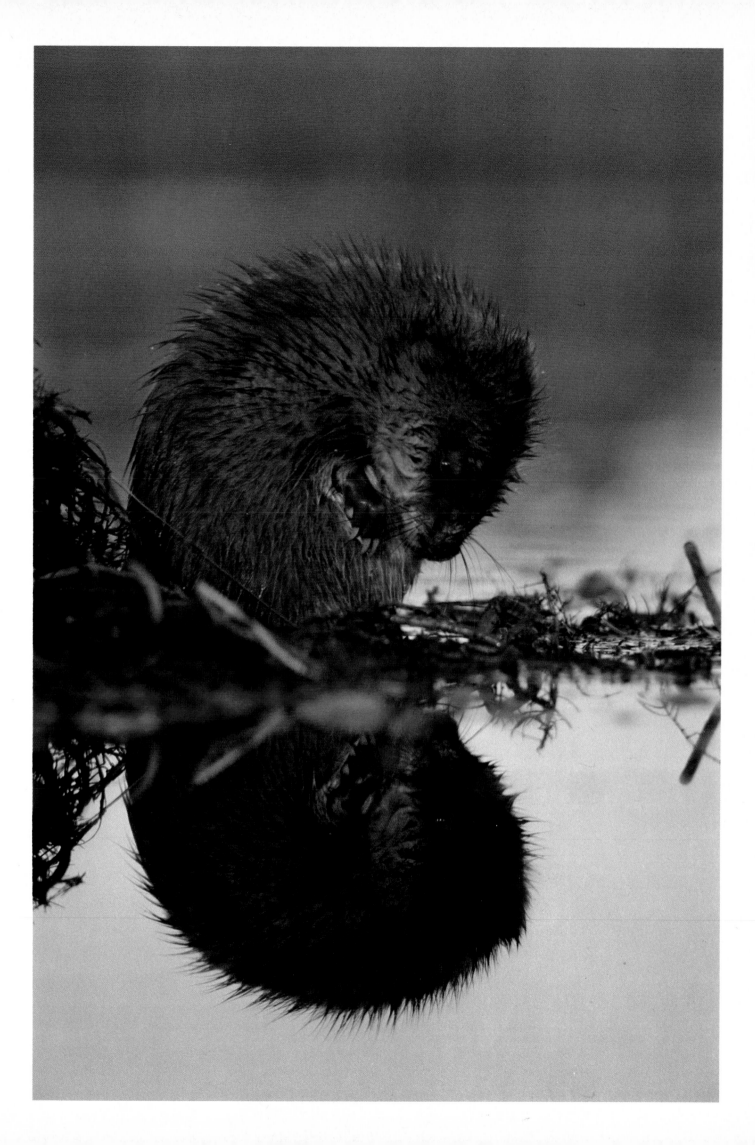

It was mid-morning in late October at the Arctic Circle when Paul von Baich photographed this back-lit spruce tree along the banks of the Porcupine River in the Yukon. Hoping to photograph grizzly bears doing some late season fishing, he was camped at the river with a group of biologists counting dog salmon. With the sun low in the southern sky, the temperatures already reached down to −25°C., and at night von Baich would bring his cameras into his sleeping bag with him in order to keep the film from becoming brittle and prone to tearing the next morning.

Like others before him, von Baich has discovered the land that beckons, and has fallen irrevocably under the spell of the Yukon. "Coming from Europe, I found the country just fascinating in its emptiness, its savage beauty," he says. "Now I feel the year is not full, the year is not complete without my having been to my beloved northwest."

Working with a minimum of camera gear, often just a 50mm lens and the 35mm lens used for this picture, he has illustrated several books about his favourite part of the country.

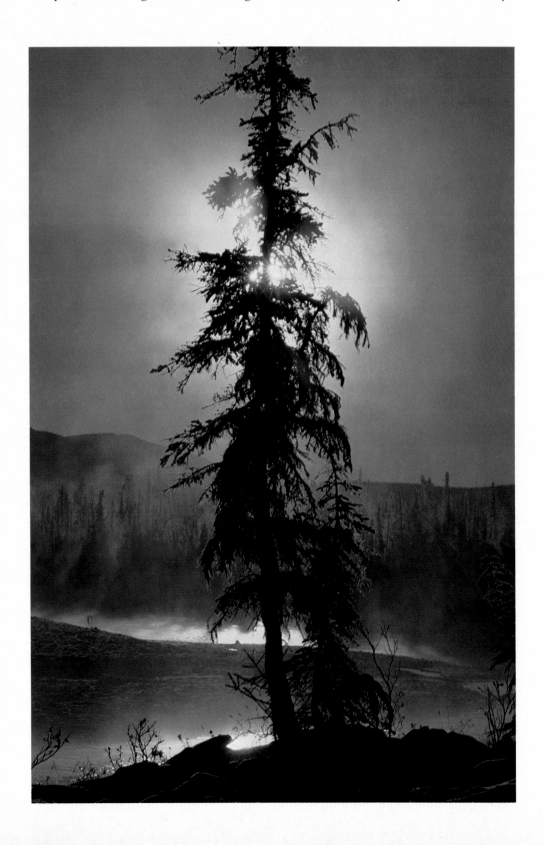

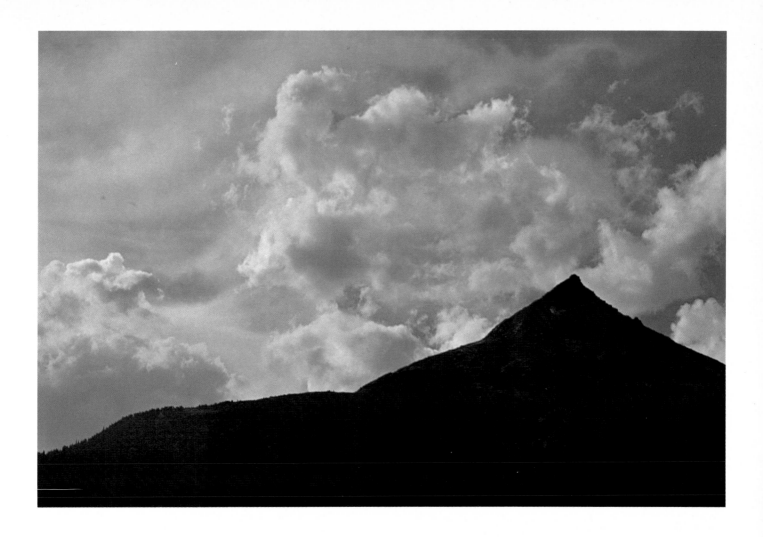

DON BEERS

In the west, where the land is forcefully three-dimensional, clouds meet the Earth far up in the sky. The clouds lend countless moods to the mountains, curling around cliff-stepped slopes or soaring high and fast over sharp summits. In this photograph of the graceful black silhouette of Mallard Ridge, Don Beers has caught a powerful image of that ever-changing drama between the ethereal white puffs and swirls that grow out of the high thin air and the hard, stark pyramids of unfathomable stone.

Beers was on an extended backpacking and mountaineering trip to Athabasca Pass, a place that once saw the march of fur-trade brigades. Today, it takes two days of hiking through the wilderness of Jasper National Park to get to the pass. Beers counted five grizzly bears on the slopes above the pass as he and his daughter approached it in late afternoon. Smoke from forest fires in British Columbia beyond the ridge added a pale of grey to the scene. Beers fitted a polarizing filter to his 50mm lens to bring out the contrast in the jumbled sky.

Like many who mix mountaineering and photography, he is frequently tempted to leave the albatross of camera gear behind, but he almost never does. He hauls along a half dozen lenses from 21mm to 200mm, but manages to keep his load within reasonable limits by using one of the most compact 35mm camera systems made, and by getting along with a monopod rather than a tripod.

Beers, a school teacher in his home town of Calgary, says that the mountains have given him some of those memorable moments of true euphoria that one experiences but rarely in a lifetime. He recalls the great thrill of seeing monumental peaks through a crack in the clouds after hours of trudging through the rain; and the happiness of returning from a summit, taking long, bouncing strides down a snow slope and breaking into joyous song. As is evident from his photography, he is well acquainted with the power of mountains to move men.

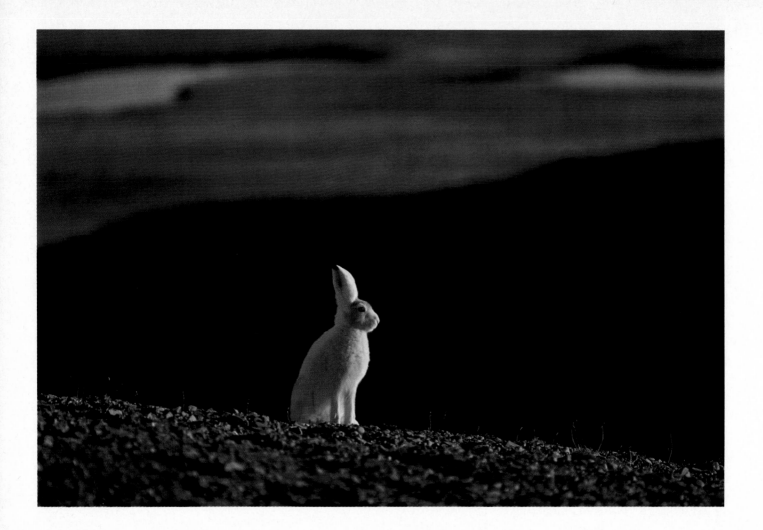

In summer, Polar Bear Pass is a lush valley that bisects Bathurst Island in the Northwest Territories. For ten years, David Gray has been returning to its treeless but verdant tundra to study the resident musk-ox herd for the National Museum of Natural Sciences. When not occupied with this research project, he has turned his interest to other wildlife in the area.

This arctic hare, highlighted by evening sunshine, was part of a four-some spotted while Gray and a companion were on an excursion away from base camp. It was the end of August, and after several nightless months, the sun had started to set and the temperatures were reaching below freezing, making walking in the mushy lowlands easier. Sneaking up on the hares, Gray attempted to frighten the group.

"Often they are really easy to approach and you can walk right up to them," he explains. "But since I am interested in animal behaviour, I wanted to get a photograph of them alarmed. When they are alarmed, they will stand up and actually run on their hind legs, jumping like kangaroos, their forefeet not touching the ground."

The animals did spook, but soon relaxed again. Gray became aware of the colourful possibilities in the surrounding landscape, enhanced by the low light. With his 200mm lens, he manoeuvred around to a position where he could frame the hare against the boldly contrasting background.

Full-grown hares stand as much as a meter tall, and are not meek, as Gray learned once when he was tagging the animals. It took three strong men with the advantage of a net to hold down a single screaming, biting, kicking adult hare.

Arctic hares generally change their coats with the season, wearing grey-brown for summer disguise and white in winter's snow. However, the hares of Bathurst Island, far north of the Arctic Circle, retain their striking whiteness throughout the brief snow-less season. It makes for a startlingly conspicuous animal, as Gray superbly shows.

DAVID GRAY

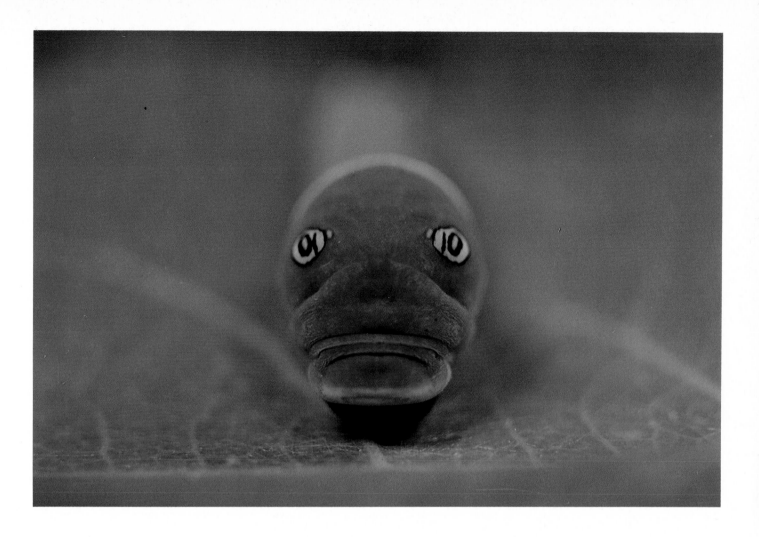

DENNIS HORWOOD

A hulking green monster devours everything in its path. Grim cold descends upon its planet. The creature withdraws into a hard, armoured shell and turns its body fluid to antifreeze. The warm season returns. Transformed, it emerges with black and gold wings and antennae on its head.

Such is part of the life cycle of the tiger swallowtail butterfly, as inconceivable and fantastic as the most farfetched science-fiction fable. For Dennis Horwood, documenting its growth and metamorphosis was part of the task of gathering material for his illustrated talks on natural history.

An eight-liter jar with a screen top, frequently restocked with fresh leaves, was sufficient to sustain the captive caterpillar. This graphic head-on view is of the fifth instar, after the caterpillar has outgrown and split its skin four times and before it retires into its chrysalis to spend the winter. Horwood used a 50mm lens with three extension tubes for the picture, after temporarily removing the caterpillar from its glass home.

The startling pair of "eyes" are in fact not eyes at all, but markings which are believed to frighten off predators. A hungry bird will usually see this front end, pointed upwards as the caterpillar hangs from a leaf, and presumably will think it has confronted a more formidable creature than is actually the case. As a further defense against being eaten, the swallowtail larva will extend two bright orange osmatoria, or scent horns, that exude a foul odour.

For an idea of what the creature will look like when it emerges from its chrysalis the following summer, liberated from its cumbersome youth, turn to page 58.

By waiting patiently for her subjects to come to her, rather than actively pursuing them, Valerie May was able to make the charming and unrepeatable photograph of four Columbian ground squirrels (below). Together with a photographer friend, she was camped near Hundred Mile House, British Columbia, when a conservation officer directed them to a field that had been taken over by an army of the rodents. "There were so many, we didn't know where to focus," she says.

May realized that the only way to deal with the abundant, scurrying animals was to ignore most of the activity and calmly concentrate on one spot. Sitting on a small camp stool and with her 640mm lens trained on one of the scores of burrow entrances around her, she was ready when, one by one, the quartet emerged. First they stood up and huddled together in a tight little circle. Then, as if having settled on a specific game plan, they each dropped down on all fours to assume this precise formation.

"Half the fun in nature photography is doing the research to learn about what you have photographed," says May, who went to some effort to identify the *Nectria* (opposite). In the woods near her southwestern British Columbia home, this parasitic sac fungus, here growing on the knot of a downed fir tree, is not very often seen.

To illuminate the subject, taken with a 50mm macro lens, she used an electronic flash, held off the camera. Opposite the flash, she placed a reflector made of silver foil pasted on a folded sheet of cardboard. Just when she was ready to take the picture, the tiny lacewing obligingly landed on the summit of the teacup-sized knot.

Some people have all the luck, it would seem. But luck is merely the unexpected made inevitable through effort. To get her photograph of the ground squirrels, May spent two full days in the same field. And both pictures are from an extensive collection which she has accumulated by working seriously at her hobby for over twenty years.

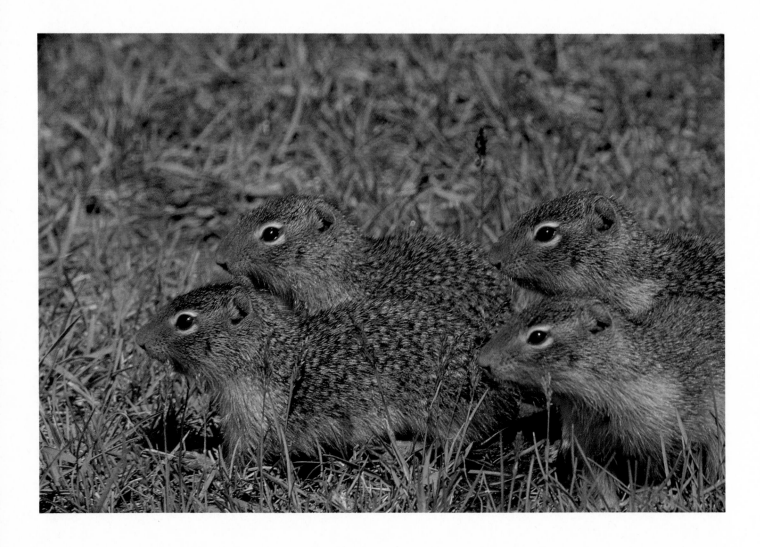

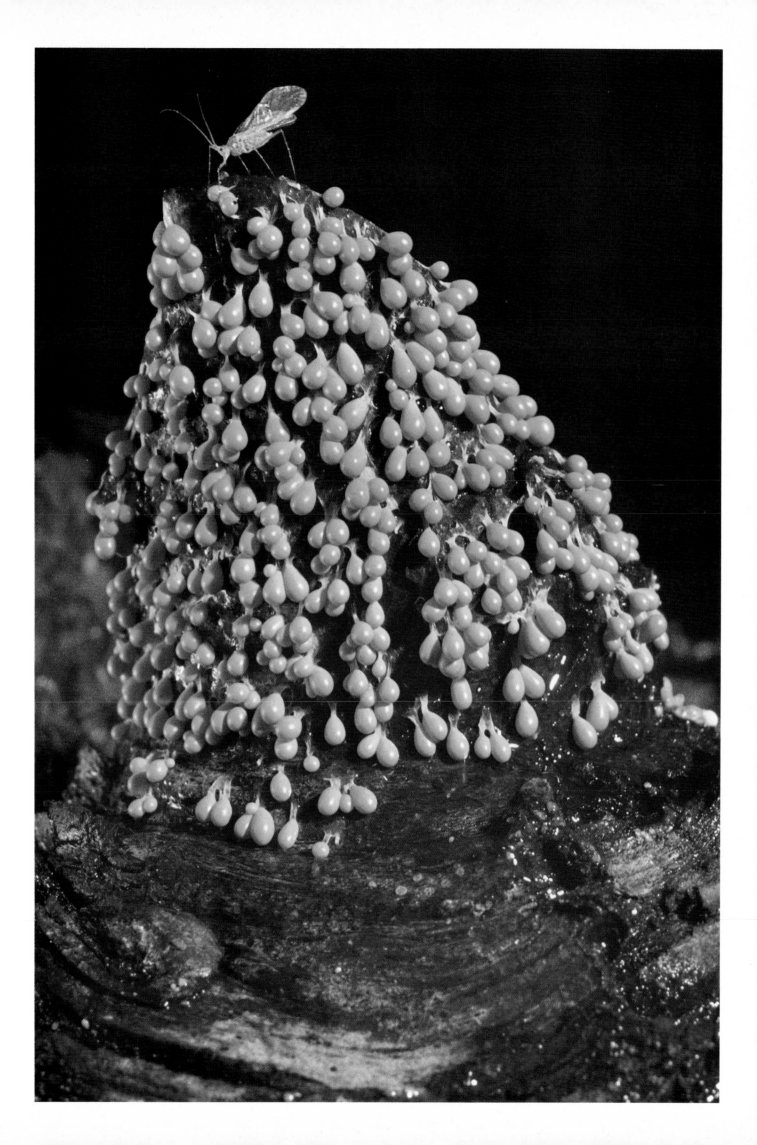

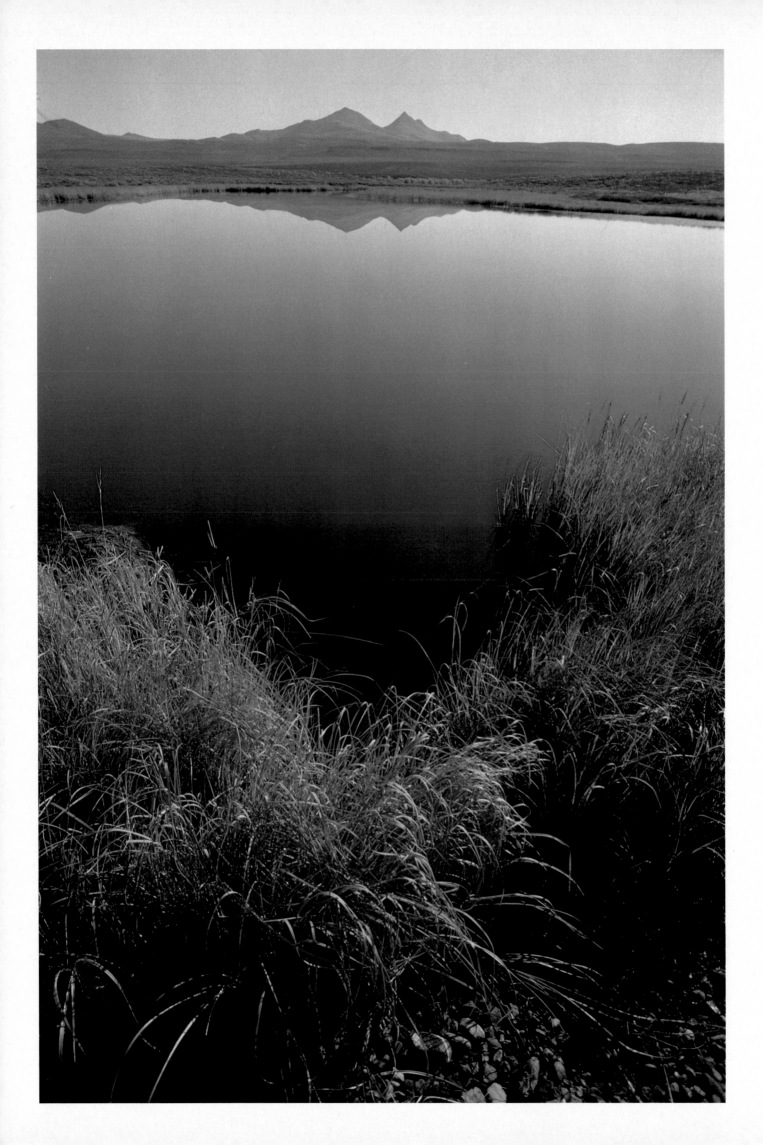

Rafting the white water of a Mexican gorge, hiking through secret canyons in the American desert, ski-touring across the icefields of the Rockies, soaring in a balloon above the Alberta prairie, hanging from sheer cliffs in the Purcell mountains, worming through the narrow passageways of Vancouver Island caves and climbing North America's highest peak by a new route: such experiences have all been just part of the job for Pat Morrow. Earning his living by writing and illustrating adventure stories, the native of British Columbia photographs nature whenever the opportunity presents itself, which for him means most of the time.

An extended trip to the Yukon brought him to this lake in the Ogilvie Mountains (opposite), flat in the midday sunshine. Next to the black of night, high noon on a bright day is perhaps the lighting condition liked least by landscape photographers. Morrow salvaged the situation with a polarizing filter and a wide-angle lens. The filter cut the glare from the grass and deepened the azure of the lake,

considerably boosting the colour contrasts in the scene. The 20mm lens permitted him to get close to the delicate grasses and at the same time separate them from the gracefully peaked distant horizon.

"I wanted to give equal emphasis to the foreground and the background," he comments. "It is, in fact, two pictures in one, with the whole being greater than the sum of its parts."

Morrow's photograph of a frosty stream at Rogers Pass, British Columbia (below), is another nicely balanced contraposition, this time between warm and cold. Two different light sources created the subtle dichrome: the shaded gully receives its illumination from the cool blue dome of the sky, while the yellow morning sun floodlights the forested mountain slopes reflected in the water.

Two days of strenuous skiing through heavy snow won him the sundown panorama of the Yukon's Tombstone Range (pages 104/105), taken with a 28mm lens. The feeling of space achieved by the strong juxtaposi-

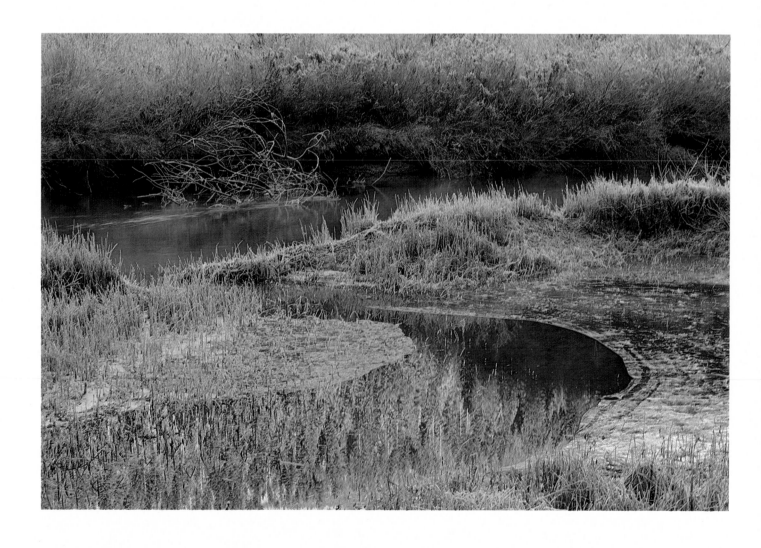

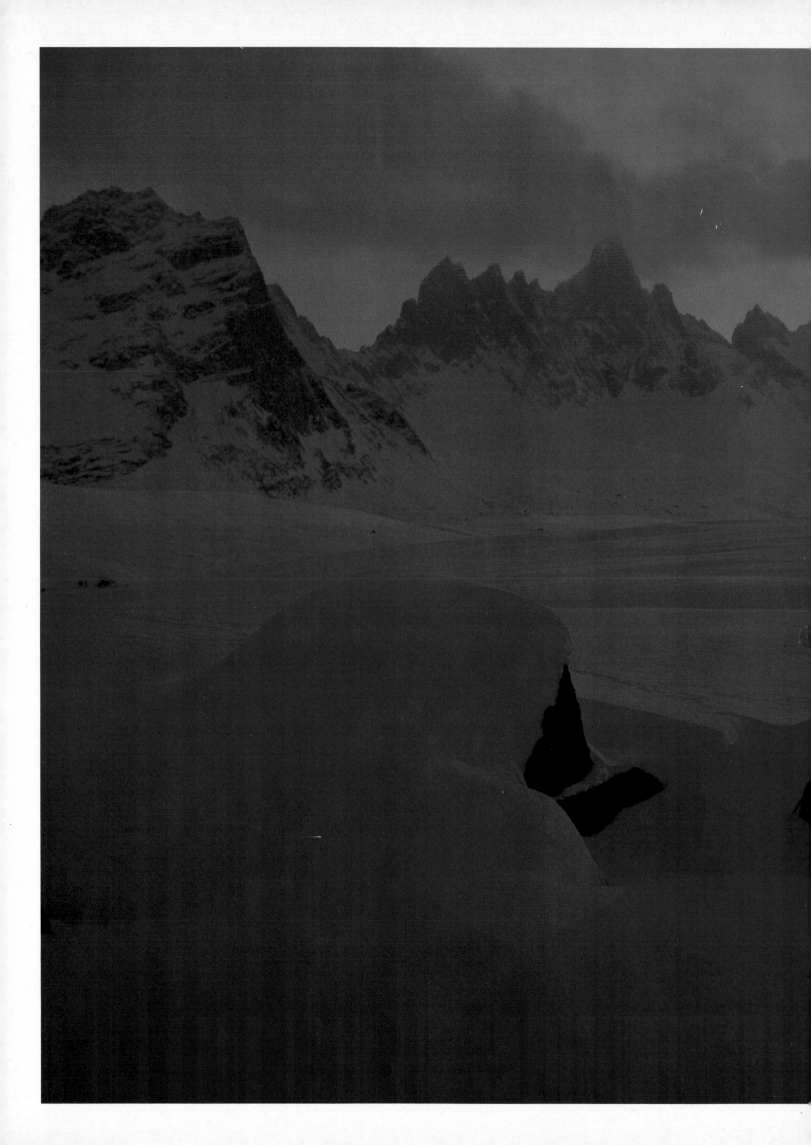

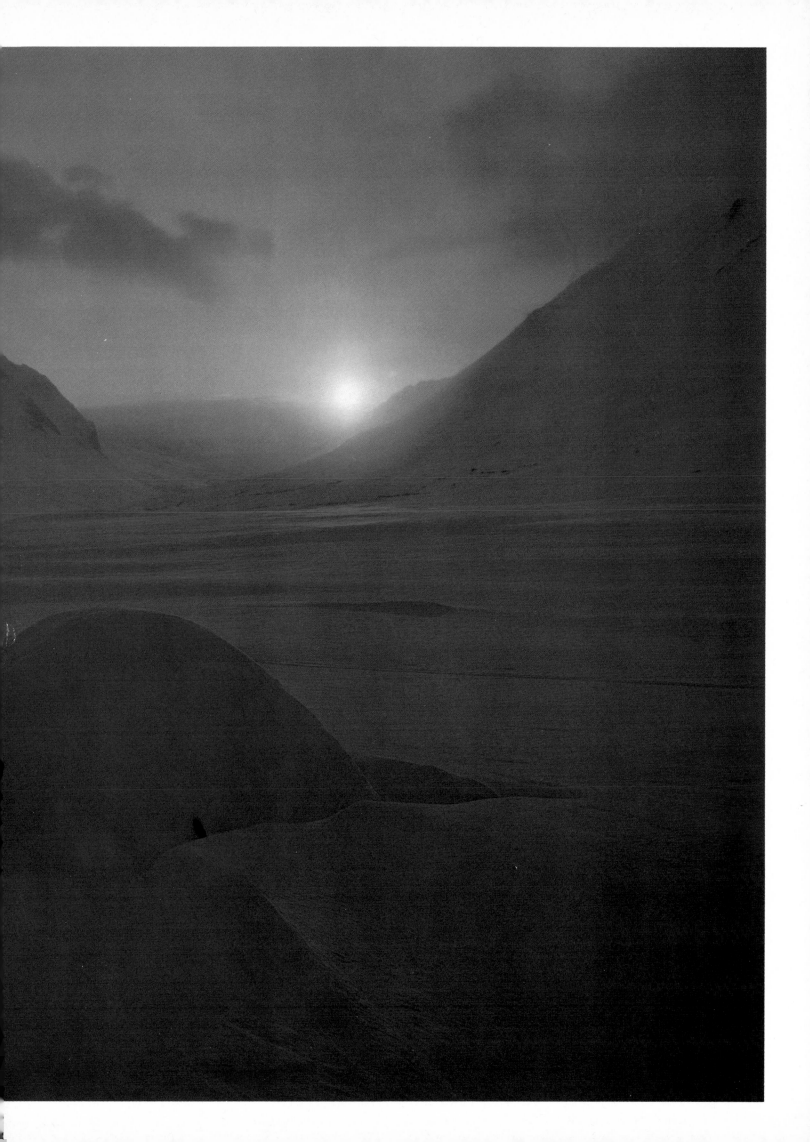

tion of near and far elements is typical of his skill with wide-angle lenses.

Morrow, who has been known to photograph landscapes from the lazy comfort of his sleeping bag, pitched camp with the compositional possibilities of the scene in mind. The day had been a dull one, the air heavy with ice haze, but when late evening suffused the vista with colour, he was in a position to exploit the favourable light.

Another well-placed campsite in the trailless wilderness of Kluane National Park provided a view across to the spectacular toe of the Donjek Glacier (below). The capability of an 80-200mm zoom lens for quick changes in framing proved useful in dealing with the fleeting shafts of light that dropped through wind-torn clouds and swept across the ice. Morrow used the long lens to isolate a portion of the scene, while at the same time maintaining the near-far progression through the distinct parts of the photograph which he likes to achieve in his work.

Climbing waterfalls in winter is one of the things Morrow does for relaxa-tion. Halfway up one such frozen curtain in Banff National Park, he stepped into an alcove and found an icy sword of Damocles above him (opposite). A compact camera with a 35mm lens was the only photo equipment he was carrying. With every extra kilogram adding to the load that threatened to pull him off into the void of eternity, Morrow keeps his gear on such vertiginous escapades to a minimum.

With his rugged lifestyle, his equipment sometimes takes a beating. On one occasion he fell, camera-first, into an icy river when the snowbank he was skiing on collapsed. Another time, he was changing lenses on a narrow mountain ridge when a friend accidentally kicked his favourite lens off a cliff. That proved to be a bad day all around for Morrow, who returned to camp to find a grizzly bear sitting amidst the ruins of his tent, chewing on a case that contained another lens, worth a thousand dollars.

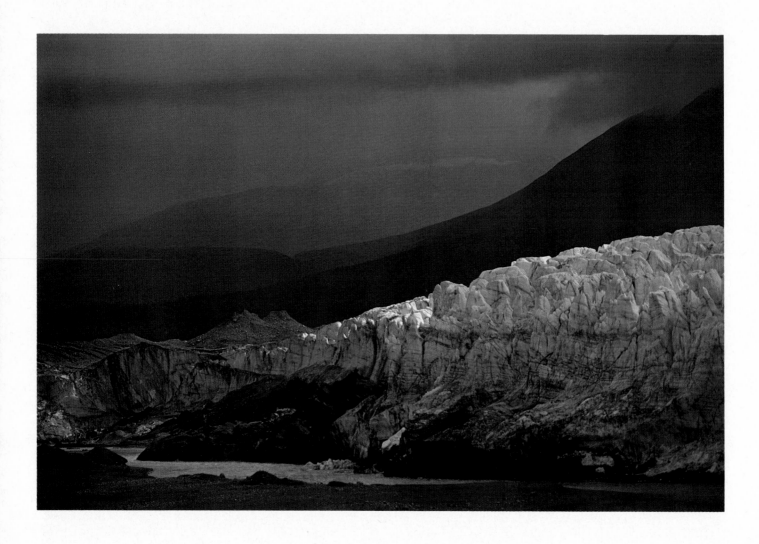

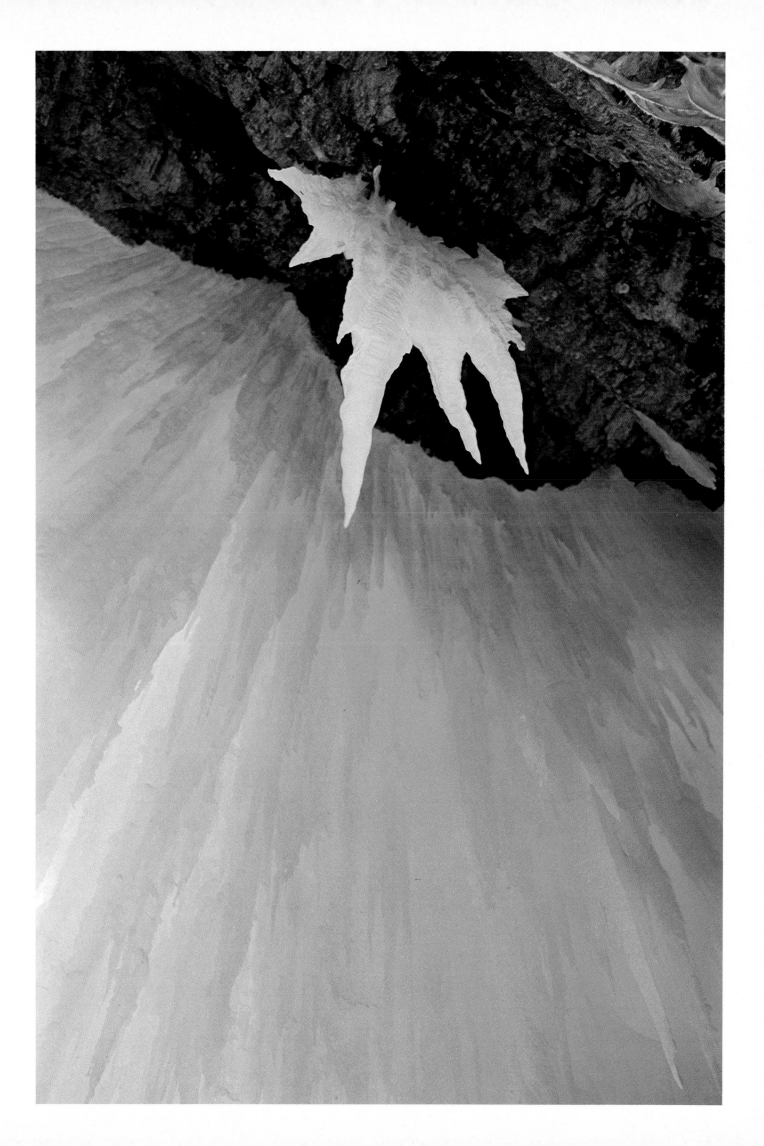

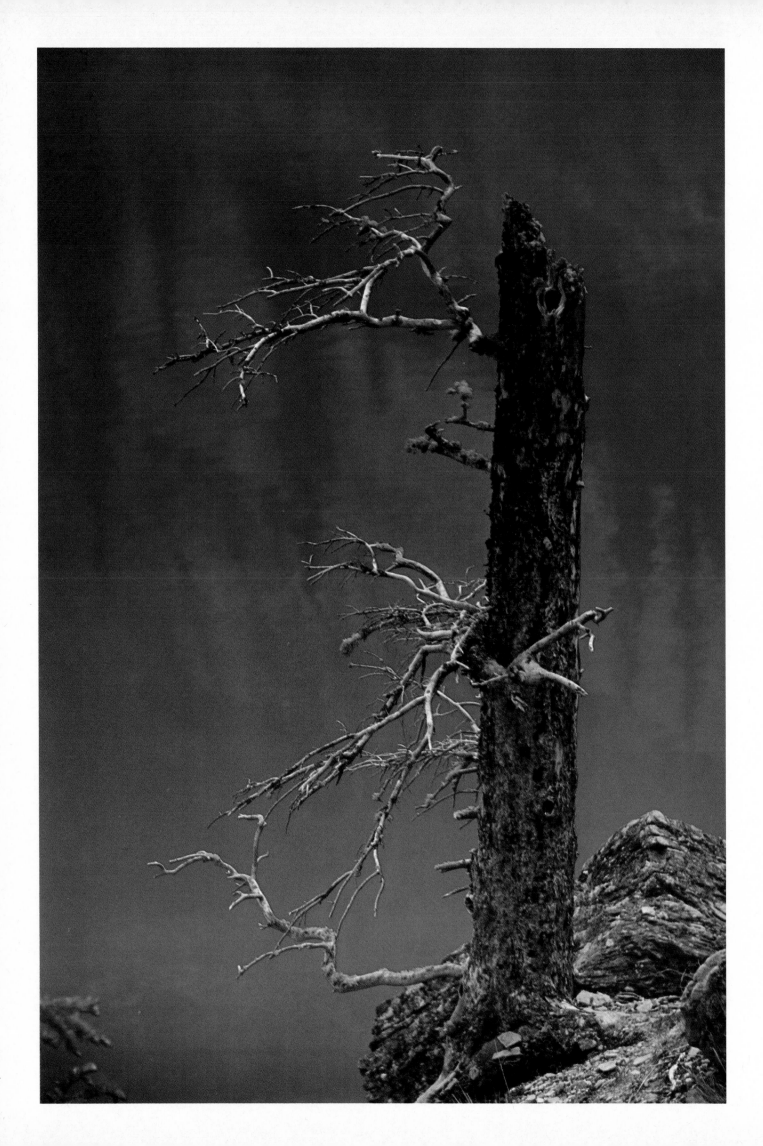

Animal tracks in the snow led Norman Lightfoot to his career. The white Canadian winters were new to him when he first arrived on this continent, having spent his youth in the British Isles and Africa. Always interested in the outdoors, he got a simple box camera in order to preserve the records of wildlife he found in the snow. One thing led to another, and today he is an accomplished filmmaker as well as a still photographer.

When he photographs wildlife, Lightfoot usually concentrates on the life histories of smaller creatures, such as snakes, frogs, mice, and shrews, rather than on the larger mammals. He is not so readily seduced by the glamorous and the obvious. Thus it was an old broken tree trunk (opposite) that attracted his eye at Moraine Lake, even while directly beyond it spread one of the most cherished sights in Canada, the scene on the back of the twenty-dollar bill.

"I liked the starkness of the tree and the stillness of the glacial waters, and the colour contrast between the tree and the water," comments Lightfoot. "What I found was a very interesting shape that was quite a strong element in the landscape, standing there all by itself. I thought of all the years that it had been growing, and what was living in it now that it was dead and falling apart. I wondered what kind of life had gone on in its branches when it had been alive, and what transformations it had gone through."

If he gets back to Banff he plans to return to Moraine Lake—to see if the tree is still there.

Lightfoot was teaching a weekend photography course when he took the abstract reflection of autumn foliage (below) at Minden near Algonquin Park in Ontario. For this photograph, as well as for the one at Moraine Lake, he preferred Ektachrome film over Kodachrome because he finds that the former gives him more pleasing results for water scenes.

One would have to consider a photograph of a groundhog leaping a stream (page 110) as most unlikely. While it is not implausible that the fat

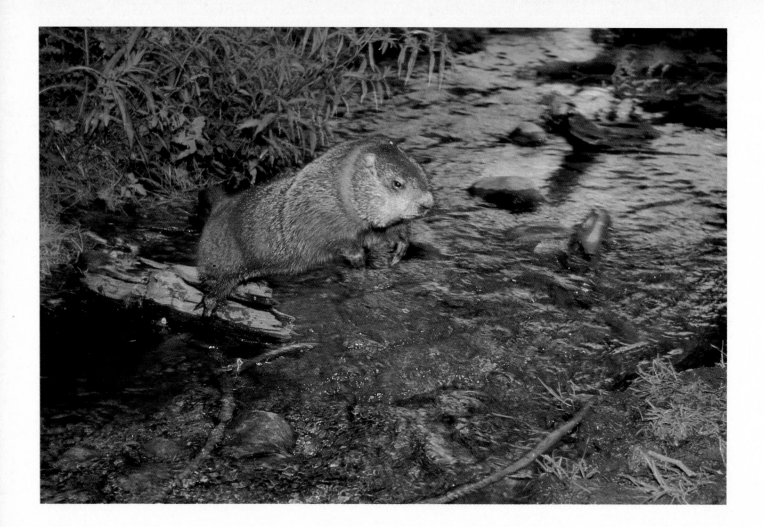

rodents will occasionally jump to avoid getting their feet wet, it strains the imagination to see a photographer reacting to the occurrence.

It wasn't really that difficult, explains Lightfoot, just a matter of observing animal behaviour. A creature of regular habits, this groundhog had worn a path through the grass to where it frequently crossed the stream. Standing behind his camera and 135mm lens on a tripod, Lightfoot didn't have to wait much more than an hour for this picture, taken in dark shade and illuminated with a small electronic flash held off to one side.

Perhaps his most memorable experience as a photographer came on the ice floes in the Gulf of St. Lawrence, where for four successive years he had been filming harp seals for the University of Guelph.

Few animals come into the world with such a rude shock. From the warmth of the womb, the harp seal pup is expelled into a world of sub-zero temperatures within a few dozen seconds. Lightfoot wanted to capture

the drama, though the odds were strictly against the possibility. Dropped off by helicopter near two female seals, one with a newborn pup near her, he set up his movie camera and hopefully focused on the lone female. When the seal with the pup became visibly uncomfortable, he thought she was expelling afterbirth, but swung his camera around, deciding to film the event anyway. Out popped a baby harp seal.

The new mother promptly chased the first pup off; it had belonged to the other seal all along.

Lightfoot continued filming until his film snapped in the cold. Then he grabbed his still camera and photographed the mother with her minutes-old pup, who had already moved away from the birthplace in the foreground (opposite). Thus, in 1979, Lightfoot became the first photographer to document the messy miracle of a harp seal's birth.

NORMAN LIGHTFOOT

"I love climbing trees," says Albert Kuhnigk. "I was always climbing trees before I ever started in photography, so I just carried it on, taking my camera up with me if I ever saw anything interesting."

This habit has got him some striking pictures of hawks and owls, as well as the classic portrait of a raccoon (opposite). Dextrous and intelligent, raccoons make adept burglars when it comes to engineering heists of camp food. This individual certainly looks the part, but there is no story about its activities that is nearly as delightful as its picture.

Kuhnigk spotted the raccoon ten meters off the ground in the top of an old hollow trunk in a woodlot near his home in St. Bruno, Quebec. When he started up a tree fortuitously located beside its perch, the animal merely glanced at him and didn't react much further. There were, in fact, two raccoons, one lower down whose fur was sticking out of a hole in the trunk. Neither one took much notice of Kuhnigk's climbing skills. It was a warm, sunny day in early spring, the snow was quietly melting, and all that concerned the raccoons was their fresh air nap. Kuhnigk took the picture with his 200mm lens and left the lazy animals.

He has had his presence acknowledged considerably more by some hawks, which raked his scalp with their talons in disapproval of his sitting in a tree beside their nest. "It feels as if someone has punched you—really hard—in the head," he says.

Kuhnigk found the chiaroscuro of shadow-striped fluffy snow and dark tree trunks (below) while out on a Sunday excursion on snowshoes, which he prefers to cross-country skis because of the greater manoeuvreability they allow for photography. The tracks in the snow are those of a varying hare, which he also managed to photograph that day.

An airplane provides the means to see the Earth in fresh and enlightening ways. The horizon recedes to tremendous distances, processes and relationships are clarified in the plan view, and abstract beauty is unveiled in patterns that are invisible from the ground. One photographer who has found irresistible the boundless possibilities revealed from the sky is Hans Blohm.

Among his many unique aerial images from across Canada is this panorama of fresh sea ice off the north coast of Baffin Island (opposite). He was on a charter flight in a Twin Otter when the co-pilot graciously allowed him to take over the right-hand seat and open a window onto the immensity of the Arctic. "It was indescribable: first of all the vastness of the space, and then the shapes, the colours, the lighting," remembers Blohm. "Once we saw an icebreaker. From the heights, it was a puny little thing, and it showed how insignificant man is in those surroundings."

Only later, back at his home in Ottawa, did Blohm learn that this picture, taken on the first day in October, was in fact made on a rare occasion. It shows sea ice in all its stages of formation, from its transparent beginnings to thick opaque slabs. The process lasts no more than forty-eight hours before the ocean surface becomes solid; a day sooner or later and he could not have obtained such an image.

To ensure that the photograph, taken with a 35mm lens, would not be blurred from the turbulence and vibration experienced in flight, Blohm used a fast shutter speed of 1/1000 of a second. To avoid the colour tint and optical distortion that shooting through a closed window would have created, he chose to contend with the arctic hurricane of the plane's slipstream. Very thin liner gloves, the space-age kind with reflective foil woven into the material, allowed him easy handling of his camera while insulating his hands against painful, direct contact with its frosty metal.

Heavily dressed and wearing a snug-fitting toque, he was still cold, but

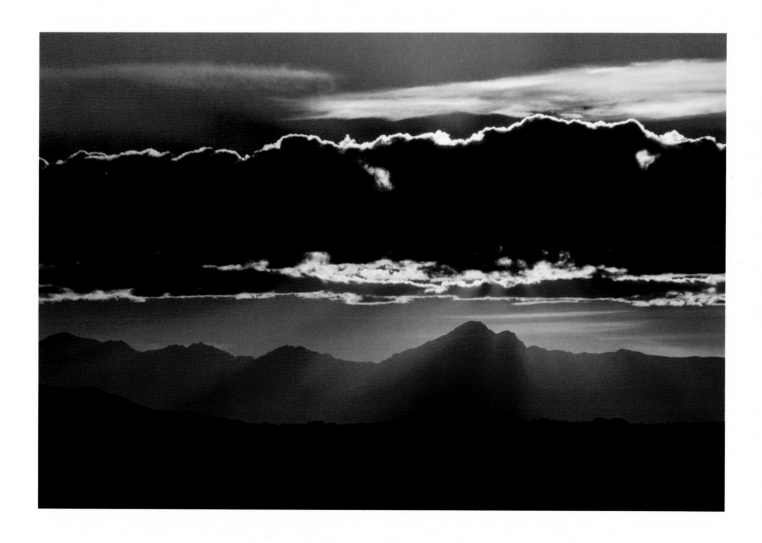

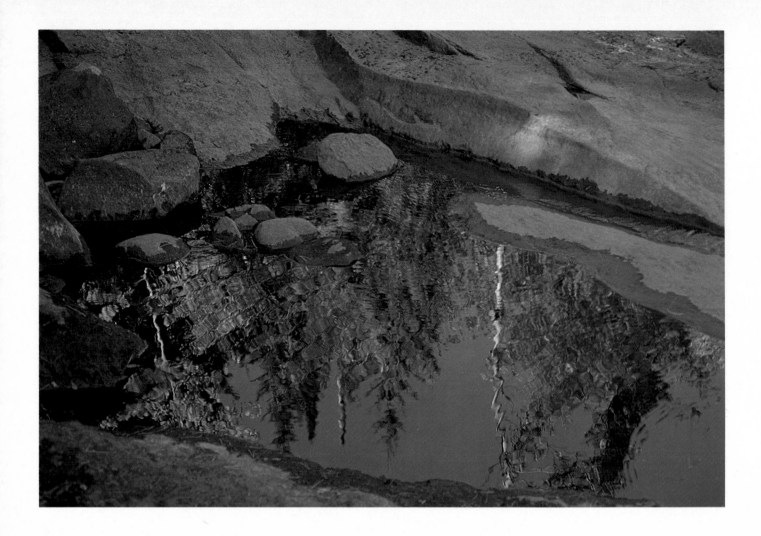

nothing like as cold as on another occasion he remembers. It was the middle of February, –30°C. on the ground, and Blohm wanted to take photographs from the back seat of a single engine Cessna with the door removed. Wearing a skimobile suit over thick wool pants over two pairs of long johns, he managed to take a quick roll of film with his 2¼ x 2¼-inch camera, whose large controls he could operate through two pairs of gloves. For the rest of the flight he was reduced to cringing in the relentless blast of the piercing slipstream. "Never, ever again," he vows. "I really thought at that moment I was going to die."

Blohm's sunset (page 115) is the type of image that too often gets dismissed as commonplace by those with a tendency to judge a picture only on the basis of subject. It is a unique photograph, no more diminished by the fact that it is of a sunset than a song is lessened by having romance as its theme. Composed of a series of horizontal bars, rich in their range of tones, relieved by the forceful diagonals of the mountain peak and the sun's rays, it can be appreciated in the abstract as bold, monochromatic design, if one is too sophisticated to be moved by the glory of a day's end.

With thirty years of experience in photography and many sunsets behind him, Blohm recognized the graphic potential on the distant horizon as he drove over the highest point on the Alaska Highway at Trutch Mountain in British Columbia. Using a 400mm lens, he isolated this tiny portion of the expansive view that stretched across a broad valley into trackless, absolute wilderness.

When Blohm drives gravel roads such as the Alaska Highway, he takes along a vacuum cleaner, a nifty minia-ture model that plugs into the cigarette lighter in the car. The penetrating clouds of abrasive dirt churned up by passing vehicles are anathema to camera equipment. He keeps his gear in dust-proof aluminum cases, but these are constantly being opened, so a regular vacuuming protects his finely engineered and expensive tools.

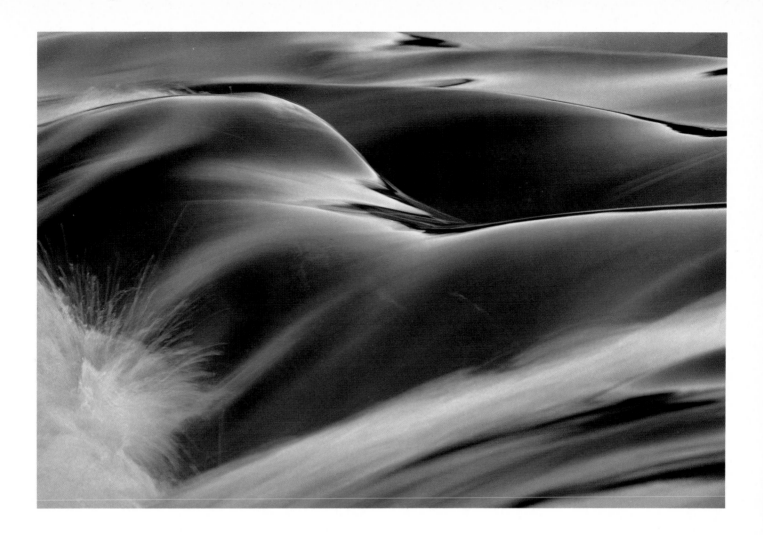

HANS BLOHM

For subjects with such high contrast as the sunset, judging exposure is difficult; the through-the-lens light meter would give widely varying readings, depending on which part of the scene the camera was pointed at. Also, in such cases, there is no such thing as the "correct" exposure; how light or dark the image should be depends on the effect the photographer wants to achieve. Like many photographers, Blohm prefers to take several different exposures in such circumstances, but there is no guesswork in his methods.

He credits his father for the confidence with which he is now able to pursue a craft where feedback on work in progress is generally nonexistent. Before Blohm was ever allowed to use a camera, he was required to read a book on photography from cover to cover. Following its advice, he took detailed and complete notes of the light conditions and of his procedures for every picture he made. "It was a tremendous help," he reflects. "I was able to learn exactly where I made my mistakes and why I made my mistakes." He still has those voluminous notebooks filled with pictures and accompanying data, though as a busy commercial photographer who often makes hundreds of exposures in a single day, making written records is no longer possible, or necessary.

A still pool of water along the stone banks of the upper Gatineau River in Quebec provided Blohm with his picture of reflected autumn foliage (opposite) made with a 35mm lens. The evening sun illuminates the mirrored maple, birch, and spruce, framed with shaded granite which picks up its complementary blue colour from a clear, cloudless sky.

In the same place, Blohm photographed the standing waves at the top of some rapids (opposite) while bracing himself and his 200mm lens on the logs which jammed a steep rocky section of the river. The rich glossy tones give a thick, heavy feeling to the flowing water, its slick smoothness enhanced by the relatively slow shutter speed of 1/15 of a second.

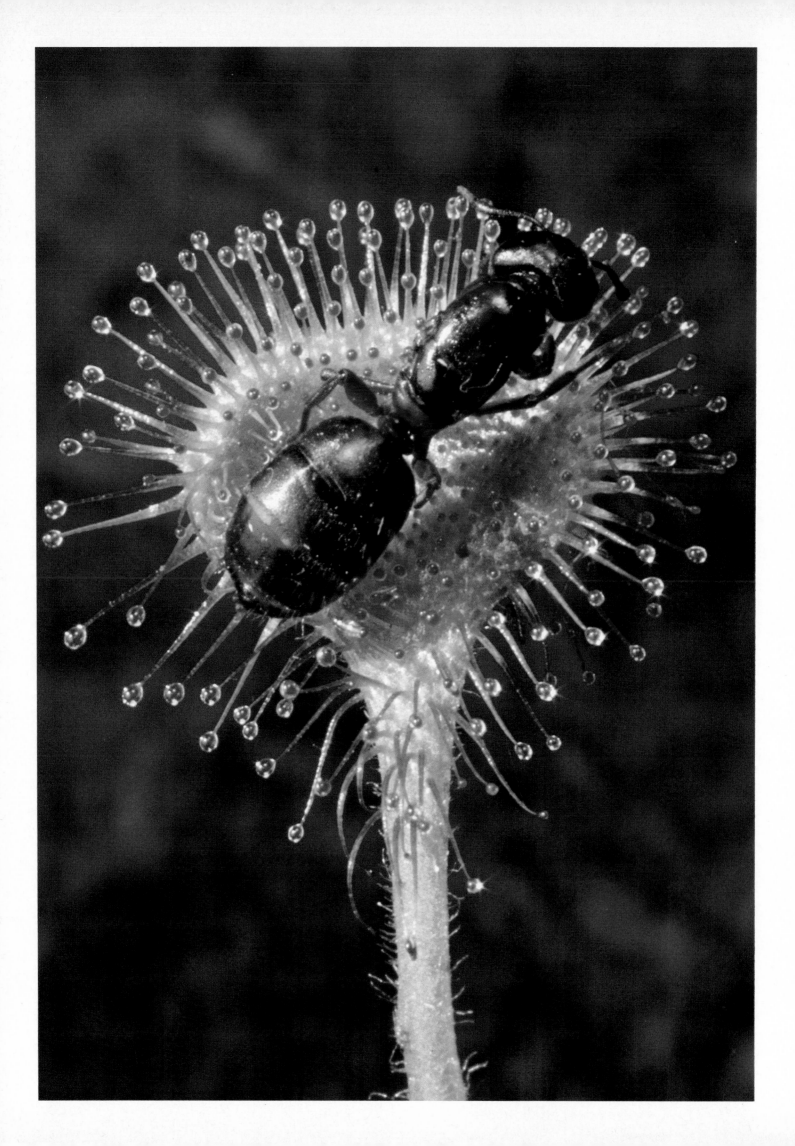

Rowing around on a pond of sewage for several hours with hundreds of people watching sounds like a strange undertaking for a nature photographer—or anyone else for that matter. For Ervio Sian it was an opportunity not to be missed. The occasion was the sighting of a rare bird from Siberia beside Vancouver's effluent treatment plant. The spoonbilled sandpiper, about the size of a pigeon, had only been seen in North America twice before. Sian realized that the only way to get close enough for a decent picture without frightening the bird was to approach it in a blind installed on a rowboat. Undeterred by the foul water or the potential wrath of birdwatchers who had come from as far away as Texas, he succeeded in photographing the lone sandpiper, which remained undisturbed.

Recording such rare occurrences has become common for Sian. Doing it in discomfort is something he has become used to. Once, while photographing owls, he spent the night twenty meters off the ground in a tree while a vicious storm broke branches and soaked him with driving rain. Another time, he huddled cramped in a hole covered with evergreen boughs for eleven hours in order to get pictures of a particularly suspicious pair of nesting hawks. He returned from one excursion carrying a naturalist companion on his back after the man had been bitten by a rattlesnake. On yet another occasion, while photographing the nest of a black tern by remote control, he was mercilessly attacked every time he went to his radio-operated camera to change film. The aggressive bird drew blood from his neck, leeches crawled all over his

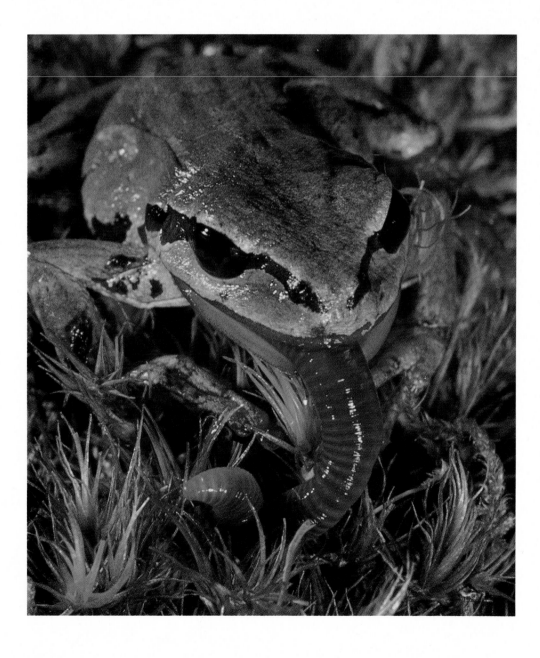

119

legs after sharp sticks from a beaver dam had punctured his gum boots, and hosts of mosquitoes took care of everything in between.

During two decades of such dauntless efforts, Sian has captured some remarkable images. "I have come to the conclusion that nothing is impossible, that anything can happen in nature," he says.

His graphic composition of a sticky sundew leaf digesting an ant (page 118) shows one such unusual event. Ants prefer dry terrain, while the carnivorous plant grows in marshy areas and generally traps mosquitoes and flies. However, this specimen at the end of a bog near the Vancouver airport had managed to capture one of the ants that had wandered across some nearby logs.

For illumination, Sian used two flash heads mounted on tripods on either side of the sundew. He positioned them so that little or no light would fall on the background, leaving it dark and uniform. With the camera also on a tripod, a 55mm macro lens, set at its minimum aperture for maximum depth of field, was used on a bellows to permit the close focusing. Sian had about twenty minutes in which to work before the ant disintegrated.

He had much less time to fix the tree frog devouring an earthworm (page 119). While gathering mushrooms in the woods, he noticed the frog when it had just discovered the worm. In the frantic minute it took him to mount his 135mm lens with two extension tubes onto a camera and ready one flash unit most of the worm had been swallowed.

ERVIO SIAN

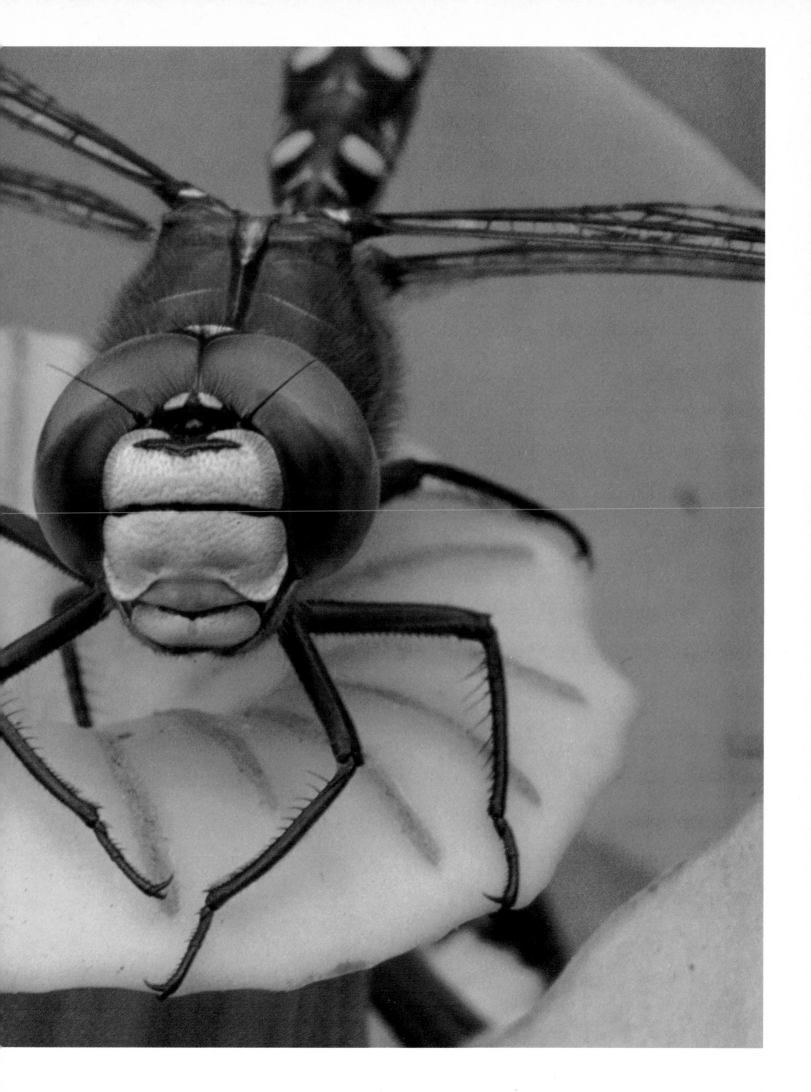

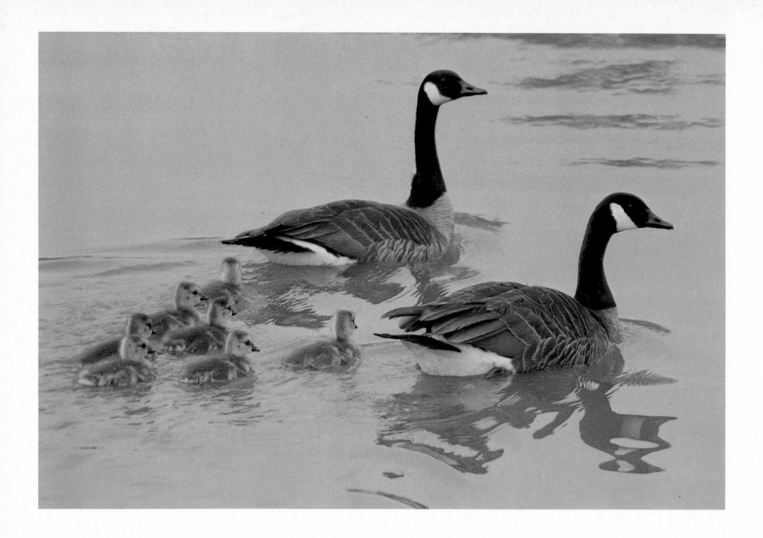

It wasn't the first time Sian had witnessed the voracity of frogs. "If I hadn't seen it with my own eyes, I wouldn't have believed it," he says of another occurrence.

"I was walking along the edge of a slough when I saw a blackbird fly up to her nest. The young birds waiting were quite feathered, almost ready to fly. They somehow got mixed up and one of them fell into the water. I saw a bullfrog on a rock about ten meters away dive in and swim for the bird. It came up like an alligator—whammo!"

Sian's quick reaction was only good enough to get a picture with just the wingtip of the hapless bird left showing.

For the past seven years, Sian has pursued a monumental project, that of documenting every kind of bird found in British Columbia. His family of Canada geese (above) is from a remarkable collection which includes almost all of the 413 species on the province's checklist. Hand-holding his 300mm lens, he photographed the parents taking their goslings out for a paddle on the Serpentine River.

In such a situation Sian seldom takes light meter readings, judging his exposure by experience gained from years of consistently working with only one or two films (the Kodachromes). Only for close-ups and unusual lighting situations will he use his meter.

The close-up of the blue darner on a yellow pond lily (pages 120/121) was made with available light on a hazy bright day at Stum Lake. He photographed the dragonfly with his 105mm lens and extension tubes from a canoe held steady by a companion.

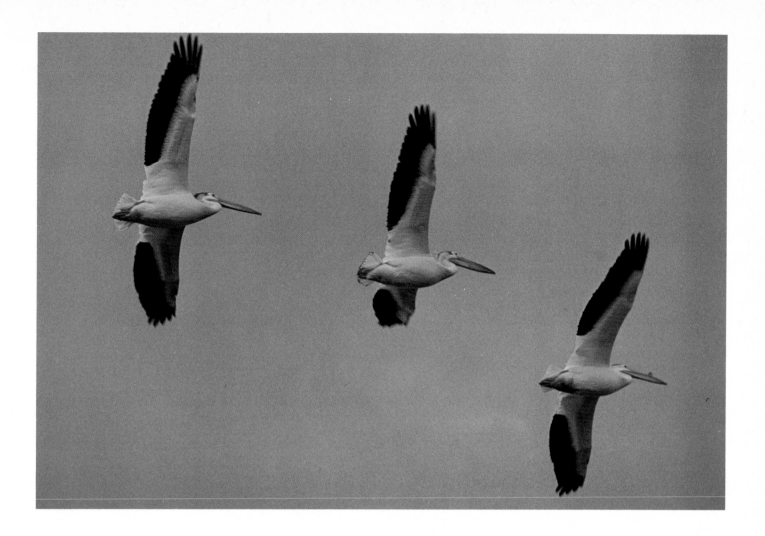

ERVIO SIAN

Stum Lake, where Sian spent ten days, harbours the only known nesting colony of white pelicans in British Columbia. The birds have depleted the fish stock in the lake, and travel as far as a hundred and fifty kilometers to harvest more populated waters. Working in teams like so many power shovels, they scoop through schools of minnows and, like wide-bodied cargo planes, return with their catch in their bellies to regurgitate it for their young.

Sian captured this trio (above) with his 300mm lens as they departed for a fishing expedition. Circling slowly on a rising thermal, the big-billed fishermen gave him sufficient time for focusing. The lead bird can be distinguished as a male by the plate on his bill, which he will lose sometime after the breeding season.

With the assistance of naturalists studying the colony, Sian commuted by canoe between his blind amidst the shy birds and camp, five kilometers away. "I would go in early, four o'clock in the morning, and stay all day," he remembers.

"The heat was tremendous. It was 25°C., full of mosquitoes, I was sitting on a pile of manure—oh, the ammonia! I went back to camp with my eyes all swollen. I had bumps over bumps on my head. You know, I used repellant."

There are many photographers who have a talent for seeing. There are far fewer who combine it with enthusiastic initiative and perseverance. Ervio Sian is one of that rare breed.

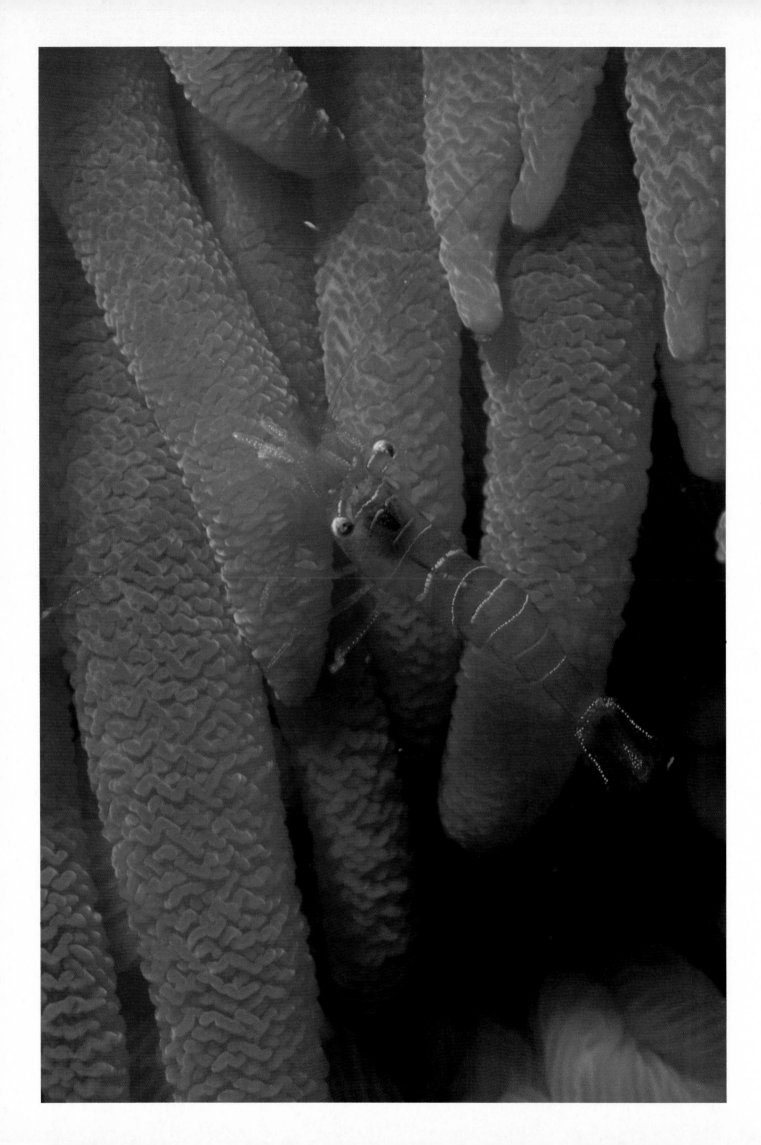

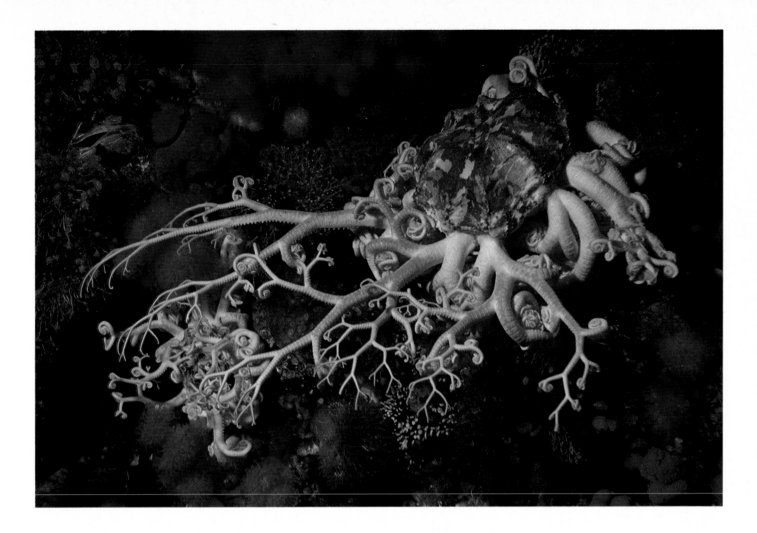

NEIL MCDANIEL

"There is a lot more down there than most people realize," says Neil McDaniel, a veteran scuba diver who is constantly overwhelmed by the abundance and diversity of undersea life along the coast of British Columbia.

"Much of the life hasn't even been described," he continues. "Over five thousand species of invertebrates, some five hundred marine seaweeds and about three hundred and fifty different fishes have been identified, and they are still counting. We have more species of sea stars here than along any comparable length of coastline in the world. We also have some superlatives, such as the large sea star and the largest sea slug in the world."

To document this richness, McDaniel, the editor of *Diver* magazine, makes some one hundred dives a year, during which his scientific background as a biologist helps him to recognize the new and the uncommon as well as to search for known subjects. Knowing where to look got him the photograph of a clown shrimp (opposite), the most colourful in British Columbia's waters.

This tiny shrimp is regularly found in association with only one out of the great variety of anemones in its region, the crimson anemone, whose stinging tentacles don't seem to bother it as it scavenges for waste material egested by the anemone.

McDaniel's other photo (above) is of a basket star, a remarkable creature found only in current-swept waters, which feeds by trapping passing particles in its multi-branched arms.

On every single dive he makes, McDaniel brings a camera, sealed in an aluminum and glass housing that permits full operation of all its controls, and his flash, without which only the most mediocre photos are possible in the dim and predominantly blue water-filtered light. If he plans on exposing more than one roll of film, he leaves another camera in another housing hanging off the side of his boat, since he almost never opens a housing before he has returned home and rinsed and dried it off. He finds the 55mm macro lens he used for both these photos among his most useful.

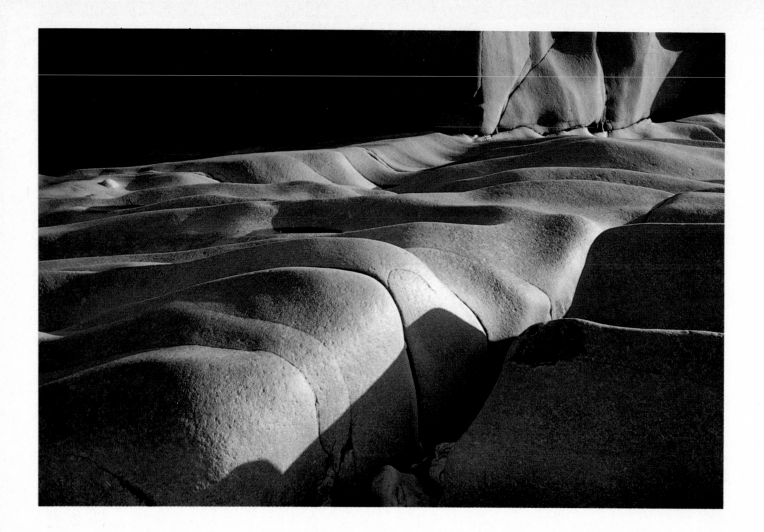

"People ask me what I photograph and I say, 'anything that is beautiful or interesting'," explains Chic Harris, who, with that kind of appetite, doesn't have to worry about being idle. Faced with choosing from among several possible hobbies to keep him busy after retirement, he settled on photography. Deciding that if it was worth doing at all, it was worth doing properly, he took some intensive courses, became active in a couple of camera clubs and now, with the illustration of several books to his credit, has established himself in a new career.

The algae-stained limestone out-crop, revealed at low tide along the wave-sculpted shoreline of Hudson Bay (above), was photographed by Harris near Churchill, Manitoba. The low-slanting sunshine of late afternoon created the strong interplay between light and shadow which makes the picture. Light, of course, is the ultimate ingredient of photography, and under-standing the different ways in which light can render and enhance a subject on film is the fundamental skill every photographer must possess. Con-versely, the effect of shadows is an important consideration in taking photos, though it usually is perceived in the negative sense of something to be avoided, something which results in too much contrast and obscures and confuses the main elements in a pic-ture. In this photograph, however, the shadows play a positive and essential role in forming the composition.

Harris is particularly aware of the design possibilities presented by cast shadows. It is one of the things he looks for in the game he plays of constantly scrutinizing his surroundings for effective compositions—even when he does not have his camera with him. With this habit of being continually observant, he produced the photograph of window frost and the sun in his bedroom (opposite).

CHIC HARRIS

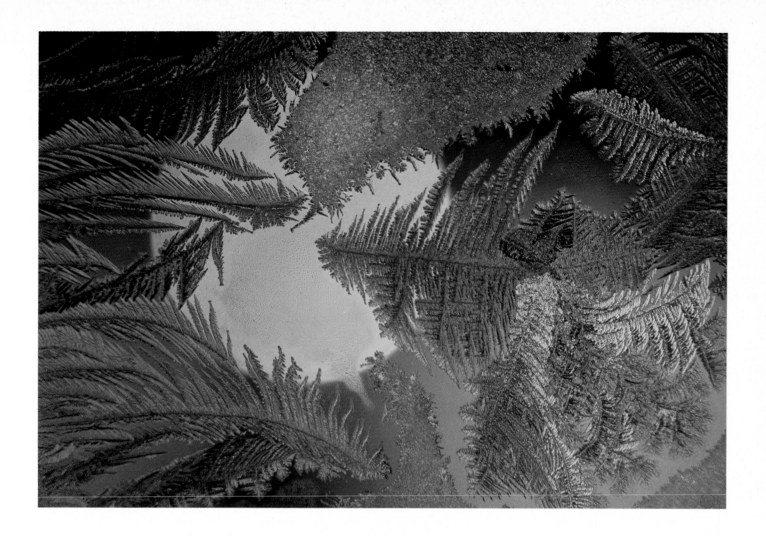

The fortuitous circumstance of the setting sun being at right angles to the window pane made the picture possible. Out of focus, the sun was rendered large and round by using the 55mm macro lens at its maximum aperture; stopping the lens down would have decreased the apparent size of the sun as well as imparted to it the polygonal shape of the opening of the lens diaphragm. But with the shallow depth of field provided by the wide aperture, and at the close distances involved, the window pane had to be parallel to the film plane in order for all the frost crystals to be in sharp focus.

Frost is a favourite subject for Harris, who has a large collection of the seemingly endless variety of etchings that winter prints on glass. "The frost crystals grow in the most amazing ways," he observes. "Occasionally you get shapes which you never see again; I have photos of some which I have only seen once in my life." Among the variables which account for this diversity in form are the temperature difference between the room and the outside, the humidity in the room and the dirt on the window pane, he goes on to say. But Harris's interest in the phenomena is that of a poet, rather than a physicist. His photograph expressively evokes a fundamental duality: fire and ice. It images the interaction of water and the sun, the primal association which is the ultimate source of our weather, our landscapes, and of life itself and all of its consequences; in short, of everything that is beautiful and interesting.

Glossary

aperture: size of the lens opening through which light is allowed to pass.

back light, front light, etc.: describes the direction of light as it shines on a subject, *e.g.,* in front lighting, the light source is behind the photographer and illuminates the front of the subject.

bellows: a collapsible, accordion-like sleeve that connects the lens to the part of the camera containing the film. It is an integral part of view cameras. In 35mm photography, it is an accessory used for close-up work.

blind or *hide*: an enclosure which conceals the photographer from the view of animals.

close-up lens: a supplementary lens which, when placed over a regular lens, focuses the regular lens to closer distances.

depth of field: the total distance which remains in focus in front of and behind an object focused upon. Depth of field becomes shallower the closer the object, the larger the aperture, or the longer the focal length of the lens.

electronic flash: a recyclable source of brief, intense illumination.

exposure: the amount of light film receives, which is a product of shutter speed and aperture.

extension tubes: light-tight tubes placed between camera and lens, thereby increasing the distance of the lens from the film so as to permit focusing on close objects.

focal length: except for mirror lenses, the distance from the optical centre of a lens focused at infinity to the film plane.

format: the size of a negative or transparency, around which cameras and camera systems are designed.

light meter or *exposure meter*: an instrument which measures light intensity and interprets it in terms of camera settings.

macro lens: in acquired popular usage, a lens capable of focusing to closer distances than a regular lens of its focal length used without accessories such as extension tubes, bellows, etc.

mirror lens: a lens through which the light path is reflected forward and back again by means of mirrors, permitting a lens of long focal length to be made much more compact than the equivalent regular lens.

motor drive: a battery-powered device which advances film automatically, thus permitting photos to be taken in quick succession.

polarizing filter: a rotateable filter useful principally to reduce glare and reflections from non-metallic surfaces, and to deepen the colour of blue skies.

shutter: the device, located either within the camera or within the lens, which permits light to reach and expose film.

shutter speed: the length of time, generally a fraction of a second, during which the shutter permits light to reach the film.

teleconverter or *multiplier*: an optical device which, placed between a camera and a lens, increases the effective focal length of the lens by a fixed factor, usually two or three, *e.g.,* a 2x teleconverter converts a 200mm lens into a 400mm lens.

ultraviolet filter: a filter which, when placed over a lens, screens out ultraviolet radiation which has an undesireable effect on film in the photography of distant views. In colour photography, a *skylight filter* is generally used; it serves the same purpose but has a very slight amber tint that further reduces excess bluishness.

view camera: a large format camera, *i.e.,* generally one which takes 4 x 5-inch film sizes or larger.

zoom lens: a lens whose focal length can be varied continuously over a certain range.